TOKYO
SIGHTS

Discover Tokyo's Hidden Gems

Stephen Mansfield

TUTTLE Publishing

Tokyo | Rutland, Vermont | Singapore

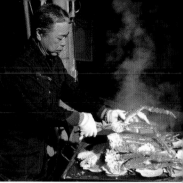

Contents

Part Four
Exploring Western Tokyo

Part Five
Excursions around Tokyo

A City of Infinite Possibilities

An alien spacecraft entering our orbit at twilight in search of a suitable landing strip, would find in central Tokyo's motherboard of neon, of structures soaked in polychromatic electronic surges, the most intense nocturnal illumination on the planet.

For a country the Japanese fondly like to think of as small, Japan boasts a surprising number of superlatives, among them Tokyo, the world's largest metropolis. The city's growth is an astonishing story given that in the late 16th century it was little more than an impoverished fishing village occupying a stretch of pestilential marshland. The rise of Edo, as Tokyo was then called, was rapid, as it became not only the military and mercantile powerhouse of the country, but also its de facto capital.

Almost 250 years of relative isolation from the outside world may have deprived Japan of the technological advances being made in Western countries, but its intense introspection created the conditions for an extraordinary efflorescence of domestic culture, driven largely by townspeople. Many aspects of today's highly visual culture, found in forms like anime, manga, painting, and the performing arts, date from this era.

Enthralled by its own hyperbole, by a delirious, super-inflated confidence, a belief in impregnable economic institutions and practices, the implosion of the bubble economy dispelled most of the euphoria associated with the heady days of the 1980s. But Tokyo is once again the stage for a rejuvenation, spurred by a new generation of artists, writers, art dissidents, creative entrepreneurs, malcontents, and contrarians. Many observers are calling today's fascination with the country the third wave of Japanophilia, the first occurring in the 18th and 19th centuries with the discovery of Japanese arts and aesthetics. The second, less publicized wave took place in the 1950s and 1960s with the translation of many works of modern Japanese literature. The current phenomenon, driven by TV, film, the Net, and a fascination with popular culture, is manifest in everything from experimental architecture, maid cafés, cosplay, anime and manga characters, lurid arcade art, rock bands like Baby Metal, and occasional performances by Hatsune Mika, a digitally created singer. Tokyo, one of the world's great fashion capitals, is the epicenter

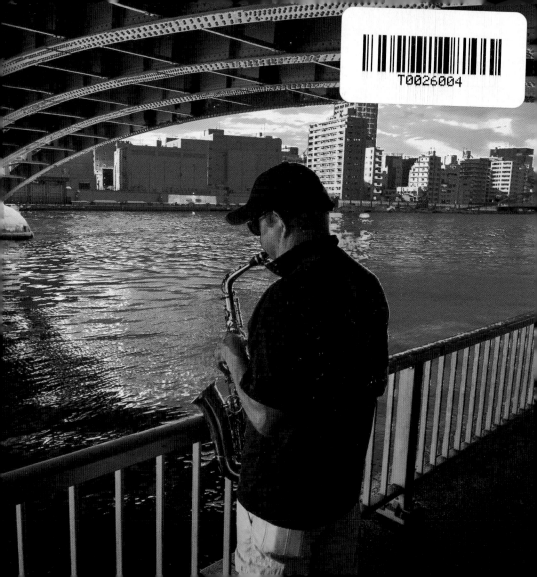

of this effulgent culture. It is also one of the best cities in the world to eat, shop, and sightsee. British food writer Michael Booth has gone on record saying, "Japan is the greatest food nation on earth, inhabited by the most discerning eaters, and with the most advanced restaurant culture in the world."

A city of incalculable angles, of cities within cities, Tokyo is easily characterized as a concrete jungle, a tangle of hyperkinetic streets, concourses, mounted video screens, game arcades, streaming advertising, prerecorded shop messages, glass elevators, and raised railway tracks, but view the city at ground level and you encounter lush implants of greenery in the form of exquisite Japanese gardens, parks, tree-lined boulevards and cultivated medians. The narrow back alleys of older quarters are a tangle of homes fronted by potted blooms, vegetable planters, and creepers.

Pleasure palace then, or urban dystopia? Historically, Tokyo has been both. Its response to natural and man-made catastrophes has

Entrance fees have been ranked according to ¥ symbols:

¥ = ¥600 or less
¥¥ = ¥600–¥1000
¥¥¥ = Over ¥1000

always been to rebuild. Ultimately, your judgment of the city will depend on whether you view it as a model of thrilling unorthodoxy or an example of how unchecked development can metastasize into urban eyesore. To be sure, not everyone has been entranced by the city. Australian journalist Hal Porter wrote in 1967 that "Tokyo is an allegory to warn, a horrifying and bloated City of Dreadful Day where post-1984 robotics and the superstitions of prehistoric animism are inextricably braided together, an abnormal metropolis, feverish and discordant, hysterical, hybrid and chaotic." A later writer, Paul Theroux, concluded, "The gray sprawl of Tokyo was an intimidating

version of the future, not yours and mine, but our children's."

Tokyo embodies, perhaps more so than any other city on earth, the message that all things pass, that permanence is a pretension. The process of emergence and extinction in the urban context is so rapid it barely registers in the mind. Tokyo today bears as little resemblance to Edo as the mega-skyscrapers of Dubai correspond to the crumbling sand medinas of the past. In its vision of urban planning, only smidgens of heritage are permitted to remain. One suspects that in an ideal world,

the authorities might favor a totally modern, replaceable city, one with historical holograms inserted into its fabric.

In the absence of a master plan, it is nevertheless possible in this most provisional, acquisitive, mind-challenging of capitals, to apprehend, as dusk falls over the city, neon lights piercing the darkness like phosphorescent meteors or waves of electric aurora, a fluid, transient beauty, in which an infinite number of alternative futures are possible.

Stephen Mansfield

OPPOSITE Elders resting up at the Gion Matsuri, an annual festival connected to Narita Temple.

ABOVE A darkened room illuminated with artist Kusama Yayoi's iconic pumpkins.

RIGHT Celebrants at the Shibuya Scramble on Halloween Day, now a huge cosplay event.

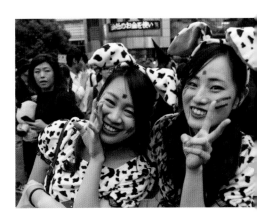

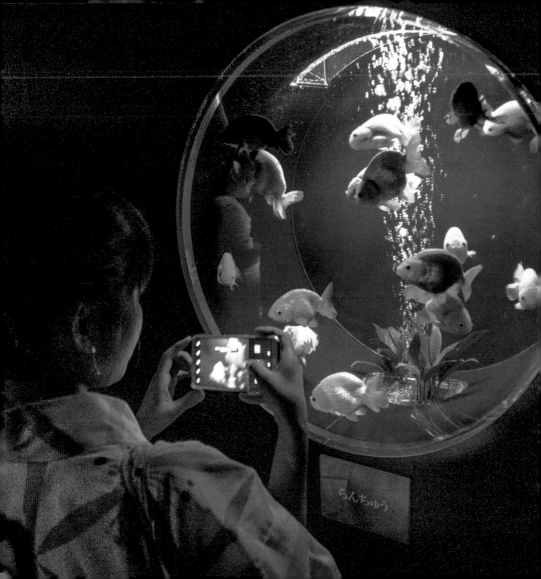

Exploring Central Tokyo

Although its vast interior is largely invisible to the eye, the area that spirals out from the Imperial Palace grounds and its circumnavigating moats, is the closest the city has to a center. Home to a single family, far bigger than Buckingham Palace, it occupies 110 ha (270 acres) of what was once Edo Castle, the authorial core of the historical city. The French critic and semiotician, Roland Barthes, famously called this empty center the "sacred nothing." When the castle was finally completed, the outer defensive perimeter measured a staggering 16 km (10 miles), the inner perimeter 6.4 km (4 miles).

It was the largest fortress in the world, though few people in Europe or the Middle East would have known that fact. The concentration of power, a centrality that confers wealth and prestige, is manifest in the nearby Kasumigaseki, home to the Diet Building and a number of government ministries, the business districts of Nihonbashi and Marunouchi,

Tokyo Station, the capital's premier transportation hub, and a number of high-end department stores and shopping districts. These components of power and affluence might be understood as legacies of the original, rigorously managed city center, where authority radiated from Edo Castle and the elite social and political structures it supported.

LEFT Art Aquarium, an annual Nihonbashi event, features thousands of goldfish.

RIGHT Futuristic car designs today at Ginza's Nissan Crossing.

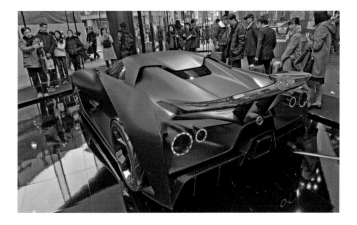

RIGHT A guardian, one of a pair, at the entrance to Kanda Myojin Shrine.

FAR RIGHT An image from London's "swinging sixties," parked in a Kagurazaka back street.

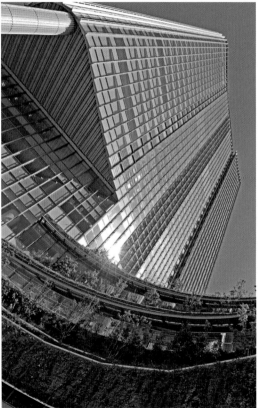

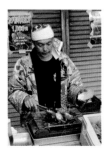

LEFT The soaring towers of Tokyo Midtown Hibiya Complex, a creatively designed shopping center.

ABOVE Illuminated with paper lanterns, the impressive entrance gate to Kanda Myojin Shrine.

RIGHT Grilling *ise-ebi*, a prized lobster, in Tsukiji Outer Market.

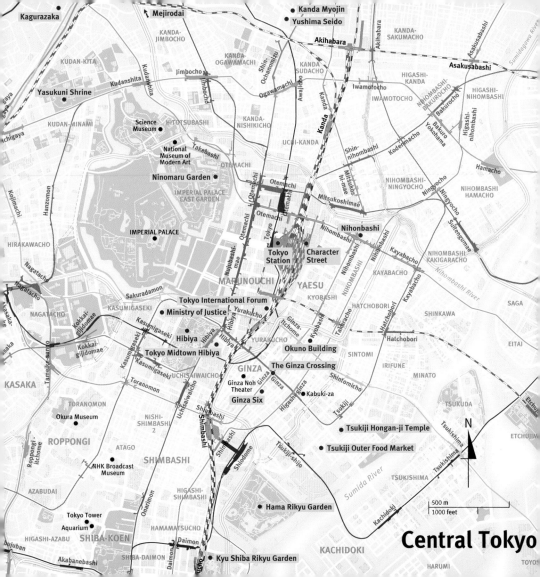

Central Tokyo

IMPERIAL PALACE EAST GARDENS

Location Chiyoda 1-1, Chiyoda-ku. **Access** Otemachi Station, Tozai Line.
Hours 9.00 a.m.–5.00 p.m., closed Monday and Friday. **Fee** Free access.

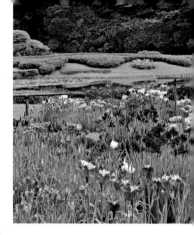

Part of the extensive Imperial Palace East Garden grounds, the Ninomaru Garden is attributed to the landscape designer and tea master, Enshu Kobori. The essence of Enshu's style is often described as *kirei sabi*, denoting simplicity and gracefulness. Although he only created a handful of gardens in his life, the harmonic mastery of land and water here suggest that even if Enshu was not directly involved, his garden principals were closely heeded. Created in the style of the early 17th-century stroll garden, it was restored in 1968 using the original design sketches. Liberally planted with

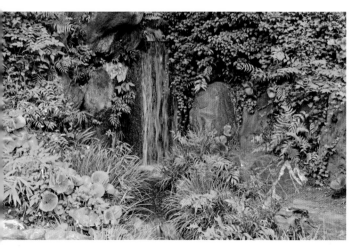

azalea, wisteria, and towering zelkova trees on its fringes, a small but dazzling field of irises come into blossom in early June, bush clover and camellia in the autumn. Recently, many of these blossoming dates have been accelerated by the effects of climate change and Tokyo's rising heat island temperatures. A pond, with cow and pygmy water lilies, Japanese seedbox, and a rare water plant known as floating heart, cool down the air during the fetid summer months. Ninomaru Grove provides further relief from the heat, its earth paths passing under sawtooth and konara oak, arrowwood, maple and wax tree, a wonderland for birds.

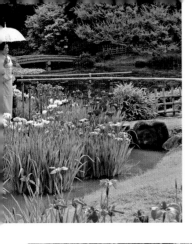

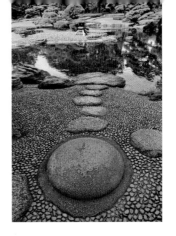

LEFT A woman in kimono pauses to admire the garden's resplendent irises.

RIGHT The angle of these stepping stones adds depth and perspective to the pond section of the garden.

BELOW A three-legged, snow-viewing lantern dominates this corner of the garden.

OPPOSITE BELOW A tight grouping of waterfall and accompanying rocks in a green recess of the garden.

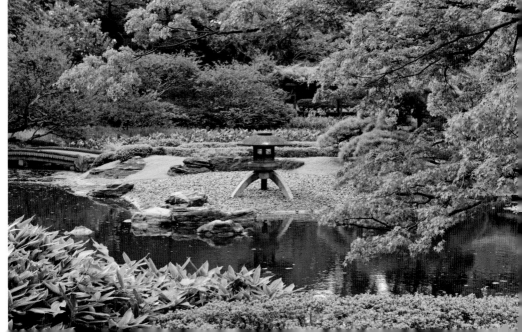

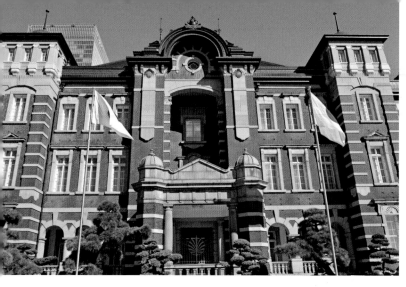

TOKYO STATION & TOKYO CHARACTER STREET

Location 1-9-1 Marunouchi, Chiyoda-ku. Character Street
Access Yaesu Underground North Exit. Hours 10.00 a.m.–8.30 p.m.

Tokyo Station, fully functional by 1914, is one of the last red brick Queen Anne-style buildings left in Marunouchi, a district once known as London Block. The work of prominent architect, Tatsuno Kingo, the station remains an important gateway to the city. Modeled after Central Station in the Netherlands, renovation on its upper structures and cupolas, lost in the B-29 air raids of 1945, was completed a few years ago. In stark contrast to early 20th-century design tastes are the station's modern subterranean passageways. Conduits for passengers in a hurry, Tokyo Character Street is one place where young people and the curious come to linger and shop. Occupying two or three lanes

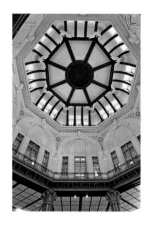

beneath the Yaesu north side of the station, the cluster of Japanese anime, manga, and TV character shops adds a dash of color and brio to the predictable cafés and restaurants found here. Over 20 shops highlight popular character goods, ranging from Pokemon to Hello Kitty, Rilakkuma, Doraemon, Crayon Shinchan, and Sailor Moon. Fans of the pioneering anime workshop Studio Ghibli won't want to miss its shop, Donguri Republic, which showcases souvenir items and collectibles from the popular animations *Princess Mononoke*, *Kiki's Delivery Service*, *My Neighbor Totaro*, *Spirited Away*, *Dragon Ball*, and many more.

ABOVE RIGHT Tokyo Character Street is a Mecca for small children but also older followers of manga, anime, and toy products.

BELOW Illustrated panels of fun characters make even a quick stroll to your train platform a form of entertainment.

TOKYO INTERNATIONAL FORUM

Location 3-5-1 Marunouchi, Chiyoda-ku. **Access** Yurakucho Station on the JR Yamanote Line. **Hours** 7.00 a.m.–11.00 p.m.

One of the city's most interesting architectural landmarks, designer Rafael Vinoly's multipurpose conference center stands in elegant contrast to the drab, elevated rail tracks of Yurakucho Station. Completed in 1996, the complex was one of Tokyo and the Japanese century's final act of architectural monumentality. Four blocky structures, modern but utilitarian in appearance, stand in contrast to a massive glass forum, the

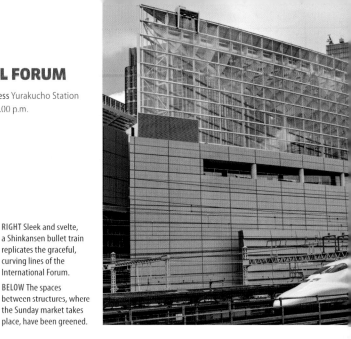

RIGHT Sleek and svelte, a Shinkansen bullet train replicates the graceful, curving lines of the International Forum.

BELOW The spaces between structures, where the Sunday market takes place, have been greened.

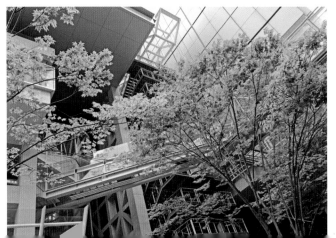

convex-shaped lobby a mesmerizing swirl of steel truss, close to three thousand plates of tempered glass and natural light, the effect reminiscent of glass domes and malls like the Milan Galleria. Its Uruguayan architect, though, is said to have modeled it after the hull of a boat. Host to galleries, exhibition spaces, restaurants, and shops, the ramps, bridges, and sky walks that dissect the upper levels of the forum, also known as the

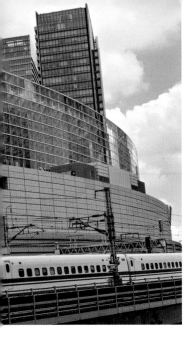

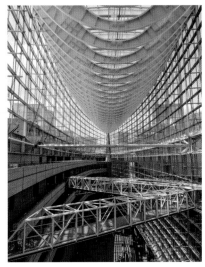

Glass Building, evoke the imaginary structures of Italo Calvino's book, *Invisible Cities*. Between the forum and the four outer halls is an open space planted with zelkova trees suggestive of European café plazas. The space hosts a moderately interesting flea market every first and third Sunday of the month. Dubbing itself the Oedo Antique Market, there are few items of genuine antiquity among the stalls.

ABOVE A statue of Ota Dokan, the warlord who founded Edo.

ABOVE RIGHT Designed to resemble the hull of a boat, light pours into the roof.

RIGHT The Forum must rank as one of Tokyo's most original designs.

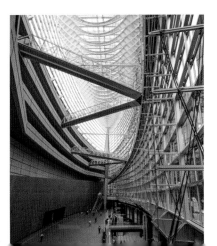

NIHONBASHI & MARUNOUCHI

Location Nihonbashi, Chuo-ku. **Access** Nihonbashi Station on the Ginza, Tozai, and Asakusa Metro Lines.

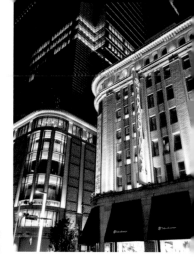

Nihonbashi, blending into contingent Marunouchi, has always stood for commerce, the unrelenting pursuit of profit and corporate power. The eponymous Nihonbashi Bridge was first built in 1603, a wooden structure denoting the starting point for the five great trunk roads leading out of the city, but also a standard for measuring distances from the capital. The current incarnation of the span, an elegant stone bridge constructed in 1911, is entirely obstructed by the overhead Shuto Expressway. As commerce morphs

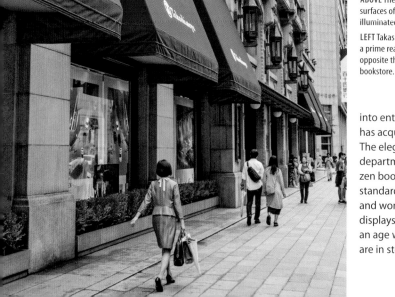

ABOVE The curvaceous 1930s surfaces of Takashimaya illuminated at night.

LEFT Takashimaya occupies a prime real estate location opposite the large Maruzen bookstore.

into entertainment, Nihonbashi has acquired a dual personality. The elegant, pre-war Takashimaya department store, opposite Maruzen bookstore, maintains high standards, its inventory of goods and wonderful food basement displays drawing in shoppers in an age when department stores are in steep decline. The area's

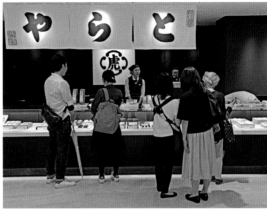

three huge Coredo stores form a commercial zone designed to replicate the lively Edo era. Besides daily goods, craft objects, and extensive culinary offerings, these multipurpose stores incorporate small shops whose names have been on the Tokyo scene for over a century. Edo Sakura-dori is a pedestrian street lined with restaurants, cafés, and confectioners that runs between Coredo Muromachi 1 and 2. A highlight of the street is its seasonally themed projection-mapping events, with kinetic images ranging from spring cherry blossoms to summer fireworks.

ABOVE CENTER Fierce griffin statues stand sentinel beneath the raised expressway above Nihonbashi Bridge.

ABOVE Takashimaya's basement food and patisserie stores are legendary.

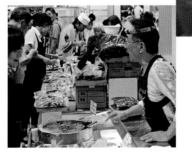

ABOVE Slim, tender cutlets of pork at a Coredo restaurant.

LEFT Vendors at Takashimaya recreate the lively atmosphere of a fish market.

GINZA CROSSING SHOPPING DISTRICT

Location Ginza 4-chome, Chuo-ku. **Access** Ginza Station on the Ginza Line.

A location staple of old monochrome Japanese films, the Ginza Crossing was the acme of Western refinement in a city that aspired, and continues to yearn, to be cosmopolitan. Two iconic buildings that define the Ginza high-end shopping district face each other across the busy intersection: the Wako Building and the Mitsukoshi department store. Photographs of the Ginza Crossing taken just after the war show Mitsukoshi as a burnt-out shell, the Wako Building, a luxury goods store, miraculously intact, replete with its Hattori Clock Tower built by Hattori Kintaro, founder of the watch company Seiko. The graceful, curving exterior of the 1932 structure, known for its creative window displays, was designed by Watanabe Jin in the Neo-Renaissance style. Equally synonymous with style, the recently renovated Mitsukoshi department store is a veritable emporium of luxury items. Its food basement (*depachika*) is legendary. Its famous roof garden once

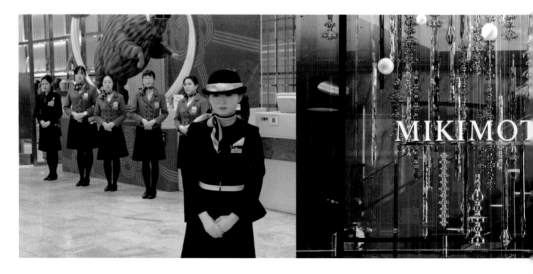

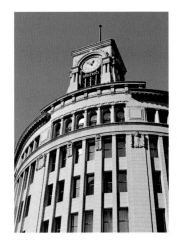

LEFT The façade of the iconic Wako Building, a pre-war structure that survived the bombing.

ABOVE Look out for creative fashion and cosmetic advertising in Ginza stores.

incorporated a curious mixture of a children's playground, a collection of bonsai trees, a Shinto shrine, and an old Buddhist Jizo statue recovered from the rubble of a 1945 American air raid. A few older businesses, such as the cultured pearl maker Mikimoto, the Kimuraya bakery, and the traditional calligraphy store, Kyukyudo, inhabit the district. The pre-war pastime of strolling around the Ginza, perusing its stores and hanging out in its elegant cafés continues to this day, with the crossing and contiguous streets closed on Sunday afternoons for "pedestrian paradise," as the Japanese put it.

FAR LEFT Opening time at Mitsukoshi is an event eagerly awaited by visitors.

LEFT The Mikimoto flag store. Its founder created the world's first cultured pearl.

RIGHT Visitors can enjoy a traffic-free boulevard on Sunday afternoons.

FAR RIGHT A family of tourists pose for a snap along Ginza's "pedestrian paradise."

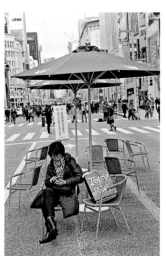

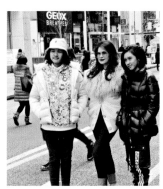

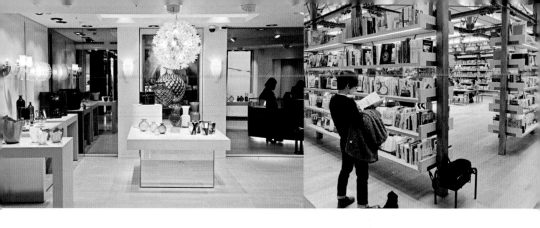

GINZA SIX SHOPPING MALL

Location 6-10-1 Ginza, Chuo-ku. **Access** Ginza Metro, Ginza Station.

Shopping complexes don't come much more luxurious than Ginza Six, located in the 6-chome area of the swanky district of the same name. The developers also sought to associate the name with the concept of a "six-star" shopping milieu. Set aside for pre-eminent fashion brands like Yves Saint Laurent, Alexander McQueen, Fendi, Kenzo, Dior, Van Cleef & Arpels, and Vivienne Westwood, over 240 shop spaces include restaurants, a food basement, wine dealers, and a state-of-the-art bookstore with a café attached.

Part of the pleasure in exploring this store are the highly creative, ever-changing displays and layouts. A strong sense of design is apparent looking at the exterior of the first floor, where parts of the building resemble traditional Japanese *noren*, the fabric dividers that hang outside the entrances to restaurants, shops, and tea houses. Architect Taniguchi Yoshio allowed six of the foremost luxury brands housed in Ginza Six to create their own *noren* designs for their frontages. A 13-floor complex, with a roof garden, its third-level basement is home to the Kanze Noh Theater, which also serves as a multipurpose hall. A gallery inside the

FAR LEFT Appreciating the product designs is half the fun of a visit to Ginza Six.

LEFT The highly original, wood and girder design of Tsutaya, a bookstore.

BELOW LEFT Window displays facing the pavement around the store provide more fashion stimuli.

RIGHT A digital waterfall cascades down an interior stairwell of the store.

BELOW Headless mannequins are the perfect props to showcase clothing fashions.

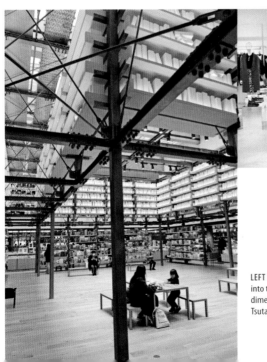

LEFT Light pours into the generous dimensions of the Tsutaya bookstore.

complex is curated by Nanjo Fumio from the Mori Art Museum. Add to that currency exchanges, a tourist information office, a terminal for tour buses, and the tens of billions of yen invested in the building, and you have something more than merely Ginza's largest retail space.

OKUNO BUILDING ARTS & CURIOS SHOPS

Location Ginza 1-9-8, Chuo-ku. **Access** Ginza-Ichome Station on the Yurakucho Line, Kyobashi Station on the Ginza Line, Takara-cho Station on the Toei Asakusa Line.

It is rarely presented as such, but Tokyo is one of the world's major art cities. A charming alternative to the grand museums and art houses, with their prestigious collections and soaring entrance fees, is the Okuno Building, located in a quiet back street of the Ginza Ichome district. Constructed in 1932 as an experimental apartment block, it is one of the only remaining pre-war buildings in the area. Its tiny rooms, now subdivided into studios, galleries, boutiques, artisan shops, and multipurpose spaces for design collectives, cover seven dimly lit, atmospheric floors. The first floor houses a European antique shop and an old school gentleman's shoe repair shop. Other floors exhibit paintings, prints, sculptures, and photography or sell used clothing. An intriguing optics shop sells new and vintage glass frames. What appears to be a relic from the past turns out to house a surprising number of progressive, ultra-conceptual, risk-taking projects, including periodic showings by well-known artists such as Takamura Sojiro and Ikeda Tatsuo. In a building where the arts and crafts are presented with heart and soul rather than as a purely commercial intercourse between gallery and customer, it's not surprising to find that the owners and curators are a friendly and chatty breed.

LEFT A charming first-floor antique store is a suitable match for a building that dates back to the 1930s.

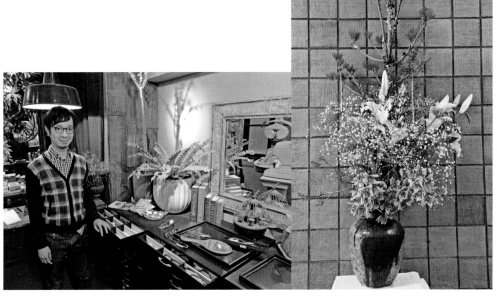

This endearingly worn-down building is well supported by art lovers and friends eager to conserve its authentic retro ambience. Unlike other historical structures in the city, it has not been fussily renovated, its old staircases, oxidized iron balustrades, tiled walls, flooring, and original elevator, replete with an accordion grill, hinting at art deco-era tastes. In the shadows of its stairwells, time stands still.

ABOVE The proprietor of a shop that sells high-quality used glasses.

ABOVE RIGHT An assertive flower arrangement in the entrance lobby.

RIGHT The owner and curator of one of the many small galleries that populate the building.

TSUKIJI HONGAN-JI TEMPLE

Location 3-15-1 Tsukiji, Chuo-ku. **Access** Tsukiji Station on the Hibiya Line Metro.
Hours 6.00 a.m.–5.00 p.m.

Architect Franco Purini may have written that Tokyo's unbridled materialism proved the non-existence of God, but in the splendidly hybrid Hongan-ji Temple we find a design drawing its inspiration from a host of Asian religions and doctrines. A glorious muddle of Indian, Javanese, Chinese, and Edo-era Buddhist Tenjika styles, this ranks as one of the largest temples in Japan. A branch of the influential Jodo sect, its interior can seat congregations of up to a thousand. The funeral services of some well-known figures, includ-ing the writers Mishima Yukio and Kawabata Yasunari, were held here. More recently, a memorial service to Matsumoto Hideto, lead guitarist with the popular *visual kei* band, X Japan, was attended by over 35,000 fans. The current temple was completed in 1934. The architect, Ito Chuta, wished to show the connection

BELOW LEFT The figure of a pilgrim cast in bronze stands sentinel over the temple compound.

BELOW Masses of people gather around a musical stage for the summer Bon Odori Festival.

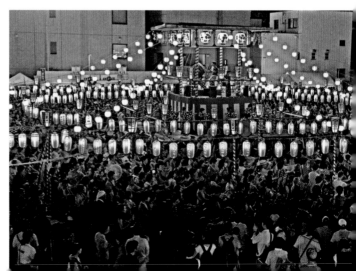

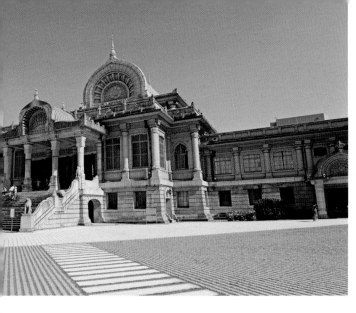

ABOVE Symmetrically designed stained glass windows grace the building's entrance.

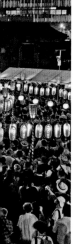

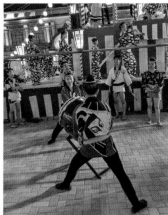

ABOVE Contemporary-looking lines of geometrical grass contrast with the eclectic Oriental design of the temple.

LEFT Well-rehearsed drum and dance performances take place during the summer Bon Odori Festival.

between Japan and the origins of Buddhism. The main hall, with its gold façade, intricately carved transoms, and religious artifacts, is ostentatious but striking. Monthly lunchtime organ concerts are held in the hall. A German-made pipe organ might seem like an anomaly in a temple, but was donated some 40 years ago to try and popularize Buddhist music. The 48 pipes at each side of the instrument represent the 48 vows contained in the Jodo Shinshu's central sutra.

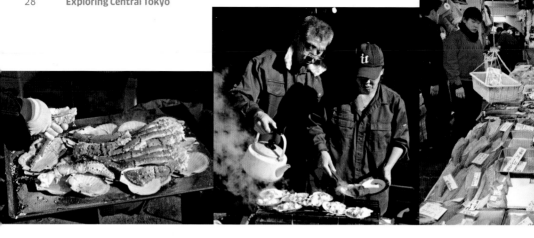

TSUKIJI OUTER FOOD MARKET

Location 3-15-1, Tsukiji, Chuo-ku. **Access** Tsukiji Station on the Hibiya Metro Line, Tsukiji Shijo Station on the Oedo Metro.

For reasons, supposedly of congestion and sanitation, the Tsukiji wholesale fish market, the largest in the world, was relocated in 2019 to a squeaky clean but decidedly less atmospheric site across the bay at Toyosu. Fortunately, that wasn't the end of the story, and at the time of writing the outer section of the market, where restaurants, stalls, and kitchenware stores meet the public, remains intact, the periphery of old, run-down buildings as characterful and well supported as ever. Arguably, the finest spot in the capital to sample fresh fish, Tsukiji Outer Market is *the* place to find salty sea urchin, fish egg omelets, sushi, juicy *ise-ebi* lobsters, giant oysters, grilled eel, blow-torched scallop, jumbo crabs, and trademark snacks like winter cod sperm and skewers of corn fishcake. The market also trades in fresh vegetables and fruit as well as items like *keshi*

ABOVE Only the freshest samples of fish are allowed to be sold in the market.

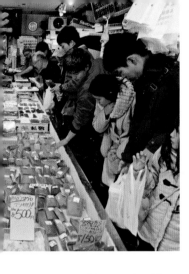

planning mandarins at the Tokyo Metropolitan Government have not given up the idea of transforming the site into part of an overarching scheme to incorporate the district into their vision for Tokyo Bay and to reinvent the Tsukiji brand in a decidedly more contemporary setting.

anpan, a sweet bun made with beer hops and topped with poppy seeds, and *taiyaki*, a seabream-shaped pancake stuffed with red bean paste. The market opens at around 5.00 in the morning, winding down in the afternoon, though the restaurants remain open until the evening. Another Tsukiji landmark that looks set to remain is the Namiyoke Inari Jinja, or "Wave Protecting Shrine," which serves as guardian for Tsukiji and its workers. It is also the site for prayers and rituals of gratitude dedicated to deceased fish. Hopefully, this great food institution will remain intact, though the

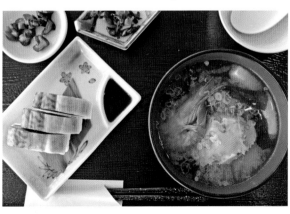

TOKYO MIDTOWN HIBIYA COMPLEX

Location 1-1-2 Yuraku-cho, Chiyoda-ku. **Access** Hibiya Station.

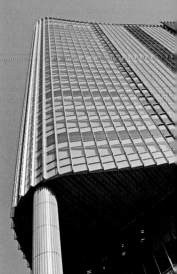

Some people have complained that Midtown Hibiya's concave-shaped glass exterior generates excessive solar glare, but unless you are a street malingerer in the immediate vicinity of this multi-purpose structure, it is unlikely to affect you unduly. Constructed in 2018, the avowed aim of this luxury, 35-story shopping and office complex is to blend commerce and culture. Entering into a spacious central atrium, visitors can either descend a floor to the building's Food Hall or ascend to upper floors. The escalators have been cleverly designed in a non-consecutive way so that you have to walk in a 160-degree semicircle, exposed to an array of life-

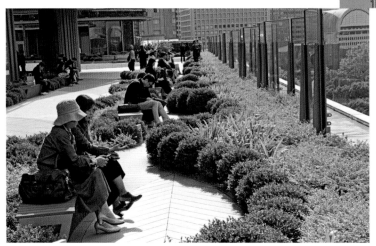

ABOVE Curving balconies heaped with plants soften the effect of steel and glass.

LEFT An elevated garden provides fresh air and a respite from shopping.

BELOW Women in bonsai-themed hairdos prepare for a cultural performance outside the complex.

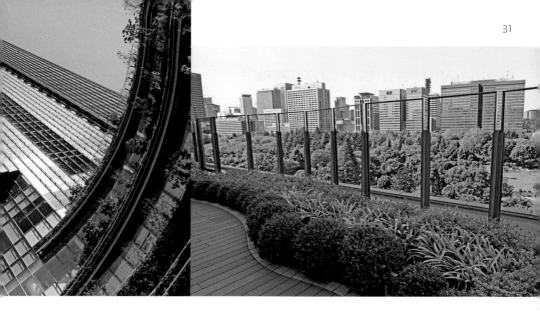

style brands, fashion retailers, cosmetic outlets, and customized stationers before reaching the next section of the escalator. The second floor boasts a number of good restaurants and bakeries, including outdoor terrace cafés. Ascend to the third floor, where a major 13-screen cinema complex and more boutiques and specialist stores stand, and a final escalator transports you to yet more cafés and the building's roof garden. The construction of this long terrace, with its al fresco café

recesses, has blown open an entirely different city vista, with Hibiya Park below, its canopy of

trees segueing into the lush greenery of the Imperial Palace grounds.

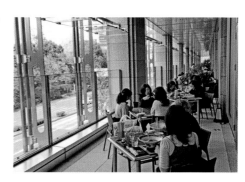

ABOVE The complex's sky garden offers one of the area's finest views of Hibiya Park below.

RIGHT Semi-outside cafés and dining are an appealing feature of the complex, especially in fine weather.

HIBIYA PARK & MINISTRY OF JUSTICE

Location Chiyoda-ku. Access Yurakucho Station on the JR Yamanote Line, Hibiya Metro.

A venue for lunchtime office workers, young couples, horticulturalists, music concerts, and *objet trouve* oddities like a giant stone coin from the island of Yap, Hibiya Koen once served as a residential area for the inner nobility before being briefly requisitioned as a military training ground during the Meiji era. The first Western-style park to be created in Japan, dating from 1903, it is now firmly a place of leisure and recreation. A combination of European and Japanese landscaping, the park hosts a chrysanthemum festival in the autumn. Just two streets west of the park, the imposing Ministry of Justice Building is one of the city's finest examples of Meiji-era architecture. After the domination of British models, the building represents a brief period of fascination with German architecture. Wilhelm Bockmann and Hermann Ende were tasked with designing the 1895 neo-baroque structure, a work whose exterior

ABOVE RIGHT Hibiya Park holds an annual chrysanthemum flower show at the end of October through November.

RIGHT Hibiya Koen's famous bronze statue of a crane dates from the establishment of the park.

is notable for its dressing of white granite bands layered over red bricks. Visitors can enter the building free of charge from Monday to Friday, exploring its chambers, a small museum, and galleries exhibiting historical material on design and the era of modernization. Perhaps it is the slightly askew location, but few people seem aware of the existence of this magisterial example of Meiji-era architecture.

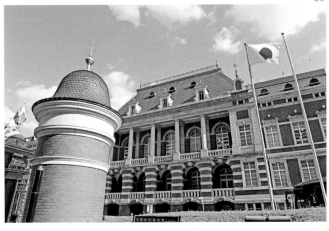

LEFT The park is spacious enough for Sunday painters to set up their easels.

ABOVE This important Meiji-era building is surprisingly over-looked by visitors.

BELOW Documents in the Ministry of Justice museum are largely in Japanese but housed in a fine interior chamber.

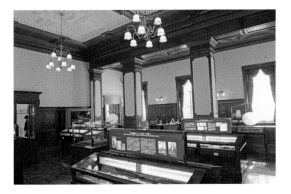

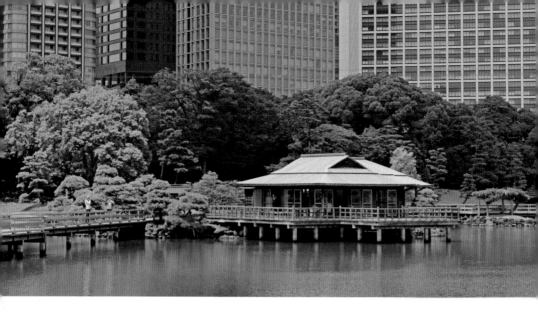

HAMA RIKYU GARDEN

Location 1-1 Chuo 104-0046. **Access** JR Shimbashi Station, Shiodome Station on the Oedo Metro. **Hours** 9.00 a.m.–5.00 p.m. **Fee** ¥

With its west side blocked by the commercial towers of Shiodome, the Hama Rikyu Garden, or Hama Detached Palace Garden, forms a virtual island surrounded by a quadrangle of water that includes the Sumida River. Completed in 1654 by the shogun Ienari, the area was used as a duck and falcon hunting ground before being converted into a traditional Japanese stroll garden. The main feature of this predominantly flat garden is its tidal pond, with a central tea pavilion. The phalanx of modern skyscrapers form a backdrop to the sheet of water, a modern-day *shakkei*, or "borrowed view." The pond draws its water from the Sumida River and

ABOVE Blocked by modern buildings, the garden remains a watery green sanctuary.

BELOW A new tea house provides insights into traditional Japanese carpentry and joinery.

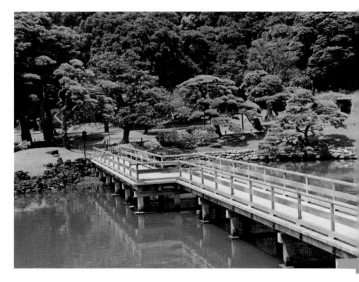

Tokyo Bay, making it quite saline. The water levels of the pond change with the tides. Built on reclaimed land, the garden is home to maple, ginkgo, and plum, and its modest showing of cherry trees are well-patronized during the *hanami*-viewing season in April. Visitors can also enjoy fields of cosmos, canola, and peony blossoms. When the garden was remodeled in 1704, a black pine, still gloriously healthy today despite damage to the garden in the Great Kanto Earthquake of 1923 and the bombings of World War II, was planted. Later cultivars include cherry, plum, and bamboo trees, patches of spider lilies, wisteria, and iris.

ABOVE LEFT Beautifully ribbed, oiled umbrellas often appear in gardens as appealing objects that associate a location with a tea house.

ABOVE Zig-zag bridges like this one are a feature of many Japanese gardens.

RIGHT A recently built tea house that will quickly weather in the Japanese climate.

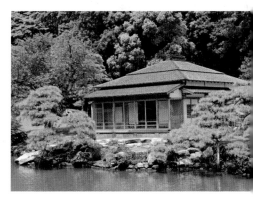

KYU SHIBA RIKYU GARDEN

Location 1-4-1 Kaigan, Minato 105-0022. **Access** JR Hamamatsucho Station.
Hours 9.00 a.m.–5.00 p.m. **Fee** ¥

A short distance from Hama Rikyu, the much-underrated Kyu Shiba Rikyu, or Shiba Detached Palace Garden, is one of the oldest landscapes in the city. Five islands float at the center of a large pond, the foremost, Horai-jima, taking its name from Taoist mythology, which talks of islands to the east of China on which the Immortals live. Originally a salt-

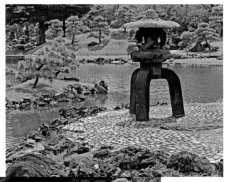

LEFT This large three-legged stone lantern is a feature of the garden's pebbled shoreline.

RIGHT This span recalls the much larger bridge spanning the West Lake in Hangzhou.

BELOW LEFT Stone bridges play an important role in linking islands and providing visitors with different perspectives.

water pond, its inspiration was the West Lake in the Chinese city of Hangzhou. Build on reclaimed land taken from Tokyo Bay, the grounds served as the residences of various feudal lords and high-ranking government officials. In 1875, after the fall of the shogunate, the grounds formed part of the Shiba Detached Imperial Villa before being opened to the public in 1924. With the urban expansion of Tokyo, the garden's terrestrial link to the sea vanished.

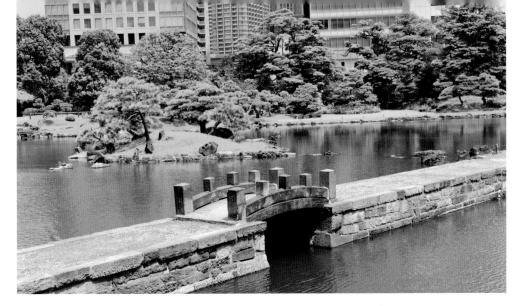

Circular paths offer diverse perspectives on the garden, and its artificial hills different elevations. A small hill, Kyua Dai, was built for the benefit of the Meiji Emperor, who could enjoy a clear, long-vanished prospect of Tokyo Bay from its summit. Surrounded by office blocks, a network of roads, and the tracks of the Shinkansen, it is still possible, with a little selective vision, to reconstruct an image of what this important garden and its environs once looked like.

ABOVE In a reinterpretation of the circular *chozubachi* (water laver), this one is triangular.

LEFT Japanese gardens are often requisitioned for wedding-related photography.

YASUKUNI SHRINE & WAR MEMORIAL MUSEUM

Location 3-1-1 Kudankita, Chiyoda-ku. Access Kudanshita Station on the Hanzomon Metro. Museum Hours 9.00 a.m.–4.30 p.m. Fee ¥¥

An impressive *torii* gate leads to the grounds of Yasukuni Shrine, whose cherry trees mark the official arrival of its pink blossoms to the capital. The doors of another gate deeper in the grounds are made from cypress and bear chrysanthemum crest insignias, the flower an emblem of the imperial family. The black-stained wood, copper roofing, and gold embossing of the main structures add somber authority to the building. For reasons of history,

ABOVE A group from Hyogo Prefecture visiting the shrine to pray for the souls of family members lost in the war.

LEFT An old tinted postcard depicting the shrine's great *torii* gate, which looks much the same today.

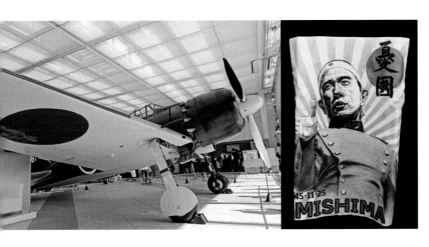

FAR LEFT This well-preserved Zero Fighter is the highlight of the museum lobby, which contains an interesting collection of war memorabilia.

LEFT A T-shirt for sale featuring Mishima Yukio, a major writer whose right-wing affiliations still divide Japanese opinion.

ABOVE A water basin in the grounds of the shrine's small, often-overlooked Japanese garden.

Yasukuni Shrine is embroiled in persistent controversy. In 1978, a secret ceremony took place in which the remains of 14 convicted A-Class war criminals were relocated to the shrine. The event occurred without the knowledge or consent of the Japanese people. Over 1,000 other war criminals, as well as the names of all those who died in wars, are enshrined here. Visits to the shrine by Japanese prime ministers and legislators are routinely met with howls of protest from countries that were subjected to Japanese colonialism. The Yasukan, a museum that takes a revisionist view of the period from 1931 to 1945, is nonetheless interesting for its displays, which include Allied documents, a Kaiten suicide torpedo, a locomotive used on the Thai-Burma Railway, and a perfectly preserved Zero Fighter plane. A subject of worship for Japan's tiny cell of ultra-right nationalists, the shrine is a testament to the fact that, if victor's get to write history, sometimes the vanquished get to rewrite it.

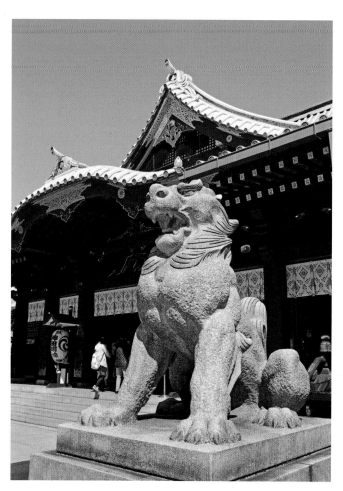

KANDA MYOJIN SHRINE

Location 2-16-2 Sotokanda, Chiyoda ku.
Access Ochanomizu Station on the JR
Chuo Sobu Line, or Akihabara Station
on the JR Yamanote Line.

There are a small number of districts in Tokyo where the historic division of the city into state and local culture collapsed, the rigid, doctrinaire principals of authority blending with the fluidity of the townspeople. One building that exemplifies this intermingling of the classes is Kanda Myojin, which moved to its present site in 1616. The shrine is associated with the usurperous Taira no Masakado, a warlord who, proclaiming himself emperor, eventually paid with his head for his audacity, but revered for his rebellious spirit would be adopted as an unofficial patron saint by the townspeople of Edo. After the Great Kanto Earthquake of 1923, the shrine was rebuilt in the elaborate *gongen* style beloved of early Tokugawa leaders. An

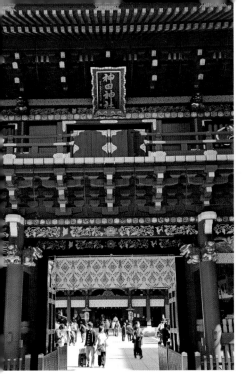

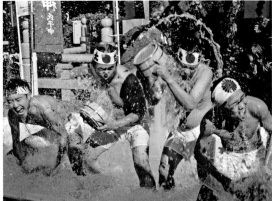

LEFT The almost baroque entrance gate to the shrine is hugely impressive.

RIGHT Dressed as one of the Seven Lucky Gods, a figure dispenses blessings over the New Year.

ostentatious but visually commanding two-story gate, the Zuishin-mon, with two Shinto guardians staring out behind a pair of chicken wire cubicles, provides the first dash of color before entering the main grounds. Other Shinto touches, such as a purification fountain with a crouching dragon, stone lions, and a statue of a white horse, take their place alongside the popular deities Daikoku and Ebisu, who are enshrined here in large statues. This vibrant place of worship is the venue for the important Kanda Matsuri in May, as well as a host of other religious and cultural activities throughout the year.

ABOVE Participants douse themselves in freezing water during the shrine's winter purification ritual.

OPPOSITE Powerful stone guardian lions flank the stairs leading to the shrine's main worship hall.

YUSHIMA SEIDO CONFUCIAN ACADEMY

Location 1-4-25 Yushima, Bunkyo-ku. Hours Daily 9.00 a.m.–5.00 p.m. The Taisenden opens on Saturdays and Sundays, 10.00 a.m.–5.00 p.m. Access Ochanomizu Station on the JR Chuo Sobu Line or Akihabara Station on the JR Yamanote Line.

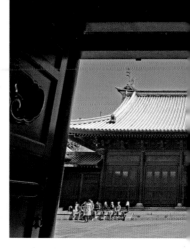

If Kanda Myojin and its precincts were the preserve of the common people, the samurai and bureaucracy of Edo found their center of ethics in an altogether more austere building just across the road, the Yushima Seido (Yushima Sacred Hall), dedicated to the spirit of the Chinese sage Confucius. The Analects and other writings of Confucius were subjected to an empirical resorting to suit the purposes of the prevailing order, keen to promote the authority of rulers over the compliant masses. The architect of this template for governance was the classical scholar Hayashi Razan, who supervised the founding of the first Confucian academy in Ueno in 1632. Yushima Seido's identification with learning con-

ABOVE One of the most impressive features of this academy, which also functions as a temple, is its massive green roof.

LEFT For a small fee, visitors can enter the main hall, with its altars, images, and offerings.

tinues. Students visiting the site in the weeks before entrance examinations, hang votive tablets of Confucius on racks set up along the covered portico that runs along the spacious main courtyard of the shrine. Roosters and "devil dogs" sit on the sweeping tile and copper roofs of the main structure, the Taisei-den, the Hall of Accomplishment, that enshrines the spirit of Confucius. The hall was rebuilt in 1935 in the Chinese Ming style.

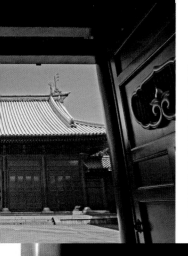

RIGHT Descend the lower flight of steps to find a large statue of Confucius in a wooded corner of the precinct.

FAR RIGHT Rooftop dolphin figures deflect the fire gods, tricking them into believing the roof is water.

BELOW There is an austere beauty to the dark pillars, heavy doors, and stone courtyard of the academy.

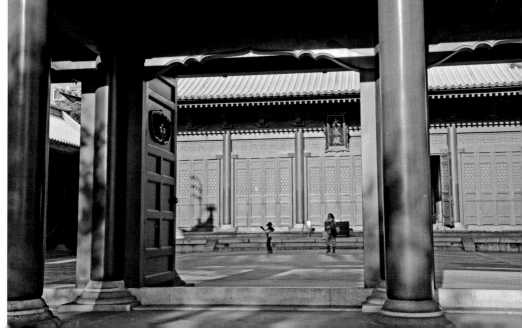

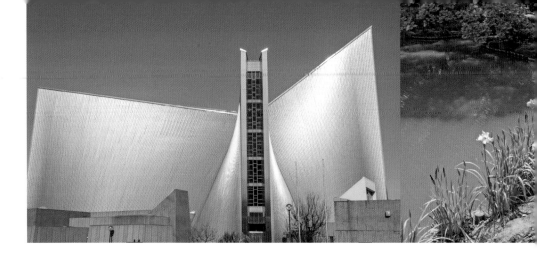

MEJIRODAI CATHEDRAL & GARDENS

Location Bunkyo-ku. Access Edogawabashi on the Yurakucho Metro.

Hilly Mejirodai, a well-to-do residential district, has a cluster of modest to magnificent sights within the same concentrated block. Replacing a Gothic-style structure razed during the war, the current incarnation of St. Mary's Cathedral is a stunning design from the iconic architect Kenzo Tange. The soaring, steel-clad apparition, shaped in the form of a colossal cross, looks as contemporary as the day it was unveiled in 1964. The fake water-falls, bridal halls, ornamental bridges, and waterwheels of the Chinzan-so Hotel garden, just across from the cathedral, may seem a touch whimsical, but serious garden scholars look harder, noting the beautifully sloping landscape near a millennium-old three-story pagoda, weathered stone lanterns, and a collection of original religious statuary. On a slope inside the garden, the wooden Mucha-an is a charming restaurant that makes its own

ABOVE LEFT Still impressive today, the cathedral was one of the world's first modernist religious designs.

BELOW The garden of the Chinzan-so Hotel is animated by the presence of curious stone statuary.

LEFT The Shin Edogawa Koen is a minor Japanese landscape, but its pleasant grounds feature some interesting garden elements.

RIGHT Among the Chinzan-so Hotel's garden ornaments and flowers is this waterwheel and a cluster of hydrangeas.

soba. A gate at the bottom of the garden faces the Kanda River, a popular promenade in the cherry blossom season. A short stroll along the river leads to the Shin Edogawa Koen, a landscape that replicates the aesthetics of Kyoto gardens, its shallow stream flowing calmly from a woodland border into a pond. Fashionably modern as it may seem, in its older sites and memory landscapes the area is haunted by the past. In the vicinity of western Mejirodai, where a graveyard once existed, phantoms are still occasionally sighted along an incline known as Yureizaka ("Ghost Slope").

ABOVE Though difficult to date precisely, this stone figure appears to hail from a different age.

RIGHT This venerable tree in the grounds of the Chinzan-so Hotel is tied with a *shimenawa*, a sacred rope, and white paper strips known as *gohei*.

KAGURAZAKA ENTERTAINMENT DISTRICT

Location Shinjuku-ku. **Access** Kagurazaka Station, Tozai. JR Sobu Line, Iidabashi.

Located just beyond the old outer moat of Edo Castle, Kagura-zaka is strongly associated with traditional performing arts like Noh and Kyogen. Traces of its days as an upscale geisha district (*hanamachi*) remain in its retro back alleys and expensive *ryotei* restaurants. Efforts to keep its traditions alive are expressed in a lively annual roster of events that include community festivals, costume parades, and performances by entertainers inspired by Edo-period musical forms, and downtown, vaudeville-style acts. Tree-lined Kagurazaka Hill is full of craft shops, Japanese restaurants, mini food markets, hole-in-the-wall bars, minimalist galleries, specialist stores, small shrines, and the brilliant Zenkoku-ji Temple. The district, with its chic European restaurants, coffee shops, and patisserie, nearby Lycee Franco-Japonais de Tokyo, l'Institut Franco-Japonaise de Tokyo, and a growing number of French residents, has become something of a Francophile quar-

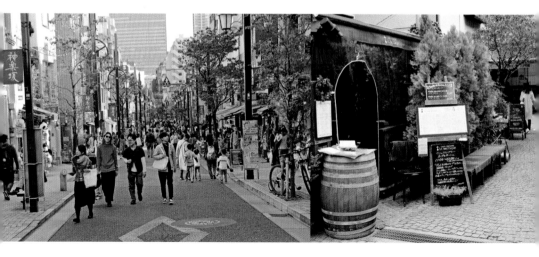

ter. Geisha Alley is a narrow passage of small eateries and bars located beside worn stone steps. The corridor connects to Kenban Yokocho, where geisha practice the three-stringed *shamisen* and performance and service events are organized. At the bottom of the lane's flight of steps, Atami-no-Yu is a rare example of a traditional public bath. Of an evening, it is still possible to see geisha shimmying through the dimly lit cobblestone back lanes of Kagurazaka.

RIGHT A striking back street wall painting advertises a seafood restaurant.

BELOW LEFT A painting of an old Edo merchant area depicted on the wall of a local craft shop.

BELOW RIGHT The district plays host to a number of live performances, like this musical event featuring drums and *shamisen*.

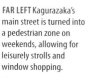

FAR LEFT Kagurazaka's main street is turned into a pedestrian zone on weekends, allowing for leisurely strolls and window shopping.

LEFT Many small eateries and French restaurants can be found in the district's cobbled lanes and back streets.

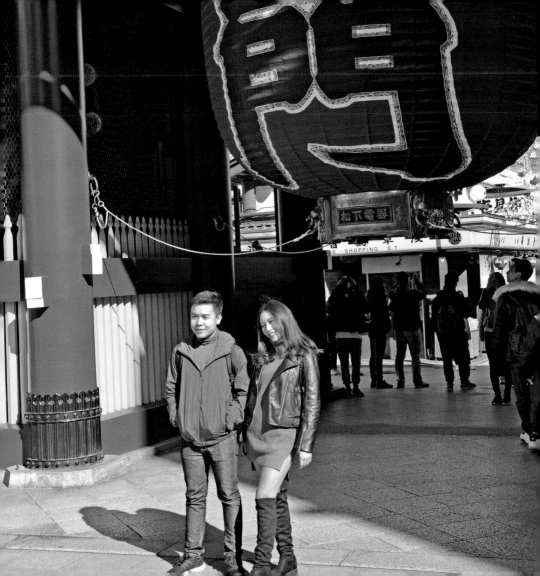

Exploring Northern Tokyo

The northeast was long viewed as the "devil's gate," a vulnerable point of infiltration for malign forces. This explains the existence of districts like Yanaka, characterized by a barrier of protective temples. The former estates of the aristocracy can be traced in diminished but still impressive gardens at Rikugi-en, Koishikawa Koraku-en, and elsewhere. The old pleasure quarter of the Yoshiwara, an enclosed, strictly controlled enclave of prostitutes, courtesans, geisha, and procurers, was located just north of Asakusa. The alternatingly brilliant and tragic lives of the women who worked in its brothels and tea houses, the life of the quarter

known as the "Nightless City," provided inspiration for some of Edo's most talented artists, writers and poets. The Yoshiwara was easily accessed from canals that fed into the Sumida River, the city's primary water course, flowing from the north into Tokyo Bay. Compared to the Shitamachi, the flat, eastern lowlands and the crowded commoner central districts of the city, the north,

occupying parts of the former Musashino Plain, a plateau incised with terraced hills and valleys, is more topographically interesting, its modest slopes and escarpments offering fresh, elevated views, though many of these are now blocked by tall buildings as Tokyo, in defiance of seismic realities, builds upwards in the spirit of cheerful fatalism that has always driven the capital.

LEFT Foreign tourists pose under the great lantern of Kaminari-mon, the "Thunder Gate."

RIGHT An anime-themed car pauses at a set of lights in Akihabara, or "Electric Town."

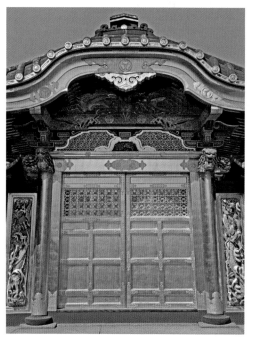

TOP LEFT An efflorescence of spring azaleas at the Nezu Shrine.

TOP RIGHT A spooky figure at the entrance to the ghost house in the Tokyo Dome Theme Park.

LEFT The gold-covered Tokugawa tomb in Ueno Park has survived earthquakes, typhoons, and air raids.

ABOVE The entrance to the animated galleries of J-World Tokyo & Namja Town.

RIGHT One of the retro street cars used for the Arakawa Line.

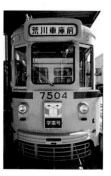

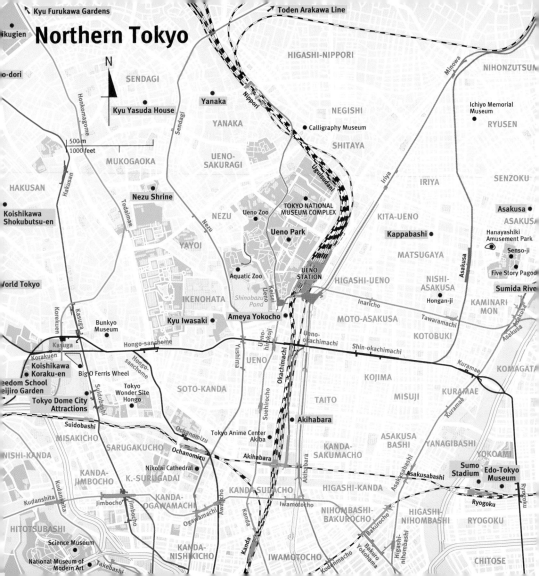

Northern Tokyo

↗ Kyu Furukawa Gardens

→ Toden Arakawa Line

...ikugien

o-dori

N

500 m
1000 feet

SENDAGI

HIGASHI-NIPPORI

NIHONZUTSUM...

Nippori

Yanaka

Kyu Yasuda House

Honkomagome

Hakusan

Sendagi

Minowa

Ichiyo Memorial
Museum

RYUSEN

NEGISHI

Calligraphy Museum

SENZOKU

YANAKA

SHITAYA

Iriya

IRIYA

MUKOGAOKA

UENO-
SAKURAGI

Uguisudani

KITA-UENO

HAKUSAN

Koishikawa
Shokubutsu-en

Nezu Shrine

TOKYO NATIONAL
MUSEUM COMPLEX

Asakusa

ASAKUSA

Hanayashiki
Amusement Park

Kappabashi

NEZU

Ueno Zoo

Senso-ji

...World Tokyo

Todaimae

YAYOI

Ueno Park

MATSUGAYA

Five Story Pagod...

Nezu

Aquatic Zoo

UENO
STATION

NISHI-
ASAKUSA

Sumida Rive...

Hongan-ji

Asakusa

IKENOHATA

Shinobazu
Pond

HIGASHI-UENO

KAMINARI
MON

Keisei

Inaricho

Korakuen

Kasuga

Bunkyo
Museum

Kyu Iwasaki

Ameya Yokocho

MOTO-ASAKUSA

Tawaramachi

Hongo-sanchome

Ueno-
hirokoji

Ueno-
okachimachi

Shin-okachimachi

KOTOBUKI

Koishikawa
Koraku-en

Korakuen

Kasuga

Hongo-
sanchome

Big O Ferris Wheel

YUSHIMA

UENO

Okachimachi

KOJIMA

KURAMAE

...eedom School
eijiro Garden

Tokyo
Wonder Site
Hongo

SOTO-KANDA

Suehirocho

TAITO

MISUJI

Kuramae

KOMAGATA...

Tokyo Dome City
Attractions

Suidobashi

Suidobashi

Ochanomizu

Tokyo Anime Center
Akiba

Akihabara

ASAKUSA
BASHI

YANAGIBASHI

YOKOAMI

MISAKICHO

Ochanomizu

Akihabara

KANDA-
SAKUMACHO

Sumo
Stadium

Edo-Tokyo
Museum

NISHI-KANDA

SARUGAKUCHO

Nikolai Cathedral

KANDA-
JIMBOCHO

K.-SURUGADAI

HIGASHI-KANDA

Asakusabashi

Ryogoku

Kudanshita

Kudanshita

Jimbocho

Jimbocho

KANDA-
OGAWAMACHI

KANDA-SUDACHO

Iwamotocho

Awajicho

Ogawamachi

Kanda

NIHOMBASHI-
BAKUROCHO

Bakurocho

HIGASHI-
NIHOMBASHI

RYOGOKU

Ryogoku

HITOTSUBASHI

Science Museum

National Museum of
Modern Art

Takebashi

KANDA-
NISHIKICHO

Kanda

IWAMOTOCHO

Kodenmacho

Bakuro
Yokohama

Higashi-
nihombashi

CHITOSE

AKIHABARA "ELECTRIC TOWN"

Location Chiyoda-ku. **Access** Akihabara Station on the JR Yamanote Line, Keihin-Tohoku Line, and Hibiya Line Metro.

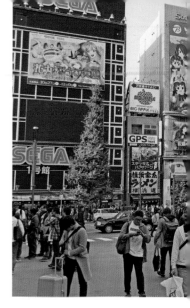

Akihabara, or "Electric Town," as the English station signs call it, is the country's premier showcase for the very latest in Japanese technology. This post-war black market developed into an area of stalls located under the railway tracks selling spare parts for radios. During the American Occupation period, many American provisions—everything from powdered milk to inner tubes and drugs—were brazenly spirited away to Tokyo street markets like Akihabara. Radios and walkie-talkies, cannibalized for spare parts, were sold off at Radio Kaikan, a warren of passages run by small dealers. Hundreds of shops and tax-free stores, ranging from multistory affairs to hole-in-the-wall businesses, are shoehorned into just a few blocks of Akiba, as it is better known. At night the multinational throng of shoppers, smoky food stalls, and votive neon billboards, a modern souk, stands cheek-by-jowl with maid cafés, *otaku* (geek) anime and manga stores, gaming arcades, and specialist enterprises like Sukuma Robot Kingdom and Technologic, where you can buy model kits for building your very own androids and cyborgs. The old creeds of cleanliness, miniaturization, efficiency, convenience, and a faith in the absolutely new, a portable culture that can be carried off and reassembled, are alive and well in Akihabara.

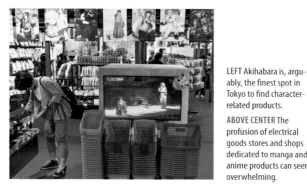

LEFT Akihabara is, arguably, the finest spot in Tokyo to find character-related products.

ABOVE CENTER The profusion of electrical goods stores and shops dedicated to manga and anime products can seem overwhelming.

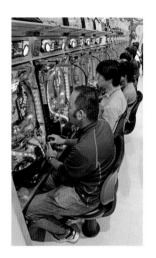

RIGHT Seeking oblivion. Customers lined up in front of their pinball machines at a pachinko parlor, a common sight in Japan.

BELOW LEFT A young woman paying homage to a fictional character at a show of anime-themed cars.

BELOW Women dressed as maid café workers. Akihabara has the highest concentration of these types of coffee shops.

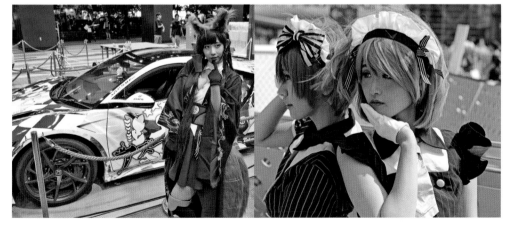

KYU IWASAKI MANSION

Location 1-3-45 Ike-no-hata, Taito-ku. Access Yushima Station on the Chiyoda Line, Ueno Hiro-koji Station on the Ginza Line. Hours 9.00 a.m.–5.00 p.m. Fee ¥

Writing about Muenzaka, the slope that snakes along one side of the Kyu Iwasaki residence, the great Japanese writer Mori Ogai described walking beside its walls, where horsetail and ferns grew among moss-covered stone. "Even now," he lamented, "I don't know whether the land above the fence is flat or hilly, for I've never been inside the mansion." Luckily for us, the residence, now run by the Tokyo government, is open to the public. Constructed for Iwasaki Hisaya, a scion of the founder of the Mitsubishi indus-

trial group, the house and its spacious lawn and wooded garden were designed by British architect Josiah Conder in 1896. The style is often called Jacobean, but in the spacious second-floor colonnad-

BELOW LEFT Spacious lawns and mature trees are influenced by the English naturalistic movement in gardening.

BELOW The shady inner-exterior spaces of the house provide fine views of the grounds.

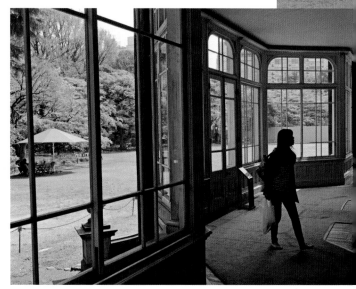

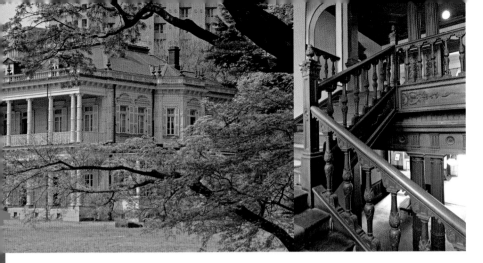

ed balcony there are touches of the Ionic features found in the country residences of Pennsylvania. The fluted columns that frame the entrance, the home's wood-coffered ceilings, parquet flooring, and interior decorative motifs that pay tribute to Islamic tastes, add interest. In order for the family to revert to their Japanese identities, their private quarters were designed in the traditional native style, one large *tatami* mat room the ideal place to sip powdered green tea beside *fusuma* paper doors decorated with seasonal motifs painted by the artist Hashimoto Gaho.

ABOVE From a distance, the main building appears to be made of stone but is, in fact, constructed of wood.

ABOVE RIGHT A spacious staircase adds a touch of European refinement to the mansion.

CENTER RIGHT The Iwasaki clan in a house that has changed little since the Meiji era.

BELOW RIGHT Sunlight replicates the design of a decorative grill gracing the second-floor balcony.

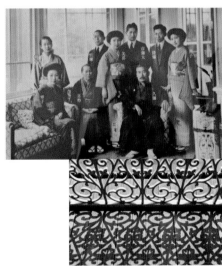

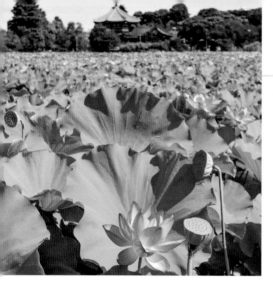

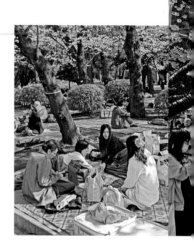

LEFT It is best to get up early in the summer to see the lotuses in bloom above Shinobazu Pond.

RIGHT If the skies are blue during the cherry blossom season, so are the blue tarpaulin spreads people use in the park.

UENO PARK

Location Taito-ku. **Access** Ueno Station on the JR Yamanote Line and Ginza Metro.

Because the district of Ueno stood squarely in the northeast corner of the shogun's new capital, a zone known as the "devil's gate," construction of a protective temple, Kan'ei-ji, began in 1625. The site of the city's first Confucian academy, the district soon became the venue for more earthly needs, as tea houses, archery booths, and stalls sprang up, along with troupes of acro-

bats, sword swallowers, traveling preachers, vendors of snake medicines, and other dubious cures. A well-patronized brothel district also stood here. In the Meiji era, Ueno Park served as a platform for a number of exhibitions of modern Western technology, with stands displaying examples of machinery, metallurgy, agriculture, and manufacturing. Ueno Station, built at this time, acted

as a gateway for migrant workers from the impoverished northern prefectures. In the misery of the post-war years, orphans, widows, and homeless people took refuge in its park and subway tunnels. A thriving black market sprang up in the area at the time. Adding to Ueno Park's cultural and historical digest are a number of religious sites, most visible among them the ox blood-colored Kiyomizu

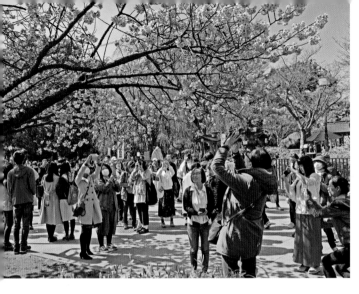

ABOVE During the cherry blossom season, the park is strung with paper lanterns.

ABOVE The park can get extremely crowded during the *hanami*, the cherry blossom viewing season.

LEFT Newlyweds in traditional costumes stroll through the grounds of the Tokyo National Museum garden.

Kannon-do, a rather unconvincing imitation of the temple of the same name in Kyoto, and the much more authentic Tosho-gu Shrine, with a causeway lined with large stone lanterns. Built to deify the shogun Ieyasu, the shrine, built in the ostentatious *kongen-zukuri* style favored by early Tokugawa leaders, remains gloriously intact. Ueno is definitely museum and gallery country. A superb collection of Japanese art is housed just outside the park in the Tokyo National Museum, the center of an

RIGHT The garden attached to the Tokyo National Museum is a minor landscape but well worth seeing.

BELOW Catering to hungry visitors, the park has many food vendors, this one serving fried squid rings.

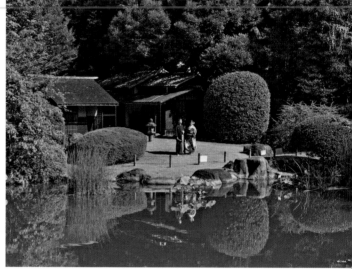

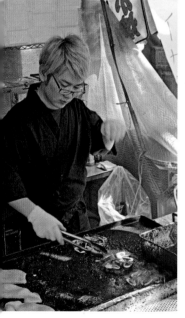

ensemble of buildings that includes the Horyu-ji Treasure House, with its collection of ancient Buddhist sculptures, the impressive Meiji-era Hyokeikan Archeological Museum, the Toyokan Asian Museum, and the Heisei-kan, where special exhibitions are held. Back in the park proper, other major collections are housed in the National Museum of Nature and Science, the Tokyo Metropolitan Art Museum, and the National Museum of Western Art, a 1959 design by the Swiss architect Le Corbusier. Beside the imperatives of learning and spiritual enlightenment, the pleasure principal is strong in this highly diverse Tokyo district. Ueno Zoo, best known for its pandas, is located on the edge of the park, whose massively attended cherry blossom viewing

event is held in the spring. Nearby, a stone causeway leads to Benten-do, an island floating above Shinobazu Pond. Dedicated to the deity Benten, goddess of the arts and music, her figure, nursing a four-stringed lute, stands in front of the shrine's main hall. Shinobazu-no-ike is the last of Tokyo's great lotus ponds, the pink flowers a symbol of Buddhism, an early morning miracle in the humid summer months. Ueno, it seems, has always been adept at combining consumption, recreation, faith, and culture.

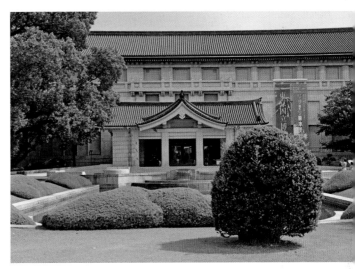

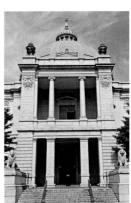

ABOVE The pre-war Tokyo National Museum exhibits Japanese art treasures.

LEFT A room in the Tokyo National Museum showing an enlarged Hokusai print.

RIGHT The stately Hyokeikan is an archeological museum but the main interest may be the Meiji-era structure itself.

AMEYA YOKOCHO MARKET STREET

Location Taito-ku. **Access** JR Ueno Station on the Ginza Metro.
Hours 10.00 a.m.–8.00 p.m.

You may hear this street, located along the elevated JR Yamanote Line tracks between Ueno and Okachimachi Stations, referred to as Ameyokocho, Ameyoko, or Ameya Yokocho. One constant is the prefix "ame", signifying sweets or confectionery. A black market district during the post-war era of rationing, its goods—some genuine, others purloined—were traded in a gray zone of legality largely overlooked by the authorities. Satisfying a craving for sugar, many of the items sold here were made from potato

ABOVE A spicy noodle mélange from a Korean eatery.

BELOW LEFT The market street is not just about food. It sells everything from discount bags and shoes to kitchenware and pharmaceuticals.

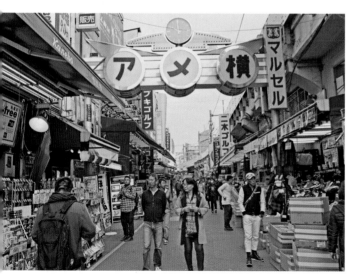

coated in a sweet syrup known as *daigakuimo*, lending the street its name, Confectionery Alley. Today's market, though retaining some of its gritty original atmosphere and conforming to the Shitamachi, or downtown, ethic of small businesses, is a very different affair, at least as far as commodities go—its assortment of wares reflecting contemporary affluence modified by an instinct for a good bargain. Look out for stores and makeshift stalls selling jewelry, tea, kelp, fruit and vegetables, handbags, and an inordinate number of shoe shops. New Year is bedlam, with hawkers

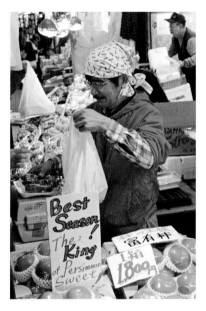

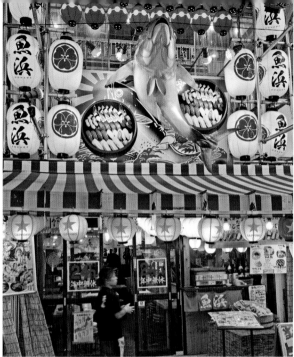

enticing shoppers to buy celebratory foodstuffs, especially fish. Korean Chinese and Southeast Asian vendors operate from inside the Ameyoko Center Building, an intriguing complex, where you might come across bags of frozen shrimp, spicy condiments, and such exotic fruits as mangosteen.

ABOVE LEFT The market is also a great place to find fresh, seasonal fruit at cost-cutting prices.

ABOVE RIGHT The menu content of this restaurant is boldly advertised in fish-themed displays and models.

RIGHT Ice creams and a Japanese favorite, chocolate and sweet-covered bananas, are on sale here.

YANAKA CEMETERY DISTRICT

Location Taito-ku. Access Nippori and Nishi Nippori on the JR Yamanote
Line. Nishi Nippori on the Chiyoda Line Metro.

Writer Stephen Barber described
Yanaka Cemetery as the "most
silent zone of the city", a place
where "Tokyo itself has stopped
still." If graveyards can be beauti-
ful, plangent in their evocation of
the past, then Yanaka Cemetery,
with its mossy tombstones, leafy
walks, wrought-iron gates, and
worn stone lanterns, is almost
Gothic in character. Among the

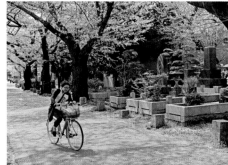

LEFT During the cherry
blossom season, Yanaka
Cemetery is a popular
viewing spot, attracting
large numbers of visitors.

BELOW LEFT Yanaka
Ginza, a narrow,
pedestrian lane, is
bulging with tiny
restaurants, tea houses,
and souvenir and craft
shops.

faint outlines of ancient tombs
and shell mounds are the resting
places of several distinguished
figures. These include two giants
of 20th-century Japanese fiction,
Natsume Soseki and Mori Ogai,
the well-known artist Taikan
Yokoyama, and the female mass
murderer Takahashi O-den, the
last women in Japan to be de-
capitated by sword. Japan's last
shogun, Tokugawa Yoshinobu, is
buried here. Although the quar-
ter has undergone a degree of

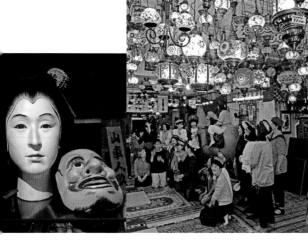

FAR LEFT A mask, model head, and wig form an eerie window display.

LEFT Zakuro, a Turkish-Iranian restaurant, has become a Yanaka Ginza institution.

ABOVE Serene on a dais of lotuses, a Buddha image graces the grounds of a small temple.

gentrification in recent years, with chic craft and souvenir shops, tea salons, and coffee houses, and artsits, musicians, and designers moving in, contemporary Yanaka retains much of the past, having survived the ravages of time. Zensho-en sits in the north corner of the cemetery, the resting place of more Edo and Meiji luminaries. Daien-ji Temple contains a monument to the charms of Osen, a tea shop girl who was chosen by the artist Harunobu for one of his woodblock prints. A statue of Kannon, the goddess of mercy, stands next to Osen's monument. Just across the street from the temple is one of Tokyo's oldest and most exquisite paper art shops, Isetatsu, specializing in *chiyogami*: designs reproduced from original samurai textiles. The Asakura Sculptor Museum, housing the Rodin-influenced work of Asakura Choso, has a roof terrace wth outstanding views of the district. Other discoveries include Tenno-ji, a Tendai sect temple known for its large, bronze Buddha image, cast in 1690. The lively downtown atmosphere of Yanaka is enriched not only by its arts and crafts but also its food vendors, plying streets like Yanaka Ginza with wobbly barrows and rickety ambulants, selling grilled corn, sweet potatoes, roasted *sembei*, baked squid, and arrow weed. Torindo, an old shop specializing in an unusual line of sugar-coated vegetables, is well-patronized. Sandara Kogei, a family-run shop, sells exquisitely crafted basketry. Perhaps the ultimate joy of Yanaka is the opportunity its tortuous back streets afford for serendipity, the sheer pleasure of getting lost in an otherwise easily negotiated, signage-assisted city.

KYU YASUDA HOUSE

Location 5-20-18, Sendagi, Bunkyo-ku. **Access** Sendagi Station on the Chiyoda Line Subway. **Hours** 10.30 a.m.–4.00 p.m. Wednesdays and Saturdays. **Fee** ¥

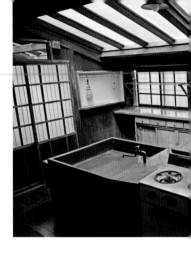

Saved from demolition by a group of locally concerned neighbors and preservation activists, the former two-story wooden Yasuda House is a priceless exception in a city fixated on tireless renewal. Built in 1919, the residence is an object lesson in the fusion of wealth and good taste. The aesthetic choices made by its original owner, Fujita Yoshisaburo, were maintained with only minor adjustments by Kusuo Yasuda and his family, who took over ownership of the house. Space restrictions in this relatively narrow plot were overcome by a zig-zag design that allows for views onto sections of a beautifully landscaped Japanese garden, replete with a dry landscape area, dry waterfall and stream, meandering paths through a miniaturized woodland, and well-selected rocks. Traditional touches are visible in the use of materials: smoked bamboo, clay plastered walls, *tatami* flooring, a coffered ceiling made in finely grained cedar, and what must once have been a very aromatic cypress bathtub. The fashion of the day dictated that, among the classic Japanese style rooms, a chamber should be set aside for a Western-style reception area. A spacious room, its fittings and fixtures include chairs furnished in silk fabric, thick curtains, and an Axminster carpet. In 2019, the foundations of the residence were reinforced to withstand mega-earthquakes, a measure that should ensure its survival for many years to come.

LEFT The villa is designed in such a way that all of its rooms offer a different perspective on the gardens.

ABOVE The spacious, well-equipped kitchen must have been very contemporary when it was built.

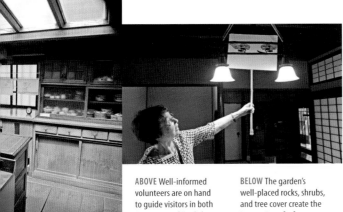

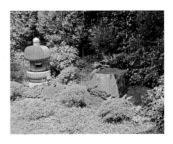

BELOW The garden is full of detail, such as this rock and stone lantern arrangement.

ABOVE Well-informed volunteers are on hand to guide visitors in both Japanese and English around the premises.

BELOW The garden's well-placed rocks, shrubs, and tree cover create the impression of a forest glade.

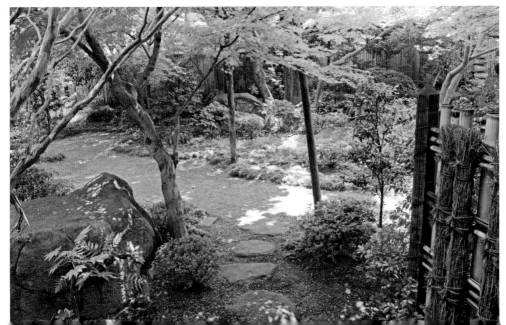

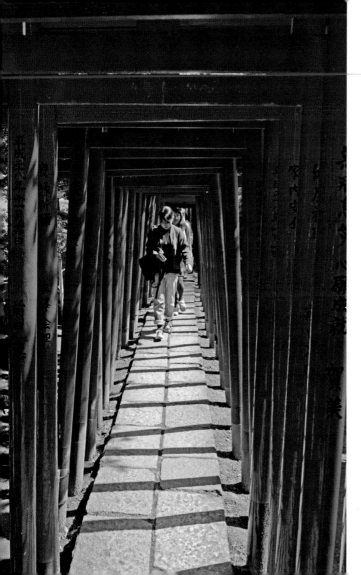

NEZU SHRINE

Location 1-28-9 Nezu, Bunkyo-ku. Access Nezu Metro on the Chiyoda Line. Hours Azalea Garden 9.00 a.m.– 5.00 p.m. mid-April–early May. Fee ¥ garden entrance.

One of the oldest religious sites in the city, Nezu Shrine honors Ienobu, the sixth shogun. Buddhist influences, obvious in the shrine's main gate and the swastika symbols on several lamps within the grounds, hint at a time before the Meiji era when the two religions were on closer terms. An inner gate in the Chinese style, a purification font, a small pond, and a stage for the performance of *kagura* dramas, are interesting details seen before visitors face the shrine's main hall, the building liberally carved with mythical creatures, and the branches of plum and pine trees. A long row of vermilion *torii* gates winds up to a hillside shrine to the fox deity Inari. This stands next to the shrine's azalea garden, the bushes flower-

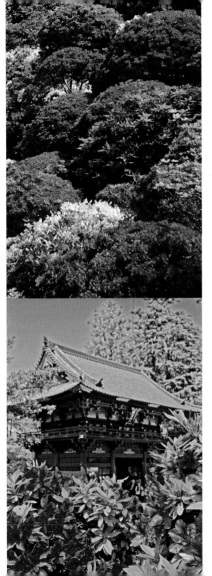

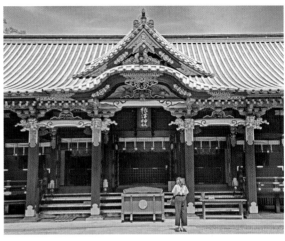

ABOVE LEFT Various azalea cultivars are grown on slopes in an intoxicating concentration of colors.

ABOVE Unlike the understated simplicity of many Shinto places of worship, Nezu Shrine is richly, though not ostentatiously, ornate.

LEFT The spring azalea garden provides different angles on the shrine and its compound.

OPPOSITE Benefactors, with their names inscribed, have donated countless *torii* gates, forming a mesmerizing red tunnel.

ing into vivid purple, pink, magenta, and white blossoms from mid-April to early May. A boom in azalea cultivation began when Edo replaced Kyoto as the nation's de facto political center. An extensive search, ranging as far as Korea and the Ryukyu Islands (present-day Okinawa), was undertaken to find new cultivars like the popular Kirishima-tsutsuji. The shrine's azalea festival is extremely well attended. Go early. The crowds swarm to the garden like bees to nectar.

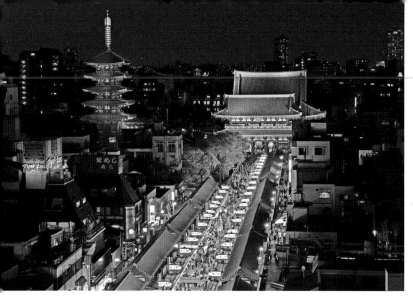

LEFT A night view of Nakamise taken from the open-air observation gallery of the Asakusa Tourist Information Office.

ASAKUSA & SENSO-JI TEMPLE

Location Asakusa, Taito-ku. **Access** Asakusa Station on the Ginza and Asakusa Metros.

ABOVE In contrast to more animated cultural events, autumn's white crane parade in restrained and beautiful.

A traditionally working-class area, Asakusa is synonymous in Japanese minds with hard work and equally hard play, a bustling mercantile mentality, romance, libertine pleasures, and a strong sense of community. The compound of Senso-ji, Asakusa's great temple and spiritual center, is best approached after passing under the Kaminarimon, or "Thunder Gate," a wooden entrance flanked by leering, twin meteorological gods and a magnificent red paper lantern with the character for "thunder" emblazoned across it. Where there are temples in Asia, there are markets, and Asakusa is no exception, Nakamise, the approach to the temple, a cornucopia of traditional goods aimed at tourists and supplicants. The earthy community that lives in Asakusa are responsible for organizing one of Tokyo's most dynamic festivals—the Sanja Matsuri. The seasons are not allowed to pass by without some sacred ritual or event of purely secular invention taking place: flowers in January, bean throwing in February, golden dragon dancing in March and again in Octo-

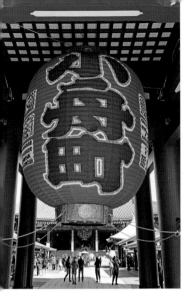

and good-humored merchant streets of Asakusa, are real echoes, albeit in remarketed forms, of old Edo, its noise and rambunctious vitality, its enduring existence as an earthy testament to the joys of being alive.

ABOVE Rickshaws, a Japanese invention, have returned to the streets of Asakusa but at fees commensurate with modern times.

BELOW Nakamise shops sell every conceivable form of souvenir, including these masks.

ABOVE Senso-ji's Kaminarimon ("Thunder Gate") has become the symbol of Asakusa.

ber, a white crane parade in November, a traditional badminton racket and kite market in December, horseback archery in April, and a relatively new innovation, a Brazilian-style carnival, in August. Asakusa has always been geared as much to the hedonist as to the incense-impregnated world of the priest and Buddhist acolyte. Here, among the busy

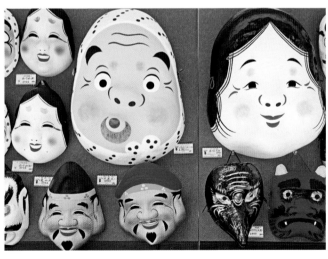

KAPPABASHI "KITCHENWARE TOWN"

Location 3-8-12 Matsugaya, Taito-ku. **Access** Ginza Line on the Tawaramachi Metro.
Hours Mostly 9.00 a.m.–7.00 p.m. Many shops closed on Sunday.

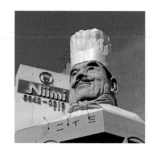

ABOVE The authorial figure of a cook looms over the intersection of Kappabashi-dori.

Kappabashi is best known by its sobriquet, "Kitchenware Town." Kappabashi-dori stretches for almost one kilometer, with over 200 wholesale stores selling everything from cook's uniforms and steam tables to restaurant signs, iron teapots, silver soup tureens, and kitchen knives at the wonderful Kamata store. The intersection where the main shops and display rooms start is difficult to miss, as the corner establishment, the Nimi Building, is topped with a giant chef's head replete with a white, pleated hat. The cook's refulgent face beams down on the busy intersection of Kappabashi and Kaminari-dori. If you have ever wondered where those life-like plastic food samples you see in restaurant windows come from, here is your answer. The best examples are mesmerizing in their veracity, comparable in their finesse to carefully crafted wood box combs, damascene, or chrysanthemum dolls. Viewed on an empty stomach they can seem like works of towering genius. Connoisseurs hold two particular Kappabashi establishments in

BELOW A culinary theme adds interest to the metal shutter of a Kappabashi store.

ABOVE Good enough to eat, but these fried fish offerings are synthetic samples.

FAR LEFT Masses of cellophane-covered food samples like this will be bought by people in the trade, but also by tourists.

CENTER LEFT A highly visible advertisement for Kamata, one of the finest knife makers in the country.

LEFT Giant coffee cups form the corner of a building at the Kappabashi-dori intersection.

especially high esteem: Maizuru and Biken. It comes as a surprise to realize that the streets of Kappabashi are practically odorless. If you decide to spend a half-day here, make your own arrangements for food as there are very few restaurants in the area.

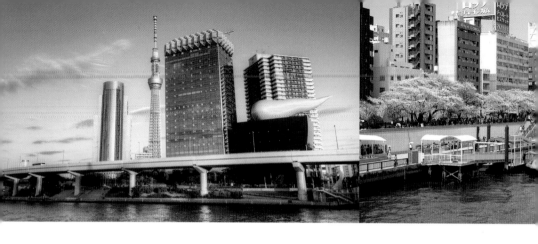

SUMIDA RIVER

Access Piers at Azumabashi, Hinode Pier, Hama Rikyu Garden, and Odaiba.

The days when the Sumida River was clean enough for fishermen to brew tea from its waters may have passed, but the city's foremost channel is currently enjoying a well-deserved revival. Riverbanks are being reclaimed from their vertical encasements, planted with grass, saplings, and bushes, the embankments remodeled with graduated slopes, creating new pedestrian zones. The river provides the setting for one of the most interesting concentrations of bridges in Japan. The best way to appreciate the ensemble, view the spring cherry blossoms of Sumida Park, take in views of the Tokyo Skytree, and the river's great summer fireworks, while appraising the urban geography of Tokyo, is by taking a river cruise. Tokyo Cruise's water buses (*suijo buses*) ply the river between quays at Azumabashi Bridge in Asakusa or Hinode Pier, the Hama Rikyu Garden, and the artificial island of Odaiba. More expensive options include dinner cruises on *yakata-bune*. Roofed vessels hung with lanterns, a section of their deck covered in *tatami* mats, these pleasure boats resemble older, more romantic vessels. An interesting alternative is to take the direct cruise between Asakusa and Odaiba aboard the futuristic Himiko, a sleek vessel designed by Matsumoto Reiji, a manga artist.

RIGHT Passengers who embarked below Nihonbashi Bridge enjoy a section of the Sumida River, which includes several pre-war bridges.

BELOW Night covers the city's imperfections, bathing buildings and river in enticing colors.

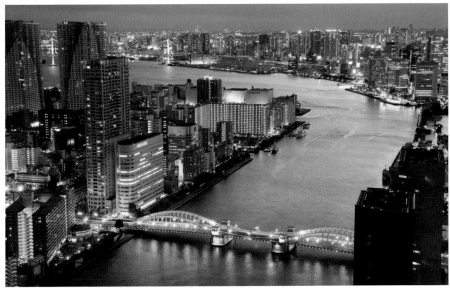

TODEN ARAKAWA TRAM LINE

Location Shinjuku, Toshima, and Arakawa Wards. **Access** Terminals at Waseda and Minowa. **Fee** ¥170 flat ticket rate for any destination.

An aerial view of Tokyo taken 50 or 60 years ago would have revealed a city crisscrossed by tram car lines. Most of Tokyo's remaining trolley buses disappeared in a final wave of decommissioning that took place between 1967 and 1972. Tokyo's well-supported 29-station Toden Arakawa Line, one of only two surviving tram systems in the city, completes its 12-km (7-mile) course from Waseda to Minowabashi in 40 minutes flat, irrespective of rush-hour traffic. As it follows its sinuous course through central and eastern parts of the city, the line takes in sections of Shinjuku, Toshima, and Arakawa wards, providing convenient access to city sights within walking distance of its stations. These include Kishibojin (the "Pomegranate Temple") in Zoshigaya, the district of Sugamo, and Oji, with its celebrated waterfall, a minute or two's stroll from the line's eastern terminus at Minowabashi. Commuters who know the line well claim that the most interesting stretch lies between Koshinzuka and Higashi-Ikebukuro, the backyard of old plebeian districts yet to be gentrified. Resi-

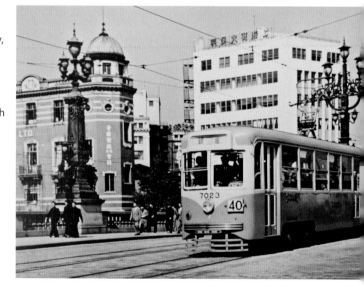

dents have been quick to take advantage of this open corridor of sunlight. Look closely and you will see flowering window boxes, miniature trees, south-facing persimmons, loquats, and modest trellises of vine and kiwi. Here is a line to be grateful for, one which interacts with its environment rather than disrupting it, a cell moving instinctively, unobtrusively through the urban system.

BELOW A shrine along the line with a series of Inari fox statues. The creatures are thought to be messengers of the gods.

ABOVE This old missionary house on the edge of Zoshigaya Cemetery is open to the public.

RIGHT An old tram that has been turned into a gallery depicting the history of the line.

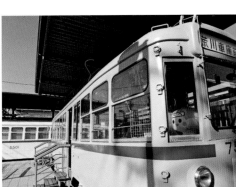

LEFT A rolling metal shutter stands in as a canvas for the image of a fox, a supernatural creature in Japanese folklore.

OPPOSITE ABOVE A tram sits in a covered siding while waiting to go into service.

OPPOSITE BELOW An old monochrome image shows a tram very similar to many of those still used today.

JIZO-DORI "HEALING" STREET

Location Sugamo 170-0002, Toshima-ku. **Access** Sugamo Station on the JR Yamanote Line or Mita Metro Line.

ABOVE LEFT Models of traditional wooden dolls outside an information center.

ABOVE A shop specializing in red underwear, an auspicious color traditionally worn by Japanese on reaching 60 years of age.

Despite its garish newer buildings, Sugamo's attachments are to the past. Its main street, Jizo-dori, attracts a mostly female crowd, elderly matrons who come to pay their respects at temples, visit its funerary supply stores, and pour over decorative candles and unmarked headstones. At Shinsho-ji, the first temple along the road, a large bronze statue of a Jizo, guardian of travelers and children, stands in the courtyard. The figure, wearing a farmer's sedge hat, was cast, along with five others, between 1708 and 1720. Kogan-ji Temple, with its figure of the Bodhisattva Jizo, better known as the Toge-nuki Jizo ("Splinter-removing Jizo"), is regarded as one of the city's most efficacious curative statues. Scrub and wash the figure with a brush and cloth in the spot that corresponds with the part of the body where you are suffering, it is believed, and the pain will vanish. Judging from the smoothest areas, head and stomach problems are common ailments

ABOVE Supplicants carefully wash parts of the Toge-nuki Jizo statue that matches the area of their ailment.

BELOW LEFT A Buddhist nun with an alms bowl at the entrance to the street.

ABOVE A vendor selling prayer beads and amulets wrapped in little brocade drawstring sacks.

LEFT An imposing Jizo statue in the precincts of Shinsho-ji Temple.

BELOW Face charts indicating pressure points at a stall near Kogan-ji Temple.

among Tokyo residents. Temples breed markets and commerce, drawing people just as much for the shopping as religious consolation. Among stores proffering wet goods and marinated plums, are shriveled figs, dried vipers, and medicinal items: unctions, ointments, rheumatic creams, denture cleaners, and Chinese cures. Many of the district's older structures may have gone but its lodestone, a shining black Jizo figure, a reference point on the cultural map of the city, remains.

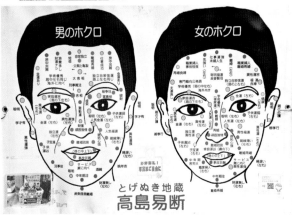

RIKUGI-EN PUBLIC GARDEN

Location 6-16-3 Honkomagome, Bunkyo-ku. **Access** JR Yamanote Line
and Namboku Subway. **Hours** 9.00 a.m.–5.00 p.m. **Fee** ¥

A more open, spacious concept in landscape design at the beginning of the Edo era saw the inclusion of lawns into the spacious gardens of *daimyo* (feudal lord) estates. In these newer visions, rustic trails and shady groves spilled into green, sunlit expanses that became synonymous with the creation of stroll gardens.

Rikugi-en, commissioned by Yanagisawa Yoshiyasu, a wealthy noble, minister, and confidant of the fifth shogun, Tsunayoshi, was completed in 1702. The design is based on the six principals of Japanese poetry found in *waka* (five-line verse), making it both a pleasure and literary garden. Though it will not be immediately evident to casual visitors, 88 sites within the garden are said to be associated with Japanese and Chinese poetry. A textbook example of formal Edo-period landscaping, the garden offers a full complement of classic garden elements, including a wooded island, large pond, traditional stone and earth bridges, tea houses, streams, miniature waterfalls, peaceful arbors, and a focally central *horai* island, home of the Immortals in Chinese mythology. Hornbeam, elm, native oaks, cherry, maple, and plum trees cluster within a small naturalistic wood. The summit of an artificial hill, called Fujishiro-toge, offers what may be one of the most exquisite garden panoramas in the city.

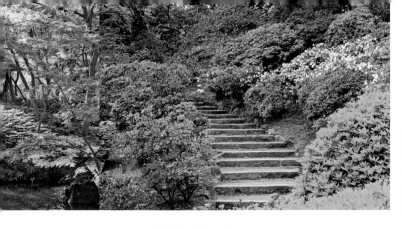

FAR LEFT A pavilion deep in the autumn foliage of the garden's woodland area.

LEFT A winding, azalea-flanked stairway leads to the summit of Fujishiro-toge, the garden's highest point.

RIGHT The magnificent view from the summit of Fujishiro-toge changes with the seasons.

BELOW Traditional oiled umbrellas add color, refinement, and contrast with the surrounding greenery.

OPPOSITE Rikugi-en has a number of formal tea houses open to the public.

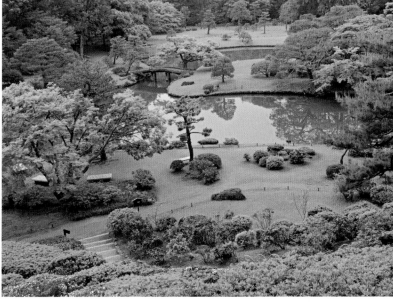

KYU FURUKAWA GARDEN

Location 1-27-39 Nishigahara, Kita-ku. **Access** Nishigahara Station on the Namboku Line Metro, Komagome Station on the Yamanote Line. **Hours** 9.00 a.m.–5.00 p.m. **Fee** ¥

ABOVE Plants wrapped in straw for protection during the winter, and Tokyo's increasingly rare incidence of snow.

RIGHT In contrast to the Japanese design, the French garden follows rigidly symmetrical lines.

The creation of two highly gifted men, Jihei Ogawa, a Japanese landscape designer, and Josiah Conder, an English architect, the Kyu Furukawa Garden merges two distinctly different styles. The mansion Conder built for Baron Toranosuke Furukawa in 1914, made from gray andesite stone, looks a little like a Scottish highland residence. It occupies the upper reaches of the four-level estate. The author of *Landscape Gardening in Japan*, the first English title on the subject, Conder opted to create a symmetrical French-style rose garden for the second plateau. A concentration of large azaleas, a flower native both to Japan and Europe, occupy the third, descending level of the estate, acting as a transition between the rose garden, with its neatly laid-out parterres, and

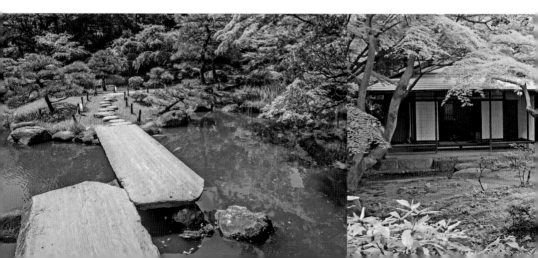

OPPOSITE BELOW LEFT Large slabs of rock act as flat bridges connecting sections of the garden.

BELOW CENTER A tea house picturesquely situated among a wooded and mossy glade.

BELOW RIGHT Large design statements, emphasizing power and authority, were a feature of early 20th-century gardens commissioned by the wealthy.

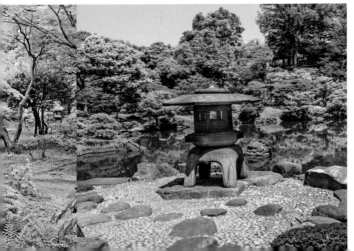

Ogawa's Japanese pond garden. Well-known Kyoto-based designer Ogawa features typical Japanese garden elements in his plan, including a dry waterfall, muscular stone lantern, classic tea house, and evergreen chinquapins and camellia. The central pond was formed into the shape of the Chinese character *shinji*, which can be read as "mind." The densely wooded grounds help to muffle the sound of traffic from a busy nearby road.

FRANK LIOYD WRIGHT FREEDOM SCHOOL & MEJIRO GARDEN

Freedom School Location 2-31-3 Nishi Ikebukuro, Toshima-ku. **Access** Ikebukuro Station on the JR Yamanote Line. **Hours** 10.00 a.m.–4.00 p.m., closed Monday and when booked for weddings and special occasions. **Fee** ¥ / Mejiro Garden **Hours** 9.00 a.m.–5.00 p.m.; 9.00 a.m.–7.00 p.m. in July and August. **Fee** Free entrance.

The Jiyu Gakkuen, or Freedom School, later renamed the Myonichikan, the "House of Tomorrow," is the only remaining Tokyo design by the master architect Frank Lloyd Wright. The project, originally a girl's school, was completed in 1929. The founders, Motoko and Yoshikazu Hani, aimed to create an experimental institution with a Christian-infused, open-minded, laissez-

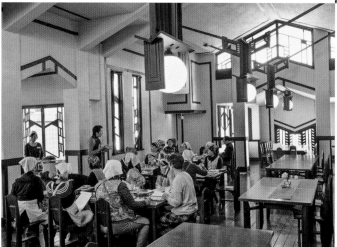

faire approach that was, even by today's conformist educational standards in Japan, well ahead of its time. The couple's liberal ideas are embodied in the high vaulted ceilings, bright interiors, soaring windows, and fluid spatial layouts. Wright used the porous, highly textured *Oya-ishi*, a greenish stone, as facing, and for columns and paving. The classrooms and an auditorium annex, designed by Wright's assistant Arata Endo, remain with their original furniture.

Just around the corner from the school, the diminutive Mejiro Garden is a pleasant green sanctuary in this quiet residential district. It is encouraging to see the creation of a Japanese garden, however minor, in this age of faux English gardens, rose parterres, herbaceous borders, and potagers that are springing up all over Japan. Built in 1990, classic elements are easily spotted in the stroll garden's pond, floating pavilion, waterfall, and impressive tea house, called Sekicho-an.

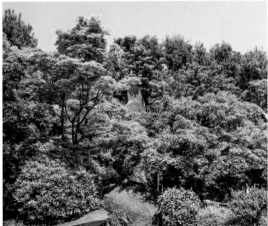

ABOVE CENTER Wright's refreshing lines and original color scheme have been retained.

OPPOSITE BELOW The spacious interior is used for a number of activities, including wedding receptions, lectures, and cooking classes.

ABOVE A soaring stone pagoda in the grounds of the Mejiro Garden.

FAR LEFT Blooming spring azaleas add a dash of color to largely green plantings.

LEFT It will take a few more years, but the Mejiro Garden is already acquiring a mature, more weathered appearance.

J-WORLD TOKYO & NAMJA TOWN

Location 3-1-3 Higashi-Ikebukuro, Toshima-ku. Access JR Yamanote Line, Ikebukuro Station; Toden Arakawa Line, Higashi-Ikebukuro Station. Hours 10.00 a.m.–10.00 p.m. Fee ¥¥; extra cost for special attractions; ¥¥¥ for Unlimited Attraction Pass.

ABOVE LEFT An assistant at the center, suitably dressed in character mode.

ABOVE The center is a good place to research popular manga and anime series and characters.

Run by giant gaming company Namco, this indoor theme park is housed within the vast Sunshine City complex. Mega-popular series like *One Piece*, *Naruto*, and *Dragon Ball* are represented in hyper-dynamic visual form. For character galleries featuring creations like Gintama, Toriko, Prince of Tennis and Bleach, head to the section called Heroes Arena. If looking is not enough, a cosplay room will kit you out in all the sartorial glory and gore of a Jump character or anime hero. Other activities include anime projections on multi-screens and interactive virtual reality games. This is total immersion for die-hard fans, a revelation for the uninitiated. The center has three restaurants serving standard dishes and more interesting, themed desserts such as Nimbus Cotton Candy Cloud and the enigmatic Blue Exorcist's Mephisto silk hat cake, but there are more robust choices a floor down at Namja Town, a nostalgia foodie theme park.

The signature retro item here is *gyoza*, steamed or fried dumplings, with some interesting variations in form and taste, not to

RIGHT Namja Town is a good spot to try out *gyoza*, a Chinese-inspired Japanese dumpling.

BELOW Character boards, murals, and projected images recreate the anime world at the center.

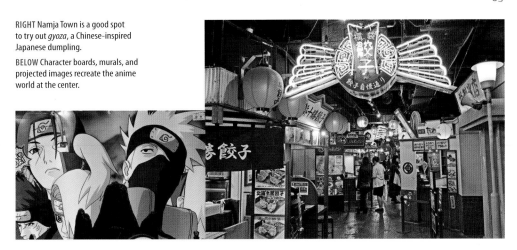

LEFT The entrance to the center provides its first visual experience.

OPPOSITE BELOW The center has a number of interactive games and activities.

mention around 100 varieties to choose from. The Patisserie Cute, with its rainbow-colored cream and sponge creations, and an ice cream parlor and crepe shop with items decorated with anime and animal characters, teleports you back to the fun house unreality of Japanese soft power fantasy culture.

KOISHIKAWA KORAKU-EN GARDEN

Location 112-0004, Bunkyo-ku. **Access** Iidabashi Station on the Tozai, Yurakucho, and Namboku Lines. **Hours** 9.00 a.m.–5.00 p.m. **Fee** ¥

An instructive model for anyone interested in the Edo-era stroll garden, Koishikawa Koraku-en is also Tokyo's oldest extant landscape design. The circuit garden was designed largely for pleasure, although its name, probably suggested by the Chinese scholar-refugee Zhu Shunshui, means "a lord must tolerate sorrow before the people, only taking pleasure after them." Despite a number of intrusive office blocks on its fringes, the outlines of the garden remain remarkably faithful to monochrome images taken for Josiah Conder's 1893 book, *Landscape Gardening in Japan*. Combining miniaturized scenes from China and Japan around a large pond with a wooded island, a stroll around the water peripheries introduces us to a technique known as *miegakure*, or "hide and reveal," in which scenes open before us and are then closed off. In this way, we have a rock representing a turtle's head, a depiction of Lu-shan, a mountain in Jiangxi Province, a scaled-

ABOVE A small lotus pond adds a touch of divinity to the garden, the flower a symbol of Buddhism.

LEFT Visitors often miss the rear of the garden, where there is a curvaceous lily pond.

down version of Tsuten-kyo, a maple-viewing bridge in Tofuku-ji Temple in Kyoto, cascades, tree groves, a rice field, and an iris bed. Perhaps its inclusion of visually stimulating elements is why Donald Richie, pondering Japan's "fondness for the geographical microcosm," concluded that Koraku-en exemplified a "vision that later made Disneyland famous." Perhaps it is no coincidence that the popular Koraku-en amusement park stands next to the garden.

RIGHT Scarecrows ward off birds, protecting a small rice field.

BELOW LEFT An irrigated iris field beside a wisteria trellis that will come into bloom at a slightly later stage.

BELOW RIGHT This vermilion maple-viewing bridge comes into its own with November's autumn leaves.

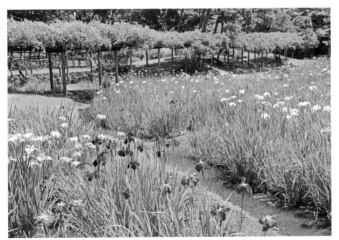

KOISHIKAWA SHOKUBUTSU-EN BOTANICAL GARDEN

Location 3-7-1 Hakusan, Bunkyo-ku. **Access** Hakusan Station on the Toei Mita Line, Myogadani Station on the Marunouchi Line. **Hours** 9.00 a.m.–4.30 p.m., closed Monday. **Fee** ¥

The rugged terrain of this botanical garden, tucked away in the back streets of a prosperous residential district, is surprising. Owned by the Tokyo University Faculty of Science, the site was established in 1684 as a medicinal herb garden. It was also used as agro-research land to test-grow new crops like sweet potato, and to experiment with cultivating techniques like transplanting. The main building of the Tokyo Medical School, built in 1876, was relocated here, its red portico and pink and white plaster-faced façade adding a touch of Meiji-era elegance to the grounds. Steep earth and stone paths climb up a slope from the lower gardens, which are an inspiring mix of natural woodland and a Japanese garden arranged around a pond, replete with irises and water lilies, its bank home to a grove of alders. The upper level is set aside for the herb garden and more wooded areas. The grounds are highly diverse, with clumps of broad-leaved ever-greens and deciduous species, conifers, a plum grove, and an improbable grouping of plantain trees, hinting at warmer climes. An impressive gingko tree stands close to the garden entrance, its leaves turning to blazing yellow in the autumn when its edible nuts fall. Being the female variety of the tree, it gives off a truly wicked odor at this time.

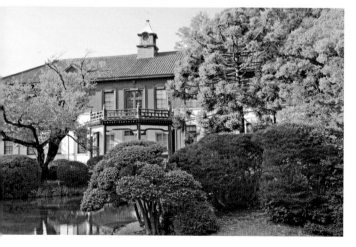

LEFT A well-preserved Meiji-era structure with design links to Continental Europe.

ABOVE Many of the ferns and trees in the garden appear to hail from subtropical regions.

BELOW The upper grounds of the garden are perfect for amateur painters.

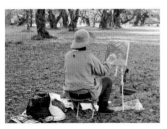

BELOW The garden offers the prospect of pleasant nature strolls in any season.

BOTTOM A gardener attends to a pine, the most difficult tree to prune.

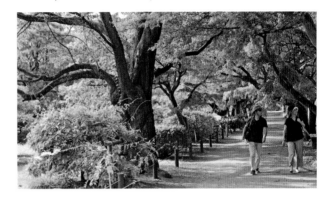

TOKYO DOME THEME PARK

Location 1-3 Koraku, Bunkyo-ku. **Access** Suidobashi Station on the JR Chuo Line. **Fee** Individual rides ¥ or pass ¥¥¥.

Laughter, delirious screams, squeals, and helium-fueled hilarity are the order of the day at this high-tension amusement park. Among the attractions is a hair-raising, nail-biting Thunder Dolphin, a high-velocity roller coaster, whose course runs through the walls of a couple of building walls. For altitude without anxiety, the Big O is a big wheel without spokes or hub, the first of its type. The views on the ascent are terrific. Softer attractions for small children include the game-packed Toys Kingdom. For a different kind of thrill, the ghoulish variety, the Onryou Zashiki is a haunted house that contains a story line, which visitors follow from chamber to cursed chamber. You have to take your shoes off to enter the resi-

LEFT Elevated views of the city come with rides on the park's roller coaster and Ferris wheel.

RIGHT Children brace themselves to be thrilled by speed and acceleration.

FAR RIGHT Even toddlers are thoughtfully catered to at the park.

LEFT A window display outside the ghost house promises some unsettling experiences inside.

RIGHT One of the novelties of the roller coaster is passing through buildings and walls.

dence, a procedure that makes you feel even more vulnerable. Baseball fans will get much pleasure from exploring Tokyo Dome, home to the Yomiuri Giants, the most popular team in Japan, and by visiting the Japanese Baseball Hall of Fame & Museum, which traces the evolution of baseball from its introduction in 1872. When games are not taking place, the space is co-opted for everything from rock concerts to tableware setting exhibits, an orchid show, and as a venue for the curious Ig Nobel Prize Exhibition.

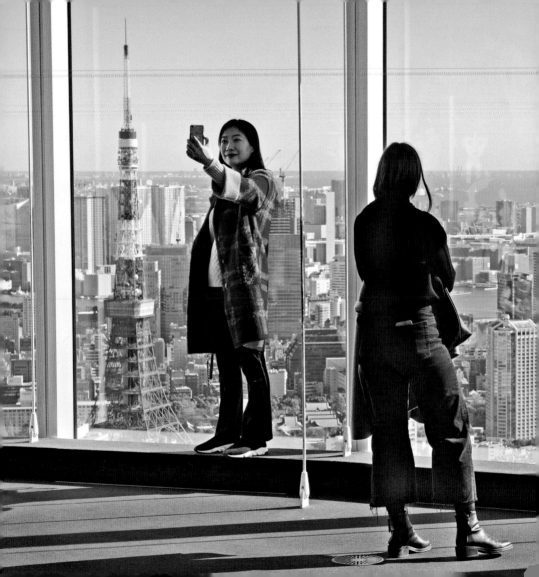

Exploring Southern & Eastern Tokyo

It might be a stretch to compare this sector of Tokyo to Venice, but like the great floating Italianate city, much of Tokyo's original wealth and culture were founded on water. Theaters, tea houses, dockyards, temples and shrines were either located on, or oriented towards rivers, canals, water courses, or the bay. The energies of the city were concentrated at the water's edge. Even its terrestrial ambitions, reclaiming land from the sea, were directed in semi-aquatic settings, the spaces where land meets the fresh or salt water elements of the city. Many of its cultural and structural aspirations continue to focus on these spatial intersections, most notably in the continued construction of artificial islands like Odaiba in the ongoing development of Tokyo Bay, and in the reanimation of life along the rivers and canals that transect the eastern and southern quarters of the capital. Its low-lying frontage, of course, increases its vulnerability to the probability of a major earthquake or tsunami. Tokyo sits above some of the world's most volatile fault lines, shifting tectonic plates that make it highly susceptible to seismic activity. Waterfront locations, and much of the crowded residential areas of the downtown districts to the east are built on exceedingly loose landfill. The constant fear is that, in the event of a major quake, convulsions will lead to liquefaction, causing structures above ground to collapse and rivers of solution to flood into underground train stations and tunnels. Such are the perils of living on the edge.

LEFT Visitors enjoy splendid 360-degree views from the Mori Art Museum.

RIGHT A toy vendor at the Design Festa in Odaiba, a twice annual event.

BELOW Sumo wrestlers have acquired an almost balletic lightness in this wall mural in Ryogoku.

BOTTOM Many of the bonsai at Shunka-en are hundreds of years old.

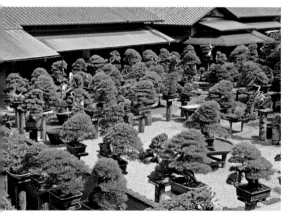

TOP LEFT Tokyo Tower, completed in 1958, may be at its most beautiful at night.

TOP RIGHT A musician plays a sizzling guitar solo during the Design Festa event.

ABOVE Kurokawa Kisho's highly original design for the National Art Center.

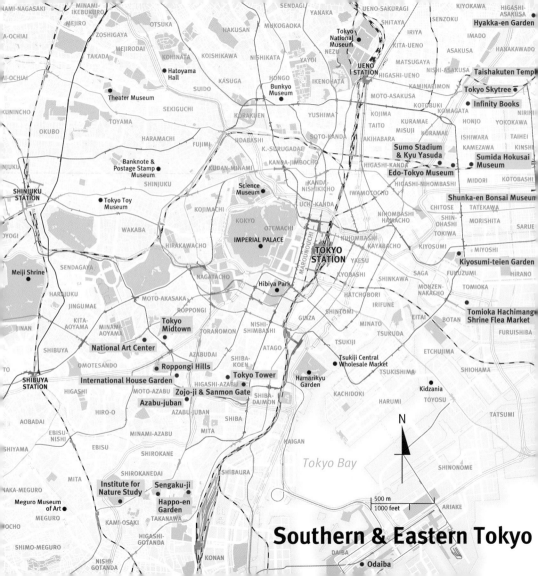

Southern & Eastern Tokyo

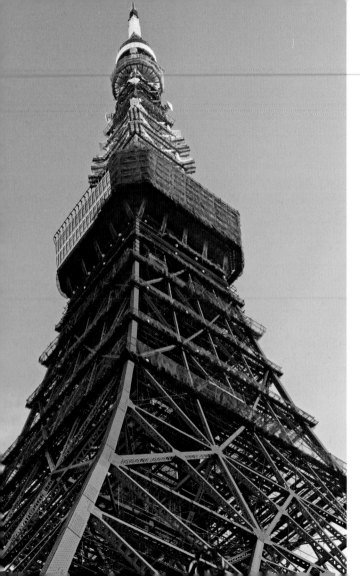

TOKYO TOWER

Location 4-2-8 Shiba-koen, Minato-ku. **Access** Kamiyacho or Akabanebashi. **Fee** ¥¥

With one of the tower's legs standing on land once occupied by the former Tokugawa tombs, the accidents and deaths that occurred during the construction period were explained as a curse. With a surplus of United States military arms in Japan after the end of the Korean War, the Tokyo Tower contracting company managed to get their hands on 300 obsolete US tanks, whose industrial-level metals were recycled into steel frames used in the welding of the tower's upper sections. Built for the purpose of transmitting radio and television signals, the tower is an early example of duplitecture, the structure bearing a remarkable resemblance to the Eiffel Tower. Not to be outdone by its French

LEFT Despite its age, and the existence of rival observatories, Tokyo Tower remains popular.

prototype, Tokyo Tower ascends to an impressive 333 m (1,000 ft), surpassing the Eiffel Tower by a small but symbolic 13 m (43 ft). Restaurants, souvenir shops, an indoor amusement park, and other attractions occupy the base of the tower, known as the Foot Town. The Main Deck is poised at 150 m (490 ft), a Top Deck at 250 m (820 ft), requiring an extra fee. The red and white tower is not as vertiginous as Tokyo Skytree or the Tokyo Municipal Building observation floors, but it offers an alternative angle on the city, including fine views of Tokyo Bay.

ABOVE The tower may not have changed a good deal since it was built in 1958, but the view has.

BELOW LEFT Plate glass reflecting illuminations both outside and inside the tower.

BELOW A small child, delights in the magic of the tower and its illuminated interior.

INTERNATIONAL HOUSE GARDEN

Location 5-11-16 Roppongi, Minato-ku. Access Azabu-Juban on the Toei Oedo Metro, Roppongi on the Hibiya Metro. Hours daily 9.00 a.m.–5.00 p.m.

International House, or I-House, as it is also known, an attractive building in one of the nicer residential areas of Roppongi, was established to nurture international exchange but now hosts a rather broader agenda of cultural and commercial events, ranging from exhibitions, concerts, conferences, and seminars. A popular venue for wedding receptions, a tea room, coffee shop, and restaurant have been added to the original 1955 structure. The work of three innovative Japanese architects, Sakakura Junzo, Maekawa Kunio, and Yoshimura Junzo, the design is a surprisingly apt compliment to a fine Japanese garden. Influenced by the Modernist movement in architecture, spearheaded by Le Corbusier, the convergent lines between building and garden, a sinuous interflow of form, suggests a more Japanese aesthetic. The garden that we see today was designed by the influential Ogawa Jihei and completed in 1930. The creator of many enduring Kyoto landscapes, Amasaki Hiromasa, a professor at Kyoto University of Art and Design, has described Ogawa's work as a "shift from gardens for contemplation to gardens for appreciation with all five senses." This is patently true of Ogawa's creation at International House, where our perceptions on entering the garden are instantly purged and cleansed of urban clutter.

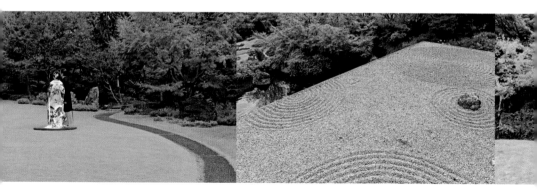

ABOVE Cherry blossoms cover one of the winding paths up to the higher elevations of the garden.

RIGHT This brilliant design touch sees symbolic water, represented by sand ripples, contrast with real water.

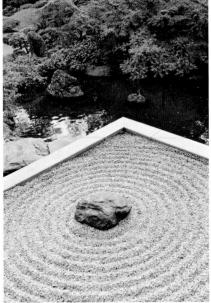

OPPOSITE BELOW FAR LEFT When the weather is fine, the lawn is perfect for wedding photography.

OPPOSITE BELOW CENTER A later but highly successful design touch is a dry landscape garden located on the roof above the restaurant.

OPPOSITE BELOW RIGHT A dry riverbed contrasts with lush foliage and lawn.

BELOW An all-seasons garden, hints and tints of autumn appear beside the small pond.

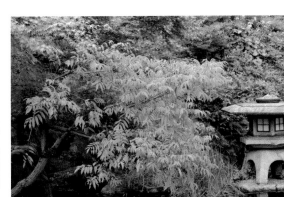

ZOJO-JI TEMPLE & SANMON GATE

Location 4-7-35 Shiba-koen, Minato-ku. **Access** Onarimon and Shibakoen Station on the Mita Metro, Daimon Station on the Oedo Metro.

Zojo-ji was moved to its current location in 1596 on the advice of geomancers jittery about the vulnerability of its previous site. A southeast purification gate leading into the city, the complex stood close to the great Tokaido Road connecting Edo and Kyoto, making it a busy highway for travelers, pilgrims, and itinerant merchants. Considerably larger than today's temple, the original compound consisted of over a hundred structures, a lotus pond, refectories, and dormitories. The new leaders of the Meiji era expressed their contempt for the old order by diminishing the importance of the temple and the Tokugawa mausoleums that served as the resting place of shoguns, by building a park here. The graveyard shrank in size with the post-war construction boom. The current temple, still one of the largest in Tokyo, dates from 1974. Snippets of

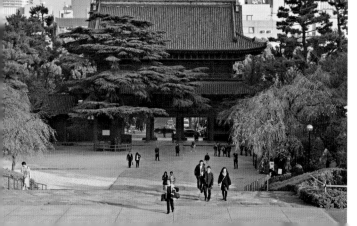

ABOVE The summit of a short hill in Shiba Park affords an overview of the temple complex.

LEFT The great San-mon Gate has miraculously survived since the establishment of the city.

history remain in statues of the bodhisattva Jizo, an old sutra storehouse, and a grand cedar tree planted by US president Ulysses S. Grant while on a visit in 1879. An exceptionally rare survivor of earthquakes, typhoons, air raids

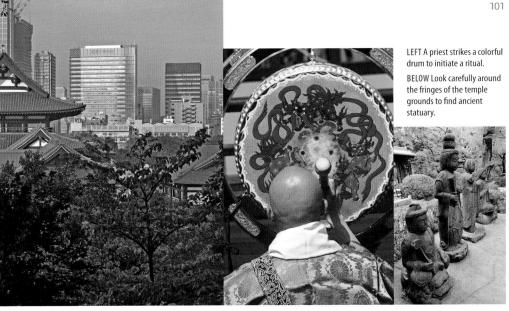

LEFT A priest strikes a colorful drum to initiate a ritual.

BELOW Look carefully around the fringes of the temple grounds to find ancient statuary.

RIGHT Guardian figures like this are placed in gate cavities to ward off malign forces.

and venal developers, the magnificent San-mon Gate, erected in 1605, remains to this day the oldest wooden structure in the city. Each of its three levels symbolizes the stages one must pass through in order to attain nirvana.

NATIONAL ART CENTER

Location 7 22 2 Roppongi, Minato-ku.
Access Nogizaka or Roppongi Stations.
Fee ¥¥¥

The apex of architect Kurokawa Kisho's storied career, the design for the National Art Center represents his concept of symbiosis, the principal that tension and contrast promote energy and originality. The center, consisting of twelve display areas, has no permanent exhibitions, allowing it to feature the work of a diverse and eclectic number of foreign and Japanese artists and art movements. The building's highly fluid façade, made from undulating panels of greenish glass louvers, interacts with changing, ambient light, promoting a sense of movement and fluidity. In creating the outer shell of the structure, Kurokawa said that

LEFT Visitors enjoy outdoor coffee on a bright autumn day.

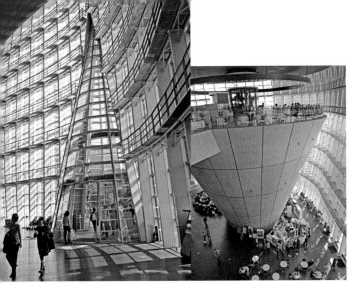

Art Museum and the Suntory Museum of Art, the center has helped to promote an area once synonymous with tacky entertainment into an attractive and worthwhile cultural destination.

FAR LEFT An interior of vaulting roofs and soaring walls.

LEFT This inverted cone serves as a venue for a top-quality French restaurant and café.

BELOW The center is distinguished by its bulging, sinuous walls.

he was influenced by the sinuous contouring of sea cliffs. The interior atrium, spacious and flooded with light, features two inverted cones, one of them hosting the Brasserie Paul Bocuse Le Musee, which serves authentic and affordable French cuisine. The largest gallery space in Japan, the center's lower levels contain a café and shop selling quality crafts. This stunning building represents, as its designer intended, the convergence of art and architecture. Part of the Roppongi Triangle, which includes the Mori

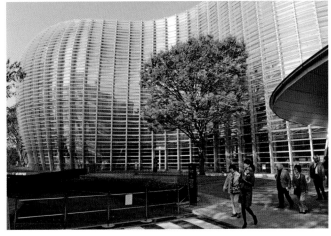

TOKYO MIDTOWN COMPLEX

Location 9-7-1 Akasaka, Minato-ku. **Access** Roppongi Station on the Hibiya and Oedo Lines.

BELOW The clean lines and converging angles of the 21-21 Design Sight gallery.

In fusing offices, commercial lots, serviced apartments, fashion stores, art galleries, restaurants, and a hotel with outdoor public space, Tokyo Midtown represents a growing trend towards building mega multipurpose city projects. Developed by the giant conglomerate Mitsui, the structures are designed to dazzle and appear global in their eclectic sourcing of design motifs applied to glossy shopping malls, glazed walls, open atriums, steel columns, and polished timber and stone floors. The layers of glass, elegant curtain walls with louvers made from terracotta that cover the tower exteriors, allude to the screens used in traditional designs, but the constructions larger cultural references and dimensions are

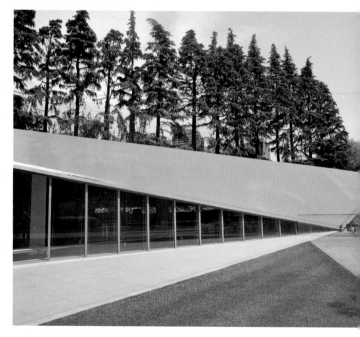

FAR LEFT The structures at Roppongi Hills can be viewed from all kinds of intriguing angles.

LEFT The idea of a Japanese garden rock cluster becomes clearer with an aerial view of the complex.

only fully appreciated when the complex is viewed aerially. From such a privileged perspective, we can see that the cluster of buildings has been arranged in the form of a *sanzonseki*, a rock grouping often seen in Japanese stone gardens. These represent Mount Sumeru at the center of the Buddhist cosmos. The soaring 248-m (814-ft)-high Midtown Tower is the centerpiece of this monumental cluster. Interesting design inserts into the complex include Kengo Kuma's graceful Suntory Museum of Art and Ando Tadao's 21-21 Design Sight gallery, which features contemporary, cutting-edge exhibitions. The Midtown Garden, planted with cherry trees, boasts the luxury in this space-pinched city of an expansive lawn.

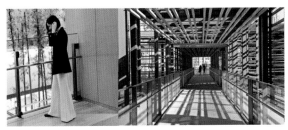

ABOVE A spacious forum with a sculpture at the center of a light well.

RIGHT Even the center's shop assistants, sensitive to imaging, are fashionably dressed.

FAR RIGHT Lattice wood and glass creates an interesting play of light in this connecting corridor.

ROPPONGI HILLS

Location 8-11-27 Akasaka, Minato-ku. **Access** Roppongi Station on the Hibiya Line.

Recalling the Roppongi Crossing, an intersection a little up from Roppongi Hills, writer Robert Whiting described its appearance in the 1960s as then "occupied only by a police box, a small bookstore, and two vacant lots.

At night, the surrounding side streets were so deserted that residents spoke of seeing ghosts." How different from today, the area synonymous with entertainment, commerce, and culture, the three themes converging in

Roppongi Hills. Consisting of the 54-story Mori Tower, with daring, meticulously curated shows taking place at its Mori Art Museum and observation deck, the complex also features apartment blocks, a shopping mall designed

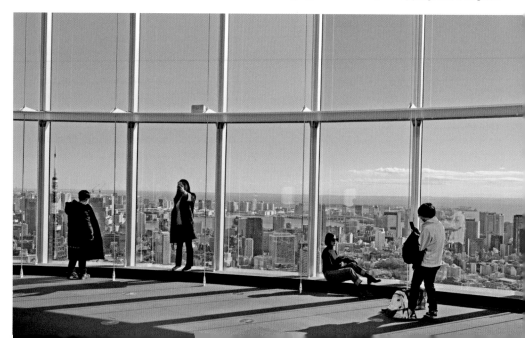

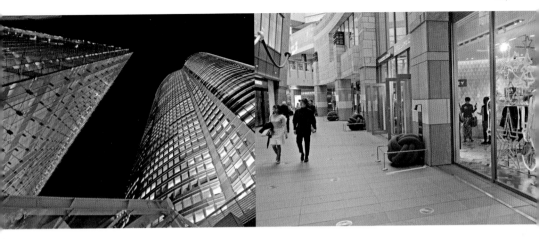

OPPOSITE ABOVE Small touches, like this design for a shop entrance curtain, add elegance.

LEFT The observation area of the Mori Art Museum offers some of the finest bayside views of the city.

RIGHT The complex's garden, though still young, is beginning to acquire a light patina of age.

ABOVE LEFT Illuminated at night, the towers of Roppongi Hill take on a fresh form.

ABOVE RIGHT Regularly changed shop windows are experiments for design.

by Californian John Jerde, restaurants and cafés, educational facilities, offices occupied by Japanese firms and global financial companies, a cinema, and a Japanese-style garden. Its open concourses and plazas are home to a number of interesting sculptures, most strikingly Louise Bourgeois's gigantic spider image made from bronze, marble, and stainless steel. Australian architect and scholar Julian Worrall has pointed out the shortcomings of a mega project that "entailed the obliteration of a neighborhood of residential houses, most of them wooden," a process he has characterized as a "merciless mechanism by which many cities worldwide are destroyed and reconstructed." Despite Worrall's reservations, Roppongi Hills does succeed in providing the experience of open access to an impressive multi-purpose complex.

AZABU-JUBAN STYLE

Access Azabu-Juban Station on the Namboku Line.

LEFT A patisserie and tea salon that might have been teleported from a fashionable French quarter.

RIGHT A restaurant standing stylistically between modernism and tradition.

It may not be Paris or Milan, but for Japanese people the district of Azabu-Juban stands for stylish elegance and chic. Although there are no major sights to speak of, the area's cleverly contrived European pretensions add texture to the city, providing yet another playground for the moneyed Japanese and expats who live here and the curious visitor. Among the high-end boutiques, pet grooming salons, and delicatessens, visitors can find quite affordable coffee shops, green tea cafés, bakeries, bars,

private galleries, and specialist shops along its narrow streets and cobblestone lanes. Home to an inordinate number of foreign embassies and their staff, the charm of the area rests, perhaps, in its synergy of the cosmopolitan with the village-like mentality of small enterprises. This appealing duality surfaces in the district's food scene, which supports both traditional Japanese cuisine alongside Italian, French, Mexican, Thai and Vietnamese eateries. One of the most intriguing restaurants, located in the

Nishi-Azabu, is Gonpachi. Better known as the "Kill Bill" restaurant, it is fast becoming a tourist attraction. Like the Karaoke-Kan in Shibuya, where a scene from the film *Lost in Translation* was made, Gonpachi was the model for a typically violent narrative in Quentin Tarantino's movie *Kill Bill*. Its moderately priced dishes include superb hand-made soba noodles, skewered meat, sushi, a mouth-watering Caesar Salad, and creative oddities like a combination Camembert cheese and tempura.

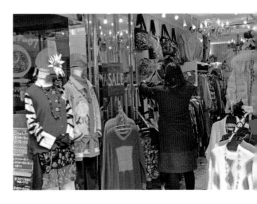

RIGHT Typifying small innovative stores is this tiny fashion boutique.

BELOW LEFT In a district where the food runs from the simple and savory to gourmet levels, you need a good wine dealer.

BELOW CENTER Hand-made soba noodles at Gonpachi.

BELOW RIGHT A shop specializing in fruit extracts, liquids, and syrups.

INSTITUTE FOR NATURE STUDY

Location 5-21-5, Shirokanedai, Minato-ku. **Access** Shirokanedai Station on the Namboku and Toei Mita Metro Lines. **Hours** 9.00 a.m.–4.30 p.m., closed Monday. **Fee** ¥

The Shizenkyoiku-en, as it is called in Japanese, is a wonderfully green, oxygen-rich alternative to urban Tokyo, a generous 200,000-sq m (2,152,000-sq ft) splash of unspoiled nature. The untamed is a novel concept in Japan, where the cultivation and training of plants, trees, and landscapes is the norm. Here, pampas grass, mushrooms, fungus, and parasitic vines are left unmolested. Fallen trees are not cleared but allowed to decompose. Over 8,000 trees grace the site, many of them labeled, though only in Japanese. Natural selection has divided these arboreal zones into oak, pine, and deciduous forest areas. Clumps of palm fronds and cycads create an almost Jurassic-era time slip, while wooden walking decks floating above marshy ponds and an aquatic plant garden favored by turtles, little grebes, and wintering mandarin ducks, advance the sense of entrancement. Dedicated to preserving the woodland wild flowers and plantings of the Musashino Uplands, the nature reserve is a rare glimpse into what this area must have looked like before the transformations wrecked by development. A nature center exhibits the plants and flowers currently in bloom. Entrants are given a ribbon to pin on. As there are only 300 ribbons available at any one time, this ensures that the grounds are never seething with people.

ABOVE FAR LEFT Wooden walkways carry visitors through the densely forested reserve.

ABOVE SECOND FROM LEFT A single winter camellia stands out against the greenery.

ABOVE SECOND FROM RIGHT The grounds attract some serious nature lovers.

ABOVE RIGHT A butterfly and stag beetle share the cleft of a tree.

LEFT The closest the temperate zone gets to being a jungle.

HAPPO-EN GARDEN

Location 1-1-1 Shirokanedai, Minato-ku. **Access** Shirokane-dai Station on the Namboku and Toei Mita Lines. **Hours** 10.00 a.m.–8.00 p.m. **Fee** Free admission.

The grand wooden entrance gate to Happo-en hints at the likely opulence of this former feudal estate. Even today, there is something stylish about the immaculate grounds and attached bridal and banquet hall, the garden providing the perfect setting for semi-informal wedding shots. The original outline of the garden, whose name means "beautiful from all angles," can still be sensed in a natural stream and grass-covered inclines despite the landscape undergoing extensive remodeling around 1910, when the industrialist and politician Kuhara Fusanosuke took over the property. The highly respected garden designer Ogawa Jihei assisted with the reinterpretation. Happo-en's understated beauty belies a number of interesting elements, among them an authentic tea ceremony house,

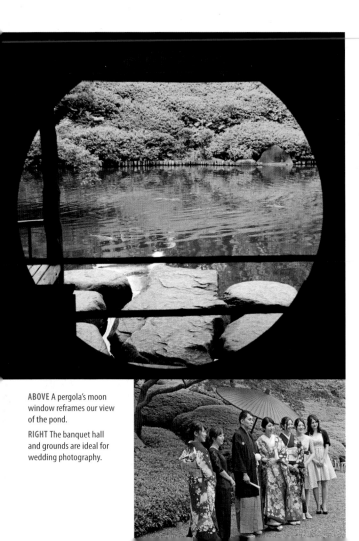

ABOVE A pergola's moon window reframes our view of the pond.

RIGHT The banquet hall and grounds are ideal for wedding photography.

a waterside arbor that appears to float over a carp-filled pond, and numerous trees, including cherry, Japanese oak, bamboo, pine, and maple. The most extraordinary are its bonsai. One specimen is reportedly over 500 years old. If it's an oxymoron that harmony with nature dictates the spirit of a garden that is essentially artificial, we also find the survival of raw nature, the grounds resonant with the sound of summer cicadas and bird song. Improbably for a residential district, snakes have been spotted in the garden, a sign that despite the city's relentless urbanization, there are still spots where all is well.

ABOVE A tea house subtly concealed behind trees and azalea bushes.

BELOW A highly controlled art form, this bonsai looks surprisingly natural.

LEFT Visitors walk past a row of bonsai, some of venerable age and rarity.

GRAVES OF THE 47 RONIN AT SENGAKU-JI

Location 2-11-1 Takanawa, Minato-ku. **Access** Sengakuji Station on the Toei Asakusa Metro or Tamachi Station on the JR Yamanote Line. **Hours** Temple 7.00 a.m. 6.00 p.m.; Museum 9.00 a.m.–4.30 p.m. **Fee** Temple ¥

One of the most electrifying events in the history of Edo took place on a cold night in December 1701. Provoked by the mockery of Lord Kira, a prominent noble, a *daimyo* from the Western provinces, Lord Asano, drew his sword, injuring his liege, a grievous breach of law. Ordered to commit *seppuku*, ritual disembowelment, Asano's death turned his vassals into *ronin*, masterless samurai. Conspiring to revenge his death, the men bided their time until the winter of 1703, when they forced their way into Kira's mansion and assassinated him. Carrying the head along

ABOVE A former head priest is honored in a beautifully fluid statue.

BELOW LEFT Universally known in Japan and even abroad, the temple compound is surprisingly quiet.

BELOW A statue of Oishi Kuranosuke, the *ronin* leader, with a scroll inscribed with revenge oaths.

snow-covered streets, they placed their trophy on the grave of their master at Sengaku-ji Temple. After long and disputatious discussions, the *ronin* were spared the indignity of decapitation and allowed to follow the same fate, and privilege, as their master. The weathered graves remain beyond a small guardhouse and the two-story Sanmon Gate. A well, in which the *ronin* washed the head of Lord Kira, has survived. A small museum commemorates the event. Incense is still burnt among the tombs, an acrid smell evoking the ancient death camps of samurai battlefields. Teleported to the modern age, *ronin* have become the subject of several Hollywood movies starring some famous actors like Robert De Niro and Keanu Reeves.

RIGHT The temple shop stocks trinkets, religious items, and *ronin*-related goods.

BELOW The graves are still visited by descendants of the *ronin*.

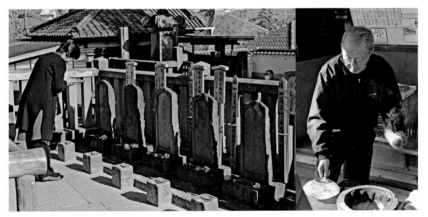

LEFT Many visitors, out of respect, buy and burn incense at the graves.

CROSSING OVER TO ODAIBA

Location Koto-ku. Access Yurikamome Monorail from Shimbashi Station, Rinkai and JR Saikyo Line trains to Tokyo-Teleport Station.

Although there isn't much of it around, Tokyo is all about space. Claude Levi-Strauss, surveying the compressed sprawl of Tokyo's living and working quarters back in the 1980s, judged that the future of the overcrowded city lay along the banks of the Sumida River. The idea not only took off along the city's pre-eminent river but transplanted itself into Tokyo Bay where, like a water-borne fetus, ectoplasms of growth soon coagulated into the hard matter of landfills. An aerial view of Tokyo today reveals a city stretched to is limits, coming to a congested stop at the waterfront. Detached from the shore, geometrically precise islands appear in the new pattern, seemingly lowered into place like space panels or dental plates. Among the platforms, exhibition pavilions and surrealistic constructions of Odaiba, an island built on

BELOW A rock band plays a blistering stage set at a Design Festa event inside Tokyo Big Sight.

LEFT Flights of street design fantasy inside Venus Fort.

BELOW At sunset, the hard infrastructure outlines of Odaiba soften.

BELOW RIGHT A stall holder at Design Festa, a creative, multi-themed event that includes art, performance, and cosplay.

RIGHT Pleasure boats drift beside Rainbow Bridge during the spectacular July Odaiba firework display.

reclaimed land sitting in the middle of Tokyo Bay, the visitor feels shades of Ozymandius, monuments to power and lost vanity, except that the structures on this not-so-remote landfill seem to hail from the future rather than the past. Connected to the city by the majestic Rainbow Bridge, Odaiba's flamboyant marriage of design and technology are present in structures like Panasonic Center Tokyo, with its Nintendo games machines and digital network museum called RiSuPia, and Miraikan, the National Museum of Emerging Science and Innovation, where visitors can explore everything from robotics to superconductivity and space technology. Architectural landmarks would have to include Tange Kenzo's surreal Fuji TV Building and Tokyo Big Sight, a massive venue for exhibitions, business fairs, the twice-annual Design Festa, the Comiket manga event, and March's Tokyo Anime Fair. The structure sits under two colossally inverted, gravity defying pyramids. Commercialism and fun come in the form of a giant Gundam model, Oedo Onsen Monogatari, a retro kitsch hot spring, the shopping outlet Venus Fort, with a ceiling depict-

ABOVE Pairing up for a cosplay presence outside Tokyo Big Sight.

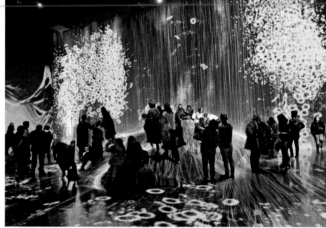

ing a changing Mediterranean sky, Mega Web, a Toyota car showcase, and Wonder Wheel, a 115-m (377-ft)-diameter Ferris wheel that offers superb views of Tokyo Bay, and Joypolis, a shopping and gaming mall facing Odaiba's artificial beach. The nearby Digital Art Museum takes project mapping to new heights. You might say that Odaiba's venues epitomize Japan's fascination with blending pop culture and high kitsch into a concoction that is both refined and ersatz.

LEFT A gallery at the Digital Art Museum, a project-mapping extravaganza.

LEFT BELOW A more tactile gallery at the Digital Art Museum.

RIGHT The twice-annual Design Festa events are a chance to see artists creating works live.

BELOW Characters from manga and anime come to life at Design Festa.

BELOW RIGHT The inverted pyramids of Tokyo Big Sight are a striking design feature.

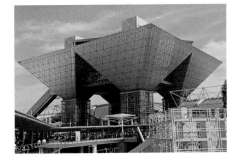

NATIONAL SUMO STADIUM & KYU YASUDA GARDEN

Location 1-3-28 Yokoami, Sumida-ku. Access Ryogoku Station on the JR Sobu Line and Toei Oedo Line Metro.

Completed in 1909, the first Kokugikan sumo stadium replaced the practice of holding tournaments outdoors or in tents. The current National Sumo Stadium in Ryogoku was built in 1985. Despite a succession of scandals surrounding the sport and the dominance in recent years of Mongolian and other foreign nationals, sumo remains immensely popular. Complex hierarchies, rules, rituals, and the assignment of specialized duties attach to Japan's national sport. Wrestling bouts between these titans take place in a carefully prepared earthen ring. A wealth of arcane detail surrounds the proceedings. Little known to audiences, for example, is the practice of burying rice, salt, dried cuttlefish, nutmeg and kelp beneath the earthen sumo ring as a talisman, the items remaining there until the end of the tournament. Tokyo *basho*, as these tournaments are known,

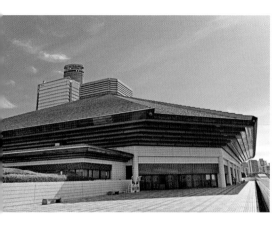

LEFT The roof design of the National Sumo Stadium is based on the shape of a sumo wrestler's topknot.

BELOW It is only a short walk from the sumo stadium to the Kyu Yasuda Tein, a minor but pleasant Japanese garden.

take place over a two-week period in January, May, and September. Tickets can be reserved from agencies. Non-reserved seats in the upper galleries are sold very early on the day of the matches. In the vicinity, it's worth strolling in the direction of the river for the Kyu Yasuda Tein, a Meiji-era Japanese garden. It's a minor design, but its pond, stone bridges, and well-arranged rocks offer a break from urban Tokyo despite the nearby Shuto Expressway.

OPPOSITE ABOVE LEFT Sumo matches begin at 8.30 p.m., but the best time to watch is the late afternoon when the stadium begins to fill up.

OPPOSITE ABOVE RIGHT Hanging streamers announce tournaments and matches. The opening of the matches is heralded from the tower.

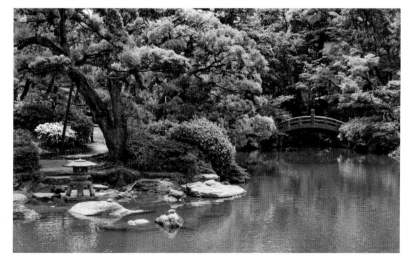

EDO-TOKYO MUSEUM & SUMIDA HOKUSAI MUSEUM

Edo-Tokyo Museum: 1-4-1 Yokoami, Sumida-ku. **Access** Ryogoku Station on the JR Sobu Line or Toei Oedo Line Subway. **Hours** 9.30 a.m.–5.30 p.m. daily. **Fee** ¥¥

Sumida Hokusai Museum: 2-7-2 Kamezawa, Sumida 130-0014. **Access** Ryogoku Station on the JR Sobu Line or Toei Oedo Line Subway. **Hours** 9.30 a.m.–5.00 p.m. daily, closed Monday. **Fee** ¥

What better way to get an insight into the city of Tokyo and its development than through its historical past. This huge museum traces the story of Tokyo from ancient, pre-city tombs and earthworks to the 1964 Tokyo Olympics. Cantilevered above four gigantic stanchions, the design is based on the elevated rice storehouses once common in the Japanese countryside. A

sixth-floor mezzanine level looks down onto the permanent exhibition, which includes a fifth floor, but also feeds visitors across a reproduction of Nihonbashi, an iconic wooden bridge. Among artifacts and displays covering a 400-year period are scale models of Edo districts, reconstructions of row houses, Asakusa's 12-story Ryounkakuin tower, and the Nakamura Kabuki Theater. Excellent signage, foreign language wireless headsets, and audiovisual displays make for a rich and comprehensive experience.

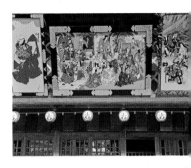

LEFT A children's climbing web contrasts with the dynamic simplicity of the Sumida Hokusai Museum surfaces.

RIGHT Hand-painted advertising boards announce a theatrical production at the Edo-Tokyo Museum.

OPPOSITE BELOW There are few original items in the Edo-Tokyo Museum but the recreations are authentically rendered.

BELOW Reproduction of a small Edo-era shop.

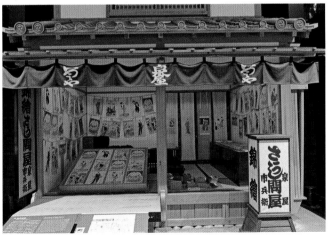

It is just 10 minutes on foot to the Sumida Hokusai Museum. Works by Katsushika Hokusai, one of Japan's most influential and prolific artists, are displayed on the fourth floor, home to a permanent exhibition, with temporary exhibitions on the third and fourth floors. Among the *ukiyo-e* woodblock prints, drawings, and paintings are works of instant recognition, including "Red Fuji" and "The Great Wave Off Kanagawa." Sejima Kazuya, a Pritzker Architecture Prize winner, created the strikingly original structure, an exercise in bisecting walkways, cool geometrics, and a metallic exterior. The originality of the design has made the structure a cultural landmark.

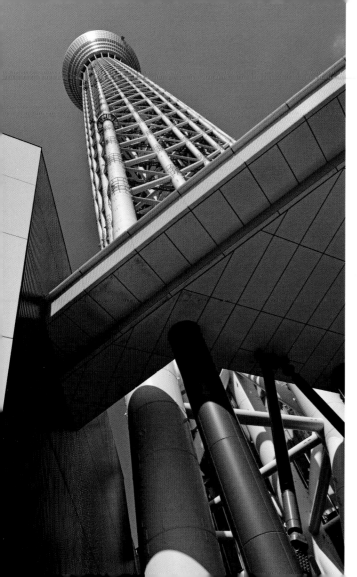

TOKYO SKYTREE

Location 1-1-2 Oshiage, Sumida-ku.
Access Oshiage Station on the Keisei Line
or Tokyo Skytree Station on the Skytree
Line. Hours 8.00 a.m.–10.00 p.m. Fee ¥¥¥

The world's tallest tower, Tokyo
Skytree is currently also its sec-
ond highest structure after
Dubai's rather more majestic Burj
Khalifa. Erupting from a largely
flat downtown area of eastern
Tokyo to a height of 634 m (2,100
ft), the aesthetics of a digital
broadcasting tower built in a low-
rise, downtown district to the
east of the Sumida River may be
questionable, but the views it
affords are unmatched. The struc-
ture is divided into two observa-
tion areas: the lower platform,
the Tembo Deck, stands at a stag-
gering 350 m (1,150 ft), providing
a 360-degree panorama of the
entire city. Stepping into the
shuttle elevator to the upper
zone and its slightly inclining
walkway, the Tembo Galleria
takes you to an elevation of 450
m (1,500 ft). Visitors pay extra for
this. Although it won't be obvious

to the casual observer, a nod to tradition exists in the height of the tower: the number 634 can be read as "Mu-Sa-Shi," the pre-settlement name of the area. The vibration-suppressing central reinforced column sways in counterpoint to the main steel frame of the tower, a neutralizing mechanism used in traditional five-story pagodas. Don't forget to look out for a set of models in the entrance lobby that illustrate the structural dynamics of the design and their historical precedents.

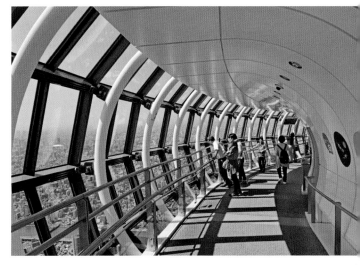

OPPOSITE The soaring trusses and support pillars of Tokyo Skytree.

BELOW Photo frames are popular with tourists.

ABOVE The curving sky corridor creates a sense of stepping out above the city.

BELOW On a fine day, the views from the observatories are unmatched.

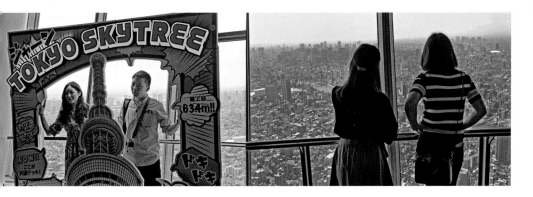

HYAKKA-EN "GARDEN OF A HUNDRED FLOWERS"

Location 3-18-3 Higashi-Mukojima, Sumida-ku.
Access Higashi Mukojima Station on the Skytree Line.
Hours 9.00 a.m.–5.00 p.m. daily. **Fee** ¥

It is difficult to make out a formal design at Hyakka-en, "Garden of a Hundred Flowers." What we have instead is something akin to a horticultural allotment, with portions of the garden set aside for the planting of small trees, herbs, vegetable trellises, wild grasses, and flowers. Contrary to the immaculately laid out gardens of the nobility, the grounds of Hyakka-en, designed by Sahara Kiku, a retired antiques dealer, in the early 19th century, represents, as the work of a town commoner, a liberation from landscape formalities. Sahara asked his friends, many of whom were gifted writers and poets, to contribute one plum tree each. Gathering together to enjoy such aesthetic pleasures as moon viewing and listening to the sound of insects, plants connected with the classical literature of Japan and China

RIGHT The garden's tunnel of bush clover, known in Japanese as *hagi*, is the focal point of September visits.

BELOW The garden's mix of rusticity, nursery space, and refinement is evident at the entrance gate.

were introduced into the garden. Many of the stones in the garden are incised with poems written by Sahara and his friends, the verses flowing in beautiful calligraphic strokes. Poetry readings and other cultural and seasonal events take place on a regular basis. Donated to the city in 1938, the garden suffered considerable damage during the 1945 air raids, but restoration efforts, spurred by local residents, have restored it to its original form.

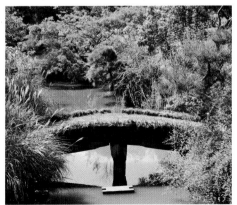

ABOVE LEFT Gourds and other tubers hang from a trellis.

TOP A butterfly alights on a leaf. Chemical sprays are not used.

ABOVE Autumn nuts and crab apples. Organic displays change with the seasons.

LEFT A bridge made from wood and compacted earth.

INFINITY BOOKS

Location 1F Komagata Bashi Heights Building, 1-2-4 Azumabashi, Sumida-ku.
Access Asakusa Subway, Ginza Line.

Run by Nick Ward, a Yorkshireman with a droll sense of humor and a prodigious knowledge of books, stepping from the sidewalk of a noisy traffic lane into this store, its interior made almost entirely of wood, is a little like passing from urban dystopia into a forest. The only dedicated Used English bookstore in Tokyo, reasonably priced titles are sold across the counter or online. In common with San Francisco's City Lights Bookstore or Shakespeare and Company in Paris, Infinity books is more than just a store, providing a social space where people can talk about books and authors in an informal milieu. With a license to serve alcohol, customers can enjoy a glass of beer or wine, chat about books, and attend poetry readings, book launches, pop quizzes, and music workshops. Acoustic music events are held on Friday and Saturday nights. Saturdays are well-attended, with

ABOVE Bookstore owner Nick Ward holding a copy of one of his most beloved authors, Gabriel Garcia Marquez.

LEFT Minx, a regular band on the Tokyo music scene, performing at the store to an appreciative audience.

a friendly crowd of Japanese and foreigners enjoying performances of everything from blues, country, bluegrass, pop, and world music to players of the Japanese three-stringed *shamisen*. Expect to hear renditions of songs by everyone from Willy Nelson to The Clash. During open mic Saturday sessions, anyone is welcome to perform. As a venue for book browsing, discussion, booze, and music, visitors can experience a rare cultural Bohemia right here in Tokyo.

ABOVE Kanke Aki, a regular at the store, plays a mean blues harmonica with musical partner Hikibuki Gen.

FAR LEFT A quiz evening at the shop. Books, booze, and music. Is there a better combination?

LEFT Keep your eyes open for information displayed on the chalkboard outside the store.

SHUNKA-EN BONSAI MUSEUM

Location Nihori 1-29-16, Edogawa-ku. **Access** Mizue Station on the Toei Shinjuku Line. Koiwa Station on the JR Sobu Line, then bus 776 to Keiyouguchi stop. **Hours** 10.00 a.m.–5.00 p.m., closed Monday. **Fee** ¥¥

RIGHT Bonsai master Kobayashi Kunio has devoted his life to cultivation, sharing his expertise with visitors and at workshops.

Strolling through the dark wooden gate of Shunka-en, urban tones change to green as your eyes focus on trays of plants placed on single rows of trellis tables or in massed tiers. Owner, bonsai master Kobayashi Kunio, has compared the art of bonsai to Japanese ink painting, the powerful trunks and branch forms akin to the monochrome lines created by brush strokes. A collaboration between man and nature, moderated by the slow passage of time, the relationship with the temporal can extend through the centuries. One particular specimen here is almost 1,500 years old. Once you have examined the bonsai, your eyes are likely to turn to the wealth of detail at Shunka-en. Kobayashi has fashioned an environment very much in the Japanese gar-

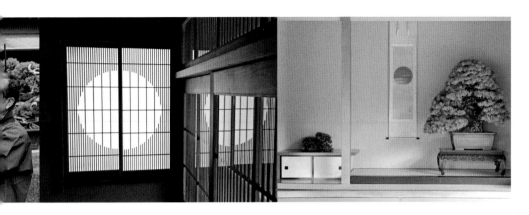

ABOVE The lattice work at the center of this paper screen window forms the image of a full moon.

ABOVE RIGHT Visitors are permitted to enter the main building where bonsai and hanging scrolls are displayed.

LEFT The courtyard is set aside for various bonsai, but especially pine trees, some centuries old.

den tradition, the wooden structures, inner galleries, alcoves, and tea house all made of the finest materials. In the polished wood floors, *tatami* mat rooms, lathered earth and straw walls, granite stepping stones, and valuable pots and dishes from Japan and China, we enter a refined world, a digest of Japanese garden aesthetics, the ideal ambience for an exhibition of miniature trees. At their best, bonsai embody unity, harmony, and beauty and transmit a sense of balance, serenity, and the sacred, all qualities the contemporary world would do well to cultivate.

BELOW Japanese garden touches at the center include a small carp pond.

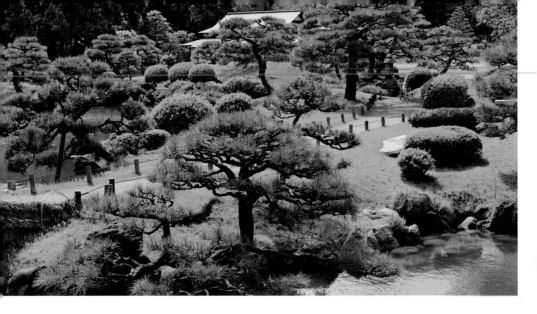

KIYOSUMI-TEIEN GARDEN

Location 3-3-9 Kiyosumi, Koto-ku. **Access** Kiyosumi-shirakawa Station on the Toei Oedo and Hanzomon Metros. **Hours** 9.00 a.m.–5.00 p.m. **Fee** ¥

ABOVE A delightful pine and azalea island add visual interest.

The history of ownership of this garden begins in the Edo era when the grounds were an adjunct to the residence of a wealthy merchant. The estate took the form of a Japanese garden when it was bought by a feudal lord. In the Meiji period, Iwasaki Yataro, founder of the Mitsubishi industrial conglomerate, purchased the garden, remodeling it as a site to entertain important guests and employees. The spacious, rarely crowded feudal stroll and pleasure garden is replete with a miniature azalea hill, a prominent tea house, dry water-falls, earth bridges, gazebos, seasonal patches of gardenia, crepe myrtle, hydrangea, iris, and camellia, and is intensively planted with over 4,000 trees. The generous pond, the site of three islands, is home to birds, carp, and turtles. A highlight of the episodic experience of walking around the pond is a long line of stepping-stones, known as *iso-watari*, which, along with other

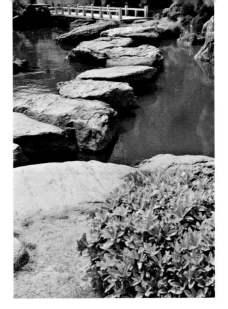

RIGHT A fine example of *iso-watari*, stepping stones placed above a pond.

BELOW The centrally placed tea house, the main structure in the garden, requires a reservation to enter.

ABOVE A small side garden featuring large rocks set in "islands" of azalea bushes.

rock groupings in the garden, were carefully selected for their rarity and form, then transported by the company's steamships to the current location. Entering a garden of this dimension and botanical lushness in one of the eastern districts of the city, its most congested belt, is nothing short of astonishing.

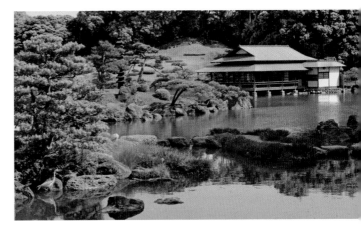

TOMIOKA HACHIMANGU FLEA MARKET

Location 1-20-3 Tomioka, Koto-ku. **Access** Monzen-Nakacho Station on the Tozai Line
Metro. **Hours** First and second Sunday of the month.

Tokyo is blessed with a good crop of flea markets, many set up in parks, weekend parking lots, or under the tracks of expressways. More atmospheric are the flea markets (*nomino ichi*) that take place in the grounds of shrines. One of the most consistently interesting in terms of size and range of goods on sale, is the twice-monthly market at the Tomioka Hachimangu Shrine, located on the flatlands of east Tokyo. The brilliantly decorated and colored shrine was created in 1627 and is associated with the origin of the current form of sumo wrestling. A number of stone monuments dedicated to the sport can be found at the rear of the compound. The market is a lively affair, with a great mix of antiques, curios, and junk. Look out for retro toys, iron pots, tinted postcards, bolts of silk, wooden chests, woodblock prints, wooden statuettes, medicine cases, used kimonos, ceramics, lacquerware, dolls, antique cameras, and all manner of bric-a-brac. Gener-

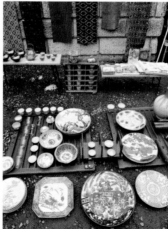

ABOVE Well-crafted dolls in near mint condition.

FAR LEFT A stallholder selling textile goods and toggles.

LEFT Ceramic wares are always a good buy at Tokyo flea markets.

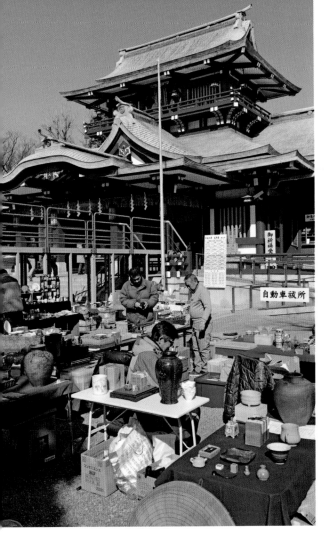

ally speaking, the Japanese are not familiar with public haggling, but in the case of flea markets it's always worth asking, *Sukoshi yasuku, dekimas ka?* (Can you knock the price down a bit?)

LEFT The brilliantly decorated Tomioka Hachimangu Shrine is a fine backdrop to the market.

TOP Amidst the junk and bric-a-brac are objects of collectible quality.

ABOVE A fine collection of wooden objects, from gourds to dolls.

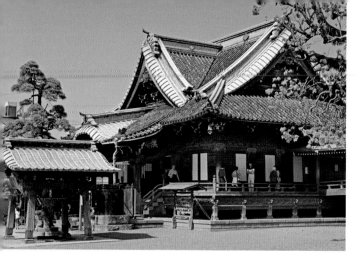

TAISHAKUTEN TEMPLE & GARDEN

Location 7-10-3 Shibamata, Katsushika-ku. **Access** Keisei Main Line train to Shibamata, or Hokuso Line to Shin-Shibamata. **Hours** Temple complex always open. Garden and Taishakudo Hall, 9.00 a.m.–4.00 p.m. **Fee** ¥

Shibamata, an old working-class town stretching along the banks of the Edogawa River, is best known to the Japanese as the home of the comic screen character Tora-san. Taishakuten-Sando, the pedestrian approach to the retro district's center of worship is bulging with restaurants, *kusa dango* (mugwort-flavored rice sweets), lucky charms, and heaps of Tora-san memorabilia. The street terminates at Niten-mon, an impressive wooden gate topped with tiles the color of powdered green tea. Founded in 1629, Taishakuten takes its name from a Buddhist divinity similar to the Hindu god Indra. The entrance ticket to the temple includes the attached Dai-Kyakuden, a guest house built in 1929. The open sides of a covered viewing cloister provide superb views of Suikei-en, the residence's spacious Japanese garden. The ticket includes the extraordinary Taishakudo Hall. The hall's main draw card is a 3D set of wooden panels, a diorama of exquisite carvings depicting the life of the Buddha. Among the transfixing swirl of levitating saints, tea-sipping deities, farm and jungle animals, and idealized natural scenery, look for strong story lines. Such illustrative galleries are commonplace in Japan, but few on this scale or done with such dexterity. Following the

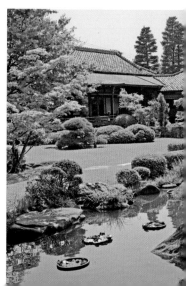

complex images and detailed narrative is almost as absorbing as reading a good book. Tucked into a lane behind the temple is a lovingly preserved Taisho-era *sukiya-zukuri*-style residence known as Yamamoto-tei. Visitors can sample powdered green tea and a traditional sweet while contemplating a highly regarded garden.

OPPOSITE The weight of Taishakuten's massive tiled roof seems to defy gravity.

LEFT Flooded with sunlight, the spacious interior of Yamamoto-tei.

BELOW Powdered green tea with a seasonally themed sweet are served at Yamamoto-tei.

BELOW LEFT Water lilies and lotuses floating in the pond of Suikei-en.

BELOW RIGHT Using the covered walkways of Suikei-en provides a 360-degree view of the garden.

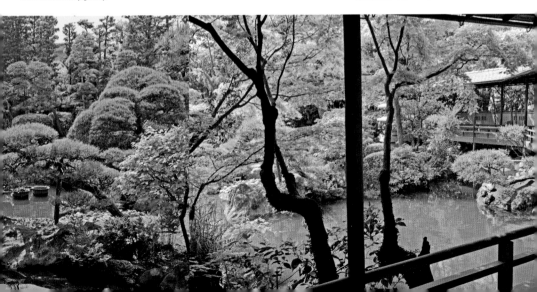

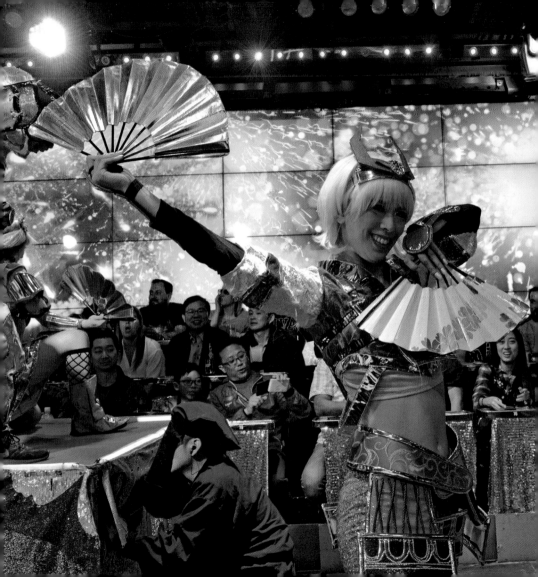

Exploring Western Tokyo

After the Great Kanto Earthquake of 1923, a calamity that took an especially severe toll on the eastern and central parts of the city, Tokyo experienced something akin to a diaspora as people moved west, extending and creating new suburban centers in areas considered safer and more spacious. The city has been spreading westwards ever since. As residents increased, infrastructure followed, the western portion of the circular Yamanote Line incorporating great entertainment, shopping, food, and fashion centers like Shinjuku, Harakuju, and Shibuya, its outer regions clustering around older sites connected to temples,

shrines, niche districts patronized by the young, and the semi-rural edges of the city. The *daimyo*, the noble families that supported the Tokugawa shogunate's successful bid for power, were awarded prime plots of land located to the west of Edo Castle, an area that came to be called the Yamanote, or High City. These districts are still associated with privilege. Compared to the eastern suburbs, the old Shitamachi, or Low

City, the capital's western denizens are more salubrious, land prices considerably higher. By Western standards, or among the wealthiest cities of Asia, these districts may still feel insufferably crowded, housing levels poor, but one has to think relatively in the world's most populous city. Stark disparities in living standards between the east and west remain despite efforts at economic levelling.

LEFT A flourish of color and spectacle at the Robot Restaurant in Kabuki-cho.

RIGHT The head of Godzilla appears above a Shinjuku edifice.

BELOW A tranquil pool of water in a corner of the Canadian Embassy Garden.

BOTTOM A craggy, fern-strewn corner of the botanical garden.

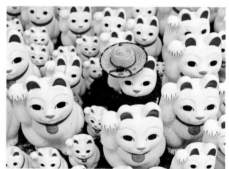

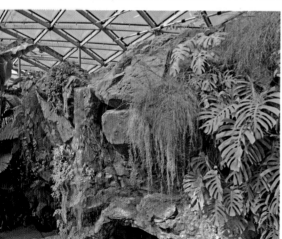

TOP LEFT Eating on the streets is a common exception in Shin-Okubo.

TOP RIGHT One of artist Yayoi Kusama's iconic pumpkin models.

ABOVE Countless offerings of *maneki-neko* figures at Gotoku-ji Temple.

RIGHT Sizzling grills and packed counter-only seating in Omoide Yokocho.

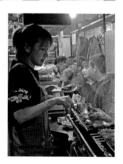

Western Tokyo

o-tokyo Open Air Architectural Museum
kano Broadway
enji

CHUO

Nakanosakaue
Nakanosakaue

HONCHO

Nishi-shinjuku

Nakano-shimbashi

Nishi-shinjuku-gochome

HONMACHI

AYOICHO

HATAGAYA

Tokyo Opera City ● Hatsudai

Japanese Sword Museum

Sangubashi

NISHIHARA

HATSUDAI

Yoyogi-hachiman

Yoyogi-koen

Yoyogi-uehara

UEHARA

TOMIGAYA

mokitazawa

● Maeda Houses

SHOTO

● Don Quijote Mega Store

ku-ji Temple

Komaba-todaimae

KOMABA

OHASHI

DAIZAWA

Ikejiriohashi

AOBADAI

← Gotoh Museum Garden
← Todoroki Gorge

● Nakameguro

● Daikanyama

DOGENZAKA

SHIBUYA STATION

Shinsen

● Shibuya Crossing

HIRO-O

Yamatane Museum of Art

MOTO-AZABU

↑ Gokoku-ji Temple

● Shin-Okubo

Okubo

Shin-okubo

Higashi-shinjuku

Seibu-Shinjuku

Shinjuku-nishiguchi

Omoide Yokocho

Tochomae

Shinjuku-sanchome

● Kabuki-cho

KABUKI-CHO

Akebonbashi

Higashi-shinjuku

Wakamatsu-kawada

HARAMACHI

● Yayoi Kusama Museum ●

Ushigome-yanagicho

500 m
1000 feet

N

Ichigaya

SHINJUKU STATION

Shinjuku

Minami-shinjuku

Yoyogi

Shinjuku-gyoenmae

Yotsuya-sanchome

● Shinjuku Gyoen Garden

Sendagaya

Shinanomachi

Kitasando

Harajuku

Meiji Shrine

Iris Garden

● Takeshita-dori

HARAJUKU CROSSING

Meiji-jingumae

Meiji-jingumae

● Kawaii Monster Cafe

● Omotesando-dori

Tobacco and Salt Museum

OMOTESANDO CROSSING

Omotesando

● Nezu Museum Garden

Kokuritsu-kyogijo
Seitoku Memorial Picture Museum

Galeemmae

Aoyama-itchome

Aoyama-itchome

MOTO-AKASAKA

Yotsuya

Yotsuya

Yotsuya

KOJIMACHI

Kojimachi

New Otani Art Museum

Akasaka-mitsuke

● Hie Shrine

● Canadian Embassy Garden

AKASAKA

Akasaka

Nogizaka

21_21 Design Sight Museum

● Fuji Film Square

National Art Center

Roppongi

ROPPONGI

● Mori Art Museum

Azabujuban

Azabujuban

AZABU-JUBAN

MOTO-AZABU

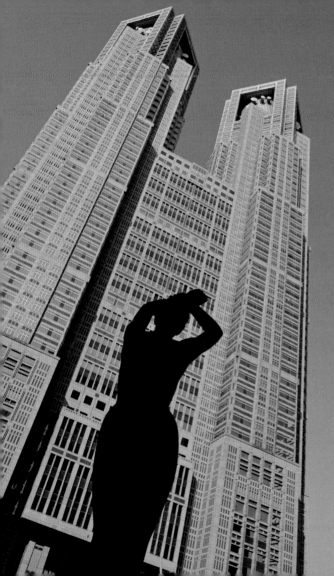

SHINJUKU SKYLINE

Location Nishi-Shinjuku. **Access** JR Shinjuku Station, West Exit.

In William Gibson's sci-fi novel *Idoru*, skyscrapers in the Nishi-Shinjuku district, covered in organic building substances, appear to "ripple, to crawl slightly ... a movement like osmosis or the sequential contraction of some sea creature's palps." It's not difficult to imagine this area inspiring supra-futuristic visions like that. Ridley Scott based sets for his dystopic urban vision, *Blade Runner*, in this area. Sofia Coppola used the luxurious sanctuary of the Shinjuku Park Tower for scenes in her film *Lost in Translation*. Older structures from the 1970s, like the Shinjuku Mitsui Building and the Sompo Japan Building, have stood the test of time. Unprecedented in scale and cost when completed in 1991, Tokyo City Hall has its detractors, who accuse it of hubris, but the structure remains, in the words of writer Julian Worrall, "un-

LEFT Sculpture as message, the form, with its appealing shape, appears to have caught on in other cities.

equaled by any other building of the modern Japanese state." Tokyo Mode Gakuen Cocoon Tower, the latest behemoth in the area, is a "vertical campus" for some 10,000 students. After the Moscow State University, this college in the air is the tallest educational institute in the world. Crisscrossed by white stripes resembling basketry, the building recalls the outline of Norman Foster's 30 St. Mary Axe design, better known to Londoners as the "gherkin."

ABOVE Though conceived in the 1970s, the designs remain very contemporary.

LEFT The unmistakable outline of the Tokyo Mode Gakuen Cocoon Tower, now a Nishi-Shinjuku fixture.

OPPOSITE Like all contentious architecture, Tokyo City Hall has divided opinion.

KABUKI-CHO ENTERTAINMENT DISTRICT

Location Kabuki-cho, 1-chome, Shinjuku-ku. **Access** JR Shinjuku Station.

Nowhere caters in such exacting depth and professionalism to Tokyo's wayward spirit, its essentially sexual nature, its craving for indulgences, nor satisfies its myriad proclivities more thoroughly than Kabuki-cho, the city's premier *sakariba*, or pleasure quarter. A contemporary version of the Edo-era red light districts, its nocturnal streets are lit in lurid reds, greens, and pinks. The tones of flesh and red cellophane-like frames from comic books or the more lascivious manga, come to life in a strange graphic effervescence. Jam-packed with pink salons, soaplands, the mirrored floors of no-panties tea rooms, telephone clubs, *nozoki-beya* peep shows, SM chambers, and "adult toy"

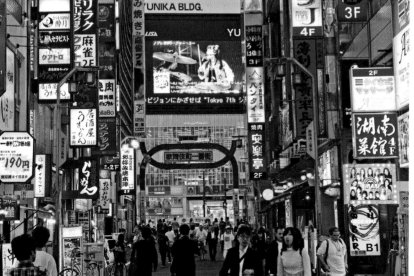

LEFT Buildings covered in a bewildering sea of advertising and signage.

ABOVE A highly polished and professional band entertains visitors before they enter the Robot Restaurant theater.

RIGHT A swirl of neon from a mechanized human form at the Robot Restaurant.

stores, Kabuki-cho is not just about sex. Witness its profusion of restaurants, bars, theaters, cinemas, discos, and game centers. One of the most electrifying forms of entertainment to appear in the district is the Robot Restaurant. Established in 2012, visitors are led through a glitzy entrance into a reception space replete with ballroom mirrors, crystal chandeliers, and high kitsch décor. A band, dressed as robots, entertains guests before they enter the theater. Skimpily dressed young women and males outfitted in

ABOVE Performers at the Robot Restaurant put everything into their act.

LEFT The theme park-style façade of a Kabuki-cho back street edifice.

quasi-samurai uniforms enact historical battles and sci-fi plots with the aid of some extraordinary mechanical props, to a blistering sound track and a barrage of LED lights. Its all done with absolute professionalism.

OMOIDE YOKOCHO FOOD STREET

Location 1-chome, 2-8 Nishi-Shinjuku. **Access** Shinjuku Station, West Exit. **Hours** 3.00 p.m.–midnight is usual; some shops open until 5.00 a.m.

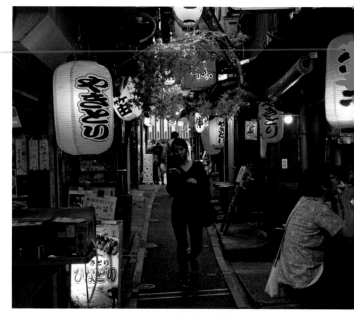

ABOVE Early evening among Omoide Yokocho's nest of cozy eateries.

RIGHT The "master" of a tiny eatery prepares an assortment of grilled tidbits.

Once known by its less fragrant sobriquet, Shomben Yokocho ("Piss Alley"), the two impossibly narrow passageways that run alongside the tracks of Shinjuku's Yamanote Line have been re-christened Omoide Yokocho ("Memory Lane"). The name may have been air-freshened but the atmospheric rows of tiny eateries have kept their grungy, underground cuisine character. Overhung with a cobweb of electrical wires, tiny counter-seating restaurants with smoke-blackened ceilings and walls, sizzling grills and woks, are overseen by no more than a single or couple of dedicated cooks. Eateries serve a broad selection of items, ranging from soba, ramen, and grilled fish to the more interesting, or chal-

lenging, horse meat, *motsu niko-mi*, a tripe soup made from animal innards, *motsu-yaki*, the grilled variety of the organs, and even fresh oysters. Sticks of charcoal-grilled *yakitori*, the chicken goblets flavored with soy sauce or salt and served with chicken wings, skin, gizzard, and

bell peppers are a signature item. Extra orders of rice, miso soup, and tofu supplement these choices. After a few glasses of cold beer, saké, or *shochu*, these cozy little eating and drinking dens can get quite crowded, noisy, and ribald, all part of the earthy dining experience.

RIGHT Chicken, pork, and liver are among the favorite meat choices of these restaurants.

FAR RIGHT Stirring a rich broth of *motsu nikomi*, a slightly spicy tripe soup.

BELOW RIGHT Limited seating presupposes fast service and a lively turnover of customers.

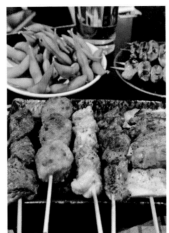

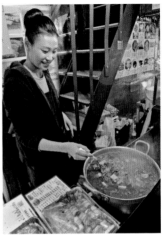

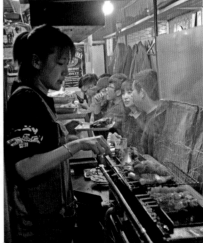

SHINJUKU GYOEN PUBLIC GARDEN

Location 11 Naitocho, Shinjuku 160-0014, Shinjuku-ku. **Access** Shinjuku-Gyoenmae Station on the Marunochi Metro. **Hours** 9.00 a.m.–4.00 p.m., closed Monday. **Fee** ¥

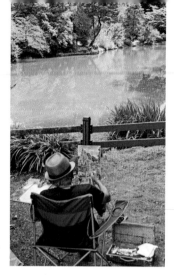

Essentially a spacious, 57-ha (140-acre) Western-style park, or national garden, Shinjuku Gyoen is a wonderful spot to step out of the urban crush of the city and take a few deep breaths of its oxygen-infused air. A popular venue for cherry blossom viewing in late April, the expansive grounds are divided into a mishmash of garden styles: a vague semblance of an English garden and a French garden, but a more authentic Japanese landscape. Well-manicured bushes and shrubs stand on beautifully cropped, landscaped lawns that drop to a pond and the imposing Kyu Goryote, also known as the

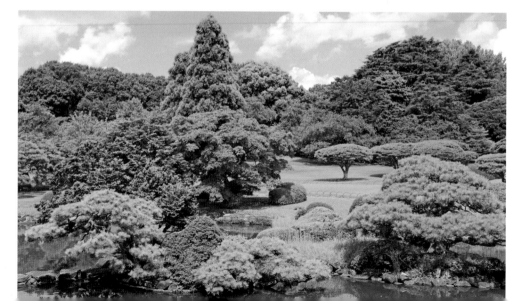

Taiwan Pavilion. The Chinese-designed structure was built as a gift to the Showa Emperor on the occasion of his wedding. A number of traditional tea houses are tucked into the garden. This Japanese garden is the site for a splendid chrysanthemum festival in late October and November. There are no fences or divides between these garden areas, each zone blending seamlessly into the next. A large temperature controlled greenhouse, a botanical garden, contains many tropical and sub-tropical plants and flowers. The remainder of the park is set aside as woodland and lawn, interspersed with a restaurant, information center, and gallery. Created in 1772 as a feudal lord's estate, the grounds were used as an experimental agricultural research center until they passed into the hands of the imperial family in 1903. Totally destroyed during World War II, the park was rebuilt and opened to the public in 1949.

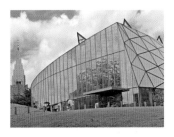

ABOVE The ultra-modern botanical garden greenhouse replaces an older, more charming one, but being made of real glass, it posed earthquake risks.

BELOW A liberal but still pleasant interpretation of a French garden.

ABOVE A gardener tending to a bird's nest fern in the botanical garden.

ABOVE LEFT The grounds offer plenty of space for amateur painters to set up seats and easels.

LEFT The Japanese garden section of the park blends effortlessly with a rear area of woodland.

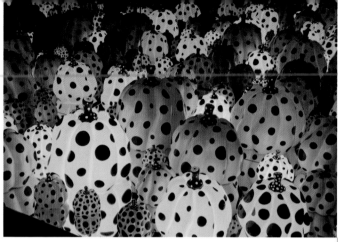

LEFT A limited number of visitors at a time are permitted to enter this darkened exhibition room.

BELOW Another version of the artist's pumpkin focus exhibited on an outside terrace.

YAYOI KUSAMA MUSEUM

Location 107 Benten-cho, Shinjuku-ku. **Access** Waseda Station on the Metro Tozai Line, Ushigome Yanagi-cho Station on the Toei Oedo Line. **Fee** ¥¥

Opened in 2017, this narrow but striking five-story museum is dedicated in its two exhibitions a year to the work of avant-garde artist Yayoi Kusama. The elderly, brightly bewigged iconoclast, the world's number one selling female artist, is a conceptualist who has incorporated painting, sculpture, performance, film, and installation elements involving mirrors and light into her work. Kusama explores psychological, sexual, and highly autobiographical themes in a heady, creative smorgasbord that references surrealism, abstract expressionism, Art Brut, minimalism, and aspects of feminism. One of Japan's foremost artists, Kusama, embracing the freedoms of the counterculture, became a leading figure in the New York art scene of the late 1950s and 1960s, taking part in a series of radical happenings involving naked participants

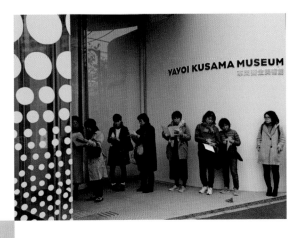

LEFT Visitors with reservations wait for the next intake of people to the museum.

BELOW Kusama's canvasses are bold and assertive, each section of color occupying an individual but integrated space.

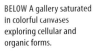

painted with polka dots. Kusama began to experience vivid, frequently terrifying hallucinations at the age of ten, an experience that has manifested itself in the obsessive multiplication of single themes in her work. The artist, who has gone on record saying that if it were not for her work she would have committed suicide a long time ago, continues to transform her personal traumas into art. The museum is located in the vicinity of the mental institution in which she has lived for many years.

BELOW A gallery saturated in colorful canvases exploring cellular and organic forms.

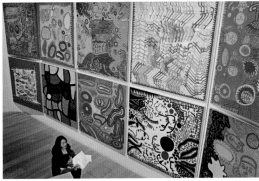

SHIN OKUBO "KOREA TOWN"

Location Shin Okubo, Shinjuku-ku. **Access** Shin-Okubo Station on the JR Yamanote Line.

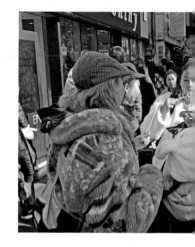

Popularly dubbed "Korea Town," Shin Okubo does have a large Korean ethnic community but the district is considerably more diverse than that. True, the city's best spicy Korean barbecues, mixed fried rice (*bibimbap*), and pancake restaurants are found here, along with K-Pop shops and cafés, but so are open markets, street food, Middle Eastern stores, and bars. Shakespeare would no doubt have loved the quarter, finding in its brazen, intemperate streets a mirror image, an Asian version no less, of the teeming Elizabethan world of Shoreditch. At night, the neon strip of Okubo-dori and the pedestrian alleys that feed into it are vibrant with conversations and importunings in a dozen different languages, its Korean Myanmarese, Thai, and Malaysian restaurants releasing pungent smells into the brothy, salty atmosphere, giving the impres-sion that one is on an island detached from mainland Tokyo. The cast of characters who step out onto the streets of this melting pot is a rich one. Mercifully, Shin Okubo has not reverted entirely to the developers who would build their own Utopia

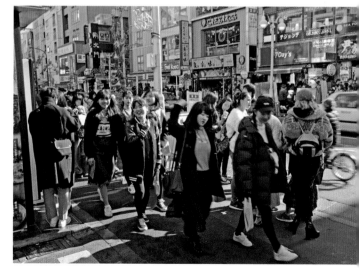

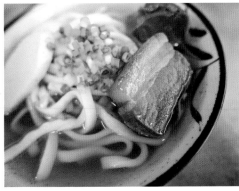

LEFT A bowl of Okinawa soba, another example of the so-called ethnic food that pervades the district.

BELOW LEFT Fast food snacks are ideal for young, busy shoppers.

BELOW Just a few meters back from the main shopping drag, a serene Buddhist statue.

ABOVE Street snacking on the crowded pavements is a common, and acceptable, sight in Shin Okubo.

LEFT The area attracts people of all ages but especially the young K-Pop crowd.

of high rents and parking lots. Instead, it has passed, for the time being, into the hands of those spirited souls from continental Asia, the drifters, migrants, and entrepreneurs who have washed up on its narrow strip.

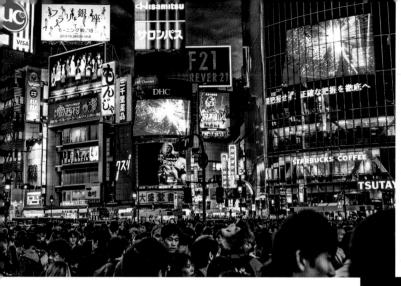

SHIBUYA CROSSING

Location Shibuya-ku. Access JR Yamanote Line, Ginza, Hanzomon, Fukutoshin Metros, Inokashira Line.

A favorite of the international media, serving as an iconic image of the city, the Shibuya Crossing, putatively the world's busiest scramble, is less pedestrian space and intersection than performance venue. Something always seems to be happening at the crossing, a stage for sidewalk musicians, the closest Tokyo has to the talented buskers of London and Paris, cosplay models, swarming groups of youth, even the odd right-right truck decked out with Rising Sun images, its driver bellowing out nationalist slogans few passersby bother to register. It is also where visitors queue to have their photo taken with the bronze statue of Hachiko, a dog

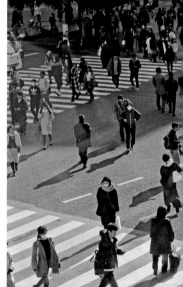

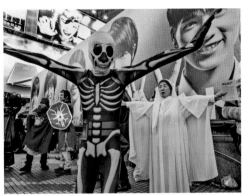

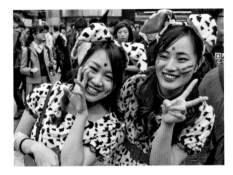

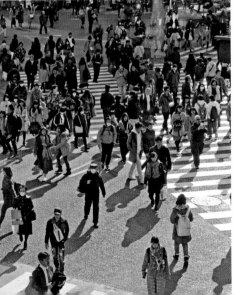

ABOVE LEFT Daytime cele-
brants at the crossing's
Halloween event.

ABOVE Striking figures seen
at the annual Halloween
binge, centered on the
Shibuya Crossing.

LEFT Orderly crowds stream
across the crossing at all
hours of the day and night.

whose story represents loyalty
and devotion, virtues dear to the
Japanese. Shibuya is one of the
city's most dynamic theaters of
dress, making it the natural venue
for Halloween, one of Tokyo's
most exciting street parties.
Alongside the traditional ghouls
and witches are Japanese anime
and manga characters, the event,
an extension of cosplay. Upwards
of a thousand people are said to
cross here when the lights turn
green, nimbly avoiding collision
with oncoming pedestrians. The
crossing's dream-like quality is
best sensed at night when its
sky, foregrounded by vast digital
panels, turns into a neon aurora,
the edges of its buildings the
jagged ruins of a supernova.

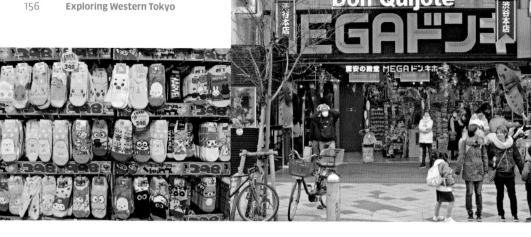

DON QUIJOTE MEGA STORE

Location 28-6 Udagawa-cho, Shibuya-ku. **Access**
Shibuya Station on the JR and Metro Lines.

ABOVE LEFT Every conceivable color of
sock is stocked in the store.

ABOVE The outside of the store faces a
busy road teeming with workers, locals,
and tourists.

The very opposite of Japanese
minimalism, Don Quijote stores,
Japan's largest discount goods
stores, also known as Donki, re-
semble the hopelessly cluttered
interiors found in many common
Japanese homes. Marie Kondo,
author of the best seller, *The Life-
Changing Magic of Tidying Up*,
would likely be appalled by the
way every conceivable smidgen
of surface in the flagship store in
Shibuya is utilized, but in a sense,
this is rather admirable space
management. There is certainly
no waste here, though the visual
barrage of so much merchandise
covering walls, shelves, and even
ceilings can be overwhelming. It
can also be great fun exploring
the seven staggering floors of this
store, largely set aside for utility
goods, but also Japanese souve-
nirs, electronic gadgets, foods
and snacks, fancy dress party
and cosplay goods, and children's
toys. The mega Shibuya branch
of the discount store, the largest
in Japan, is a 24/7 operation, a
true shopping entertainment.
With its own ATMs, signage in
Japanese, English, Chinese, Thai,
and Korean, and a Tax Free coun-
ter, a massage and relaxation
store, and a helpful staff, this is
a store geared towards conveni-
ence. Fans of Kit Kat will be
ecstatic to find that there are over
200 flavors on offer at this store.

LEFT It may look like a bewildering jumble of goods, but the store is actually very well organized.

BELOW LEFT The store may have the world's largest selection of Kit Kat. The chocolate has always been popular in Japan.

BELOW Costumes, tricks, and party wear are well-represented in the store.

DAIKANYAMA & NAKAMEGURO CAFÉ CULTURE

Location Nakameguro: Meguro-ku. Daikanyama: Shibuya-ku. Access Daikanyama Station on the Tokyu Toyoko Line. Nakameguro Station on the Hibiya Metro.

The trendy districts of Daikanyama and Nakameguro are synonymous with a clientele of youngish but slightly older patrons of style than in nearby Shibuya. The maturity in fashion is especially evident along the Meguro River, a laid-back corridor of small businesses, boutiques, cafés, and restaurants that burst into color during the spring cherry blossom season, with hundreds of trees in bloom along its roadside banks. It can get phenomenally congested at this time, but usually the area is perfect for languid strolling and art appreciation at venues like the Container Gallery, a space situated, as the name suggests, inside a shipping container. Even smaller in scale but big on chic, the fashion core of Daikanyama is its Hillside Terrace complex, designed by

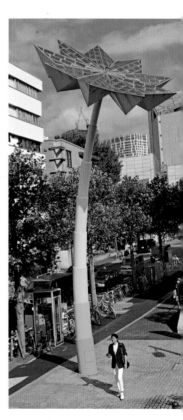

LEFT In space-pinched Tokyo, outside eating and drinking terraces and decks are precious.

RIGHT An artificial tree towers over a row of real ones outside the Hillside Gallery.

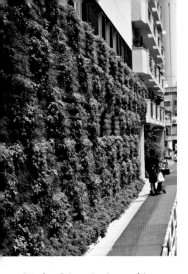

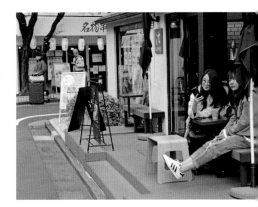

LEFT Plant-covered facades are a small but helpful effort in the greening of Tokyo.

RIGHT The back streets of Daikanyama provide a cool place to hang out.

BELOW Elegant rooms and observation corridors afford fine views of the Kyu-Asakura Garden.

Pritzker Prize winning architect Maki Fumihiko, a concentration of tony restaurants, cafés, boutiques, and spacious courtyards. Other reasons to be here are the engaging Hillside Gallery and the more recent Log Road complex, a shopping zone noted for its craft beer pubs. Belonging to a very different age but possibly more expressive of refinement and style, is the 1919 Kyu-Asakura-tei, a villa and Japanese garden. The immaculately preserved residence and landscaping, reflecting indigenous garden aesthetics and Western naturalism, is a study in tranquility.

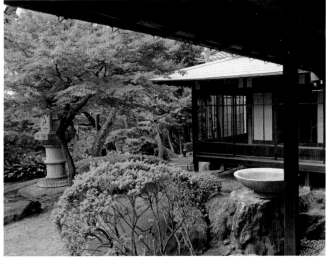

MAEDA FAMILY MANSIONS

Location 4-3-55 Komaba, Meguro-ku. **Access** Komaba Todai-mae Station
on the Inokashira Line. **Hours** Wakan 9.00 a.m.–4.00 p.m., closed Monday.
Yokan 9.00 a.m.–4.30 p.m., closed Monday and Tuesday. **Fee** Free admission.

For an insight into the wealth and privilege enjoyed by the newly affluent of the Meiji era, the Maeda houses near the University of Tokyo's Komaba campus are instructive. The Marquis Maeda Toshinari, a one-time military attaché to Great Britain, had the luxury of owning not just one home but two. The Yokan, or Western-style residence he had built in what is now Komaba Park, is a vaguely Tudor-style three-story home completed in 1929. Designed by architect Tsukamoto Yasushi to withstand earthquakes, it was constructed of reinforced concrete with brick

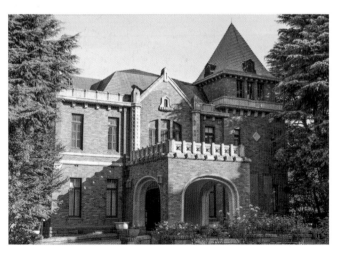

facing. Serving as the main residence for the Maeda family, the ample reception rooms, master suite, hallways, parlors, stained-glass windows, and marble pillars speak of a level of prosperity undreamt of by ordinary Japanese then or now. A Wakan, or Japanese-style annex, created for the purpose of entertaining foreign visitors, was added in 1930. Its sparse 50 *tatami* mat main room, devoid of ostentatious decoration or ornamentation, is enormous by Japanese standards. Beautifully carved sliding doors and windows, some embossed with the Maeda family crest, look out onto an uncluttered Japanese garden with a pond and small waterfall. During the post-war American Occupation period, the Maeda houses were requisitioned as the residence of General Matthew Bunker Ridgway.

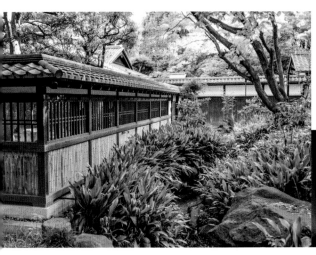

BELOW The old residence's beautiful lattice screens and polished floors.

BOTTOM The grand staircase and balustrades of the Western residence were made to impress.

TOP The Japanese-style entertainment and accommodation annexe (Wakan) is set in dense greenery.

ABOVE The Japanese annexe is enhanced with Japanese aesthetic touches like this stone path.

OPPOSITE ABOVE A moon window looks out on the rear garden.

OPPOSITE BELOW The Tudor-style Western residence (Yokan) has a sweeping drive leading to the porch in front of the entrance.

CANADIAN EMBASSY GARDEN

Location 3-38 Akasaka, Minato-ku. Access Aoyama-Ichome Station on the
Ginza Metro. Hours Monday–Friday 9.00 a.m.–4.30 p.m. Fee Free admission.

In this highly contemporary garden, completed in 1991, master landscape designer Shunmyo Masuno has infused rocks and boulders with an extraordinary sense of lightness and fluidity. Representing the relationship between Canada and Japan, the southeast portion of the terrace facing the tree line at the periphery of the Akasaka Palace grounds, symbolizes the Pacific Ocean. The large expanse of granite stones constituting the main garden, an outside terrace with the cantilevered roof of the embassy projecting across a section of the landscape, represents the Canadian Shield, with a row of polished pyramids standing for the Rocky Mountains. What appears to be a modern art sculpture or installation in this corner of the garden turns out to be an *inukshuk*, a traditional marker symbol used by the Inuit people. Due to the weight of

the larger boulders on this ledge, they were hollowed out to make them lighter. The roughly cut edges of the rocks are unusual, their wedge holes left intact. A second, smaller garden at the rear of the building represents Japan. Here we find flat, geometrically

aligned slabs, a checkerboard pattern of stepping stones interspersed with raked gravel, a familiar design in dry landscape temple gardens. Firmly bolted and bonded to the embassy structure, one wonders about the future of this landscape in a city notorious for the impermanence of its buildings. Is it possible to dismantle and relocate a garden?

ABOVE A side pool overlooking the greenery of the Akasaka Palace contrasts with the dry landscape theme.

LEFT Invisible from the street, the spatial ingenuity of the landscape suggests massive vistas.

ABOVE RIGHT A small Japanese rear garden featuring a checkerboard of stone and gravel with a fractured rock as the visual centerpiece.

RIGHT The trees of the adjacent Takahashi Memorial Gardens create a naturalistic perimeter for the Canadian Embassy garden.

HIE PROTECTIVE SHRINE

Location 2-10-15 Nagatacho, Chiyoda-ku. **Access** Akasaka-mitsuke or Tameike-sanno on the Ginza Metro.

Visitors enter Hie Jinja via a tunnel of vermilion *torii* gates, the isolating stillness of the approach creating a counter atmosphere for a shrine that sits above a busy thoroughfare. Dedicated to the god Oyamakui-no-kami, a protector against evil, the shrine's history stretches back to AD 830, though its present location dates from the 17th century when the site was chosen to protect Edo Castle from the southeastern flow of malign forces. That structure was destroyed in the devastating Long Sleeves Fire of 1657. Yet another complex was razed in World War II air raids. The current buildings, a branch of the grand Hie Shrine in Kyoto, were constructed in the 1960s. The first two structures visitors see are the Haiden (Prayer Hall) and Honden (Spirit Hall). A spacious courtyard facing the main shrine serves for a number of different religious and cultural activities. The practice for pregnant women to visit the shrine for protection is well-established. To the left of the shrine is a carving of a monkey holding a baby, a symbol of maternal fertility. Monkey images and figures can be seen throughout the complex, the creature acting as a messenger for the shrine god. Joining the representational menagerie is a miniature shrine dedicated to the Inari fox

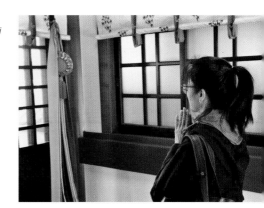

OPPOSITE FAR LEFT One of several impressive *torii* gates placed around the shrine grounds.

LEFT Visitors pass through the transitional space of a *torii* tunnel to reach the shrine.

RIGHT The Japanese often claim to not hold strong religious beliefs, but nevertheless often pray at shrines.

BELOW Votive tablets known as *ema* are for writing personal wishes or messages of goodwill.

BELOW RIGHT A monkey statue in which the creature is wearing Shinto attire.

deity. The shrine is the starting point for the important Sanno Matsuri festival, which is held in June each year.

MEIJI SHRINE & IRIS GARDEN

Location 1-1 Yoyogi Kamizono-cho, Shibuya-ku. **Access** JR Harajuku Station on the Yamanote Line, Meiji-Jingu mae on the Chiyoda Line Metro. **Hours** Sunrise to sunset. Garden 9.00 a.m.–4.30 p.m. Garden **Fee** ¥

ABOVE Shinto priests officiate during a dignified but solemn ritual.

BELOW A relatively new *torii* gate. While Shinto revers tradition, it also embraces the new.

When the Meiji Emperor died in 1912, a huge plot of land, 125 ha (309 acres) in all, was set aside to erect a shrine dedicated to deifying his spirit and that of his consort, Empress Shoken. Destroyed in the US air raids, the current shrine buildings were completed in 1958. Passing through the inner precincts, the sense of being in a forest in the city is enhanced by the presence of over a hundred thousand trees, many of them camphors and broadleaf evergreens. The broad path to the main cypress and copper buildings of the shrine, the quintessence of traditional Shinto architecture, passes the Imperial Treasure House, home to royal memorabilia. The shrine's busy cultural calendar includes rituals, horseback archery, court music, and traditional Shinto weddings. Over 1,500 irises bloom in the Inner Garden during the early days of June. On an elevation above the iris fields, a path leads under a canopy of trees to a natural spring, known as Kiyomasa's Well. A few years ago, a TV celebrity visited the site, anointing it a "power spot," drawing crowds of visitors. It has since recovered from the attention.

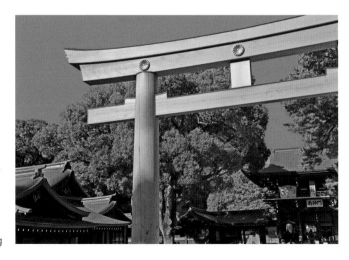

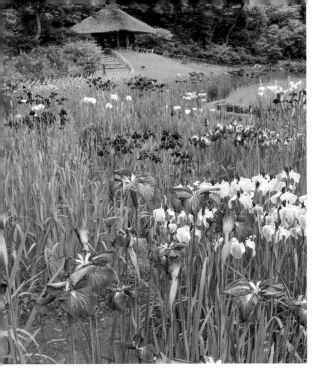

LEFT A sea of irises planted in an irrigated wetland area of the garden.

ABOVE Barrels of saké, a sacred beverage, presented by donors.

BELOW LEFT Rows of lanterns contributed to the shrine by individuals, companies, and even prefectural governments.

BELOW Posing in traditional wear at the entrance to the main compound.

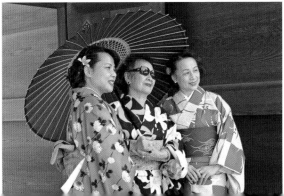

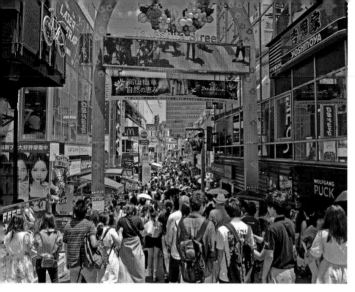

TAKESHITA-DORI FASHION STREET

Location Jingumae 1-chome, Shibuya-ku. Access Harajuku Station on the JR Yamanote Line, Meijijingu-mae Station on the Chiyoda and Fukutoshin Lines.

At the earliest heart of the youth district of Harajuku, Takeshita-dori was best known for its crepe shops, niche stores, Gothic Lolitas, dolly-*kei* teens, skin-seared *ganguro* girls, and a slew of ephemeral imaging fads and visual caricatures, like the *kogal* high school look, the baby-pink skirts, tutus, and ponytails of the *decora*, or the black glad-rags, chains, spikes, and dark makeup of *angora kei*, a fashion movement inspired by underground music. It was a heady time. Who remembers Gwen Stefani's pop-rap smash hit "Harajuku Girls"? Once the exclusive domain of the creative but economically pinched young, birthplace of brands like Hysteric Glamour, Undercover, and The Bathing Ape, a place to socialize and be seen, Takeshita-dori has grown into a commercial and tourism monster. Globalization may be the street's natural destiny, the shift from sub to main culture with special Harajuku characteristics, inspiring a revitalization that embraces everyone. Whether you are looking for hipster fashions, idol goods, uber-kitsch outfitting,

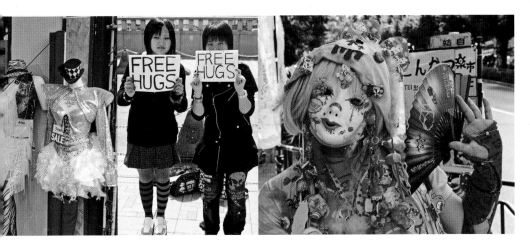

ABOVE SECOND FROM LEFT
Costumes suitable for fancy dress
events, parties, or eye-catching
street appearances.

clothes festooned with cuddly
toys, or other assorted eye candy,
creative eccentricities, and exper-
imentation, the idea of the street
as a testing ground for new con-
cepts in visual trending is alive
and well. A fashion zone that
has never aspired to elegance,
Takeshita-dori continues to excel
at what it does best—packing a
powerful sartorial blast.

**ABOVE SECOND FROM
RIGHT** Well-meaning
teens offer a simple
solution to social harmony
in the form of free hugs.

ABOVE RIGHT A young
man dressed in the
syncretic elements of
cute culture is making
his own statement. But
what is it?

LEFT Dressed as a flight
attendant, or retro
elevator operator or
a movie usher?

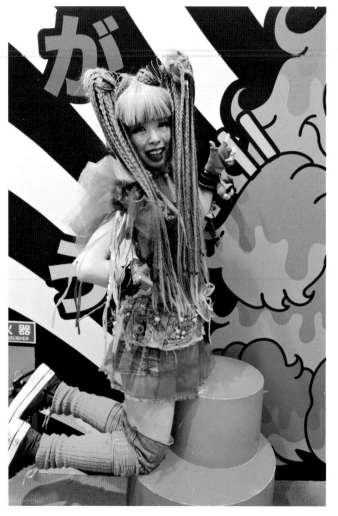

KAWAII MONSTER CAFÉ

Location 4-31-10 Jinqumae, 4F, M Square Building, Shibuya. Hours Daily 11.00 a.m.–8.30 p.m. Some seasonal change in opening times. Fee ¥500 entrance. 90-minute limit. Visitors must order at least one item on the menu.

The Japanese have a passion for themes. The Kawaii Monster Café embodies many of the aesthetics of J-Culture: bright colors, whimsical decor, faintly erotic infantilism, cosplay, the cult of the cute. Even for non-geeks, the café is about having fun, tumbling into Alice's rabbit hole without the Gothic nightmares. A highly original fusion of pop art and café dining, the concept for this *kawaii* (cute) setting came from the mind of art designer Sebastian

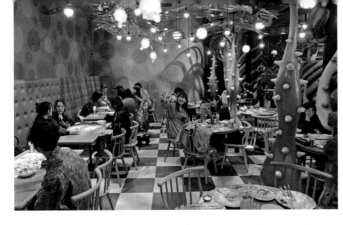

LEFT The café incorporates staggering color schemes, like this eating and drinking zone.

OPPOSITE FAR LEFT One of the café's "models" in a dazzling combination of colors and materials.

OPPOSITE BELOW The creamy character-themed desserts may look curious but actually taste pretty good.

Masuda, who in order to create this psycho-tropic cocktail, mixed and stirred a few drops of surrealism, Disneyland, and Japanese manga and anime. A Sweets-Go-Round at the entrance is a preview of some of the colorfully designed light meals and imaginatively shaped cakes, creams, peppermints, and parfait on the menu. "Models," young women resembling cartoon characters, are on hand to show visitors around, answer queries, and take orders. Visitors are free to wander at will, taking in the Bar Experiment, Mushroom Disco, Mel-Tea Room, and the modeled interior, an assemblage of giant fungi, poisonous mushrooms, Perspex jellyfish, oversized macaroons,

LEFT "Models" posing and performing on the café's Sweets-Go-Round carousel.

BELOW Relaxing among a colorful debris of food and drinks, two of the café's cool customers.

frosted wainscoting, and pastel chandeliers. Immersion in this alternative reality, a rainbow-tinted Nirvana or animated pop mandala, may be about entering a different dimension but it's one that strangely prepares you on exiting for the city's endearingly wacky excesses.

OMOTESANDO SHOPPING BOULEVARD

Location Minato-ku. **Access** Meiji Jingumae and Omotesando Stations on the Ginza Metro.

Omotesando and Aoyama are synonymous in many minds with the kind of fashion refinement found along the boulevards of Paris or Milan. Architecture, fashion, and art fuse along Omotesando-dori, the street host to Pritzker Prize winning SANAA's (Sejima Kazuyo and Nishizawa Ryue) Dior Building, Aoki Jun's Louise Vuitton Building, and the footwear store Tod's designed by Ito Toyo. Omotesando Hills, a sparkling complex of high-end boutiques and cafés designed by world-renowned architect Ando Tadao, stands on the former grounds of the demolished Dojunkai Aoyama Apartments. The ivy-covered housing block, built after the great 1923 earthquake, was converted into a venue for artists and designers, many of its rooms serving as galleries.

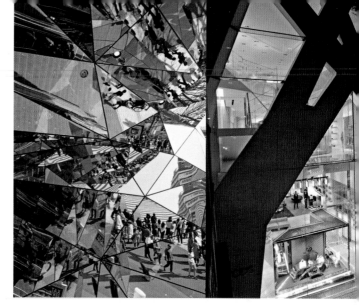

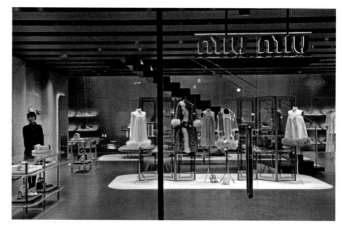

FAR LEFT Omotesando-dori reflected in the fragmented glass of a shopping center.

CENTER LEFT The night face of Tod's, a high-end shoe and bag store.

LEFT A helix-shaped fashion store adds interest to the street.

OPPOSITE BELOW A store window in the narrow, increasingly fashion urbane upper section of Omotesando-dori.

BELOW Windows resembling spaceship portals peer into the interior of Prada.

As a tribute to the old buildings and the nostalgia attached to them, Ando has recreated a segment of the old apartments at the end of his new, rather soulless shopping complex. The showrooms of many icons of Japanese haute couture line Omotesando Street as it transects Aoyama-dori, before it shrinks to a two-lane avenue. The three-sided Prada Aoyama Building, designed by Herzog & de Meuron, is here. Looking like an illuminated shard of glass bubble pack, it stands

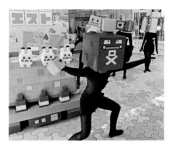

alongside other brand names like Comme de Garcons, Miyake Issey, Bapexclusive, and Tsumori Chisato. The street represents a dazzling portfolio of designer names.

LEFT Street promotion is less common in the area, but when undertaken is done with flair.

BELOW A small, preserved section of the much-missed Dojunkai Aoyama Apartments.

NEZU MUSEUM GARDEN

Location 6-5-1 Minamiaoyama, Minato-ku. Access
Omotesando Station on the Ginza Line Metro.
Hours 10.00 a.m.–5.00 p.m. Fee ¥¥¥

It is not possible in a single glance
to see the Nezu Museum garden
in its entirety. Instead, you must
reconstruct in your mind each
individual portion of the garden
that is revealed to you. Founded
in 1940 by the politician and busi-
nessman Nezu Kaichiro, the origi-
nal building, now replaced by
architect Kuma Kengo's luminous,
highly contemporary glass and
steel design, was erected to
exhibit Nezu's collection of tea
ceremony utensils, Chinese
bronze ware, and Buddhist relat-
ed art. Korin Ogata's famous
Kakitsubata screen, a timeless
portrayal of irises, is housed in
this fine art institute. The deeper
you enter the garden, the less
audible the sounds from this busy
corner of the Aoyama district. The
dense blanket of trees and paths
descend to an iris pond, creating
the illusion of a natural environ-

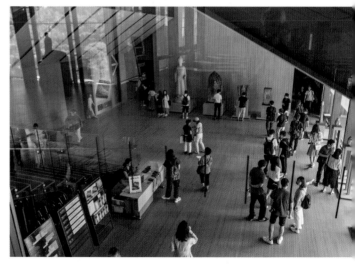

ABOVE A watery dell at the center of the garden's dense greenery.

LEFT Architect Kuma Kengo has created an airy first floor dedicated to allowing light to enter.

ABOVE This ancient, intricately carved stone panel forms part of the exhibit.

RIGHT A wicker window that allows just enough light into the tea house to retain its air of subdued mystery.

ABOVE Black pebbles and granite slabs fused to form an attractive garden path.

ment disassociated from the city. Adding to the sense of inhabiting a green and pleasant sanctuary is an air of profound antiquity emanating from the placement of beautifully chiseled and incised Buddhist stone work. If there is some conscious schemata in the positioning of these treasures throughout the garden, it remains concealed, set aside by our pleasure at randomly encountering a sandstone standing Buddha triad dating from China's 6th-century Northern Wei Dynasty, a seated bodhisattva, precisely dated 1466, or a Muromachi-era carved statue of Ksitigarbha Bodhisattva.

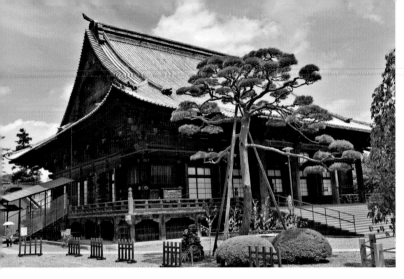

LEFT The main temple hall, the Kannon-do, remains one of the oldest wooden structures in the city.

ABOVE Ogival windows such as this suggest a firm Zen connection.

GOKOKU-JI TEMPLE

Location 5-40-1 Otsuka, Bunkyo-ku. Access Gokokuji Metro on the Yurakucho Line. Hours Main hall open 9.00 a.m.–4.00 p.m.

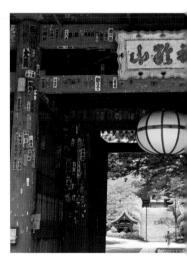

Founded in 1681 by the fifth shogun, Tsunayoshi, the wonder of Gokoku-ji is that it is so little visited. Hiding in plain sight, the absence of visitors is surprising given that the temple is among a handful of religious structures in the city to have survived the air raids of World War II. Its majestic outer Niomon Gate dates from the year the temple was founded. The Taisho-do, a hall constructed in 1701, has tremendous architectural authority, as does the temple's even older bell tower and a rare two-story wood and plaster pagoda. The imposing main hall of the temple, the Kannon-do, is notable for its four gigantic pillars, steeply inclined copper roof, and carved transoms, the work of master carpenters and other artisans gathered from all over the country. The inner recesses of the hall reward

exploration, with Buddhist figurines and paintings of celestial maidens dancing across the ceiling. The Yakushi-do to the left of the main hall, with its Zen-style ogival windows, is another fine piece of Genroku-era design. Dating from 1691, it contains a statue of Yakushi-nyorai, a deity known to relieve the sick. The left hand of the figure clutches a medicine flask. A lively flea market is held every second Saturday in the grounds of this extraordinary temple.

ABOVE Its monthly flea market is not one of the largest in the city but contains many interesting items.

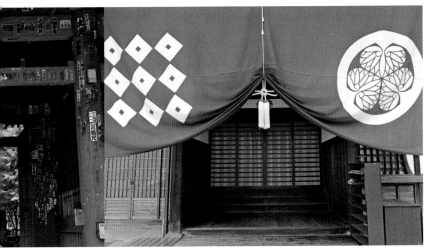

ABOVE Look carefully, and you will find several incised stones.

FAR LEFT The outer Niomon Gate, dating from the 17th century, reeks of antiquity.

LEFT A faded purple curtain. The color is strongly associated with the imperial family.

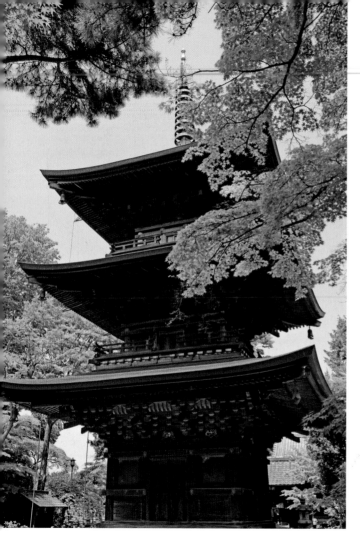

GOTOKU-JI "CAT" TEMPLE

Location 2-24-7 Gotokuji, Setagaya-ku.
Access Miyanosaka Station on the Okyu
Setagaya Line. **Hours** daily.

The verdant grounds of Gotoku-ji, with its magnificent three-story pagoda, is best known for hundreds of white porcelain cats known as *maneki-neko*. Placed in neat rows around a statue of Kannon, the goddess of mercy, the beckoning cats, their right paws held up in welcome, attract a steady trickle of visitors interested in folklore, superstition, and the identification of the felines with Japan's ever-expanding world of the cute. Believed to bring good fortune, the cat models are said to have originated at this temple. According to one account, a feudal lord, Naotaka, spied a cat while passing Gotoku-ji, at that time little more than a wretched wooden hut. The cat

LEFT The temple's three-story pagoda is the architectural centerpiece of the grounds.

appeared to be imploring him towards the temple. Intrigued, he entered and was met and given tea by its single occupant, a monk, who kindly offered a sermon. At the same time, a terrifying thunderstorm broke outside. In gratitude, Naotaka donated land and rice to the temple. The cats have become a symbol of the district. Visitors hope that by buying a *maneki-neko*, some of that good fortune and prosperity will rub off on them.

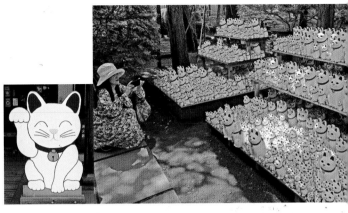

ABOVE LEFT A *maneki-neko* cut-out welcomes visitors to the temple's souvenir shop.

ABOVE Hundreds of *maneki-neko* models stand in the open in a wooded section of the temple compound.

LEFT The well-laid out grounds of the temple create a park-like space.

RIGHT The *maneki-neko* figure has been cleverly linked to divinity for the design of this votive tablet.

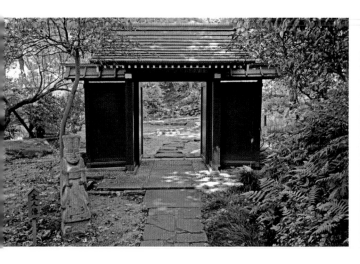

GOTOH ART MUSEUM & GARDEN

Location 3-9-25 Kaminoge, Setagaya-ku. **Access** Kaminoge Station on the Tokyu Oimachi Line. **Hours** 10.00 a.m.–5.00 p.m. **Fee** ¥¥

ABOVE LEFT An elegant gate helps to divide this section of the garden and break up the monotony of a single path.

This private museum was built in 1960 to house the Japanese and Oriental art collection of Gotoh Keita, a prosperous businessman. Taking pride of place among rare objects and fine art works, some designated as National Treasures or Important Cultural Properties, which include ancient mirrors, swords, ceramic ware, paintings, and tea ceremony paraphernalia, is a beautifully illustrated hand scroll depicting scenes from the classic 11th-century narrative, *The Tale of Genji*. Crossing a manicured lawn from the museum, paths descend through thickets of trees, the slopes here forming an intriguingly complex terraced Japanese garden. Skillfully landscaped, with tea houses incorporated into the scheme, this is an all-seasons garden, with azaleas, maples, and an ancient magnolia tree among the arboreal highlights. Stone lanterns, pagodas, weathered water basins, wooden gates, and a small pond form other elements of a landscape loosely categorized as a stroll garden.

LEFT Late April and early May are the best times to view azaleas.

BELOW The garden is endowed with dozens of Buddhist steles, statues, and carved tablets.

ABOVE A tea house is glimpsed above banks of azaleas.

Gotoh's interest in Buddhist sutras may explain the wealth of religious statuary visible in the museum's garden, many of the carved stones centuries old. The figures add a solemn dignity to a garden that, despite the occasional passing of Oimachi Line trains, is perfect for moments of snatched contemplation.

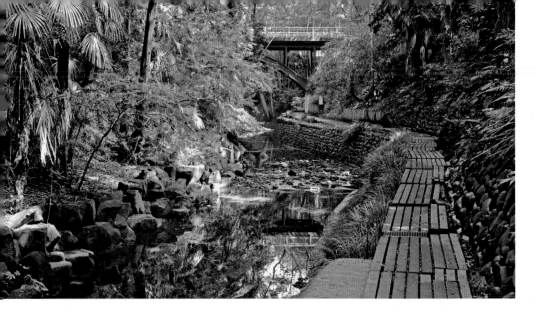

TODOROKI GORGE

Location 3-15-1 Todoroki, Setagaya-ku. Access Todoroki Station on the Tokyu Oimachi Line.

If elevated areas of the city alter mood, sunken zones create their own distinct atmosphere. Slicing through the last stages of the Musashino Uplands, the shallow Yazawa River adds to the fertile dampness of Todoroki Gorge, whose steep slopes are covered in dense thickets of oak, konara elm, zelkova, native alders, dogwood, wild fronds, and evergreen shrubs like fatsia and tsuwabuki. Only a 20-minute train ride from central Tokyo, it is a world away from the city's streets. According to legend, the 12th-century Buddhist priest Kogyo Daishi discovered the gorge after encountering it in a dream. Beside a flight of stone steps leading to Todoroki Fudo Temple and its wooded grounds stands a small waterfall, used by pilgrims for purification rituals. Water pours from the mouths of two dragon heads cast in iron. Adding to the antiquity of the valley are weathered shrines, Buddhist statuary, and tombs set into the side of the ravine. One

ABOVE The only forested gorge remaining in Tokyo, visitors stroll along well laid out boards.

RIGHT An iron dragon head spouting water, one of a pair, protrudes from the gorge's rock face.

ABOVE A dense concentration of trees and foliage create the impression of being in a rural setting.

LEFT The small Todoroki Fudo Temple located on the edge of the gorge.

LEFT A carved Buddhist figure adds interest to a section of the walk. There are plenty of other details along this walk.

of these is the resting place of a 7th-century tribal leader. Cultural adjuncts have been added in the form of a quasi-Japanese garden and a small tea house named Setsugekka, where you can sample green tea and *kuzumochi*, a traditional dessert. Shaved ice is served in the summer, sweet red bean soup in the winter.

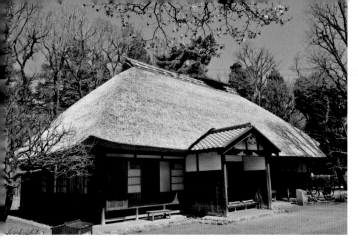

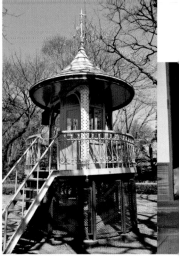

EDO-TOKYO ARCHITECTURAL MUSEUM

Location Koganei, Sakura-cho, 3-7-1. **Access** The park and museum are a 20-minute walk from Musashi-Koganei Station on the JR Chuo Line. There are buses to the park. **Hours** 9.30 a.m.–5.30 p.m., closed Monday. **Fee** ¥

Containing some 30 reassembled Tokyo buildings dating from the end of the Edo (1603–1868) to the Meiji era (1868–1912), this open-air museum takes some fruitful liberties with time lines by including one or two structures from the 1930s and 1940s. The great Meiji-era building boom turned the old city of Edo into something akin to an Expo site, but the museum is more organized, its structures set in green,

bucolic quadrangles. The eclectic assemblage includes private residences, merchant shops, an Art Deco photo studio, a farmhouse, tea room, an elevated granary, and even a stone and brick Meiji-era police box. Entrance to private homes is allowed, quite literally by opening a door on the interior life of these buildings. Some of these homes have a composite feel. The residence of Hachirouemon Mitsui has a

dining room built in 1897, an older storehouse, and a main building constructed in 1952. Fans of animator Miyazaki Hayao will be enchanted by the large and imposing Aburaya bathhouse, the inspiration for a similar structure in one of the artist's best-known films, *Spirited Away*. Being "spirited away" is an apt description for the effect this museum has on visitors, transporting them to a very different time and place.

FAR LEFT This farmhouse has been reconstructed from its original site on the outskirts of the city.

LEFT The curious tripodal structure of a 1925 fire watching tower, originally belonging to the Ueno Fire Department.

CENTER LEFT One of several craft workshops for children at the museum.

LEFT Demonstrations by craftspeople such as this man working with colored strings of cotton, can be seen at the museum.

BELOW LEFT The brightly painted roof of a shrine adds a sacred touch to the museum's mostly vernacular architecture.

BELOW The structure on the right is the entrance to the Aburaya bathhouse.

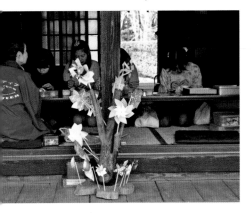

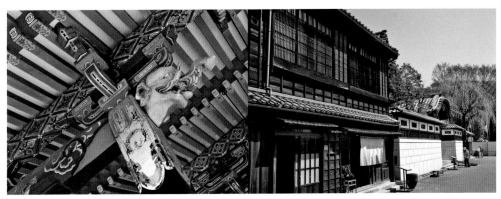

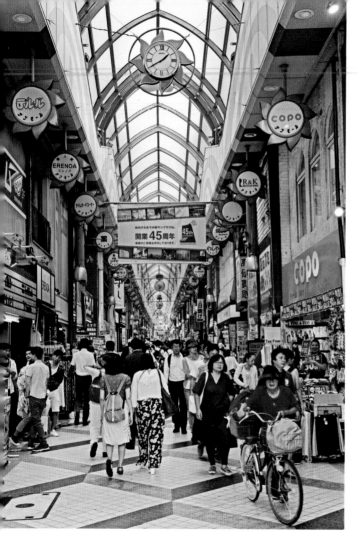

NAKANO BROADWAY SHOPPING ARCADE

Location 5-52-15 Nakano, Nakano-ku.
Access Nakano Station on the JR Chuo-Sobu Line, Tozai Metro.

The Nakano Station area seems to be busy every day of the week, crowds swarming here for discount shopping and, in the evening, its warren of back street eateries catering to all tastes and pockets. The main draw, though, is Nakano Broadway. The first floor is fairly tame, with a familiar offering of clothes stores, fast food venues, fruit and vegetable shops, cafés, watch dealers, pharmacies, small fashion boutiques, and souvenir trinkets. Its B1 basement is the place to find supermarkets and delicatessens. A popular stop here is the Daily Chiko Tokudai Soft Cream shop, with its signature giant, ten flavors in one cone. The upper floors of the mall get more interesting from the youth culture point of view, with countless stores devoted to manga, anime, and idol-related goods, such as key rings,

models, stickers, character figurines, rare toys, idol playing cards, DVDs, and game consoles. The massive geek emporium includes several small Mandarake stores specializing in manga and anime titles, many of them collectibles. What you can't find in Akihabara may turn up here. Entering the game arcades at the end of the first-floor mall is to encounter pleasure seekers, escapists plunging themselves into the oblivion offered by the machines, and hardcore punters, many of the latter women. Look closely and you will see they are wearing light rubber gloves to protect their skin against excessive staining from coins.

ABOVE LEFT Fans outside Mandarake, a general and specialist manga and anime operator.

ABOVE CENTER Advertising the strange and unsettling world of horror manga.

ABOVE RIGHT Narrow alfresco dining spaces add charm to the area's back alleys.

CENTER RIGHT Fresh slices of tuna being brazed and seared before serving.

RIGHT A colorful banner placed along an internal wall of a restaurant.

OPPOSITE The no-frills Nakano Broadway arcade forms the shopping centerpiece of the area.

KOENJI HIPSTER DISTRICT

Location Koenji-minami 4-chome, Suginami-ku. **Access** Chuo and Sobu
Line trains, and Tozai Metro to Koenji Station.

There are no sights of great note in Koenji. The main appeal of this laid-back neighborhood rests on the fact that the area still retains some of the city's pre-development mentality, expressed in a love of the small scale. Koenji grew as a modest residential area after the 1923 Great Kanto Earthquake, which saw laborers and small merchants displaced from their homes in downtown Tokyo, moving west. Often described as Tokyo's "retro hub," the nexus of narrow back roads close to the station are the places to find used stores, vintage clothing outlets, tiny hole-in-the-wall restaurants and bars, doughnut shops, tea and coffee houses, old-style malls, tattoo studios, galleries, niche vendors, and venues for young fashion designers. Koenji also has an expanding creative side. It hosts a lively traditional Awadori dance and music festival in the last week of August. Many of the district's walls and shop shutters act as canvases and murals for the work of the Mural City Project run by BnA, a creative group which also has a hotel. The walls of rooms in its tiny BnA Art

LEFT Although the district attracts a largely youth following, there is something for everyone here.

ABOVE Creative use of steel shutters. These are often requisitioned by painters and designers.

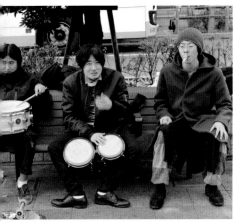

ABOVE A stone water laver in a local temple is a reminder of the past.

FAR LEFT A Roy Lictenstein-style wall mural near the station.

CENTER LEFT There are many trendy bric-a-brac stores like this in the area.

LEFT Street buskers are a rare sight in a country with city ordinances for almost everything.

Hotel are covered with original themes painted by professional artists. Aside from art, shopping, and rummaging for bargains, Koenji, a district that manages to be both retro and hip, has a lively, progressive music scene, the area remembered for hosting some of the city's best punk bands in the late 1970s. Adding to its liberal, counter-culture credentials, the district was the platform for the first anti-nuclear demonstrations following the meltdown in Fuku-shima in March 2011.

SHIMOKITAZAWA ART VILLAGE

Location Setagaya-ku. **Access** Shimokitazawa Station on the Keio-Inokashira Line or Odakyu Line.

In a city that excels at surprise oddities, glorious nuggets of kitsch appear in the form of wall murals, painted store shutters, and remodeled façades that animate the narrow lanes of this artsy district of Shimokitazawa, or Shimokita as locals prefer it. Its assorted outlet stores, market stalls, thrift shops, used record businesses, craft centers, galleries, offbeat bookstores, and coffee houses, suggest a kind of Ivy League junk shop. The seeds of Shimokita's bohemian image were germinated in the 1960s when small fringe theaters (*shogekijo*) opened there. Some of these, like the rather famous Honda Gekijo, have survived. Shimokita also has one of the densest concentrations of small to tiny live houses in the city, venues providing a blistering mix of cool that takes in roots, hip-hop, ambient, ska, drum'n'bass, jazz, cyber, rap, and Japanese indie punk. With both small Japanese restaurants and ethnic establishments, the district is a

ABOVE LEFT The area is full of shutter and wall art and small photogenic corners.

ABOVE Perhaps in the absence of real trees, the owner of this house has created his own.

fine place to eat. After the food come the bars. In contrast to the city's rowdy, often lugubrious salarymen denizens, the mood at these drinking dens is generally upbeat. Perhaps it is the difference between the responsibilities of debt-sodden middle age and the weightlessness of youth. This grungy art village, a haphazard mixture of early Showa and pop art, though unquestionably one of the city's fashion towns, remains light years away from the likes of Aoyama or Shibuya.

LEFT Retro objects and movie themes used to lure customers into a store.

BELOW LEFT A barman mixes a mojito in one of the area's more colorful drinking holes.

BELOW The district is one of the best places in town to find authentic, home ground coffee shops.

OPPOSITE BELOW Walls are often co-opted as canvases for images, such as this well-known anime character.

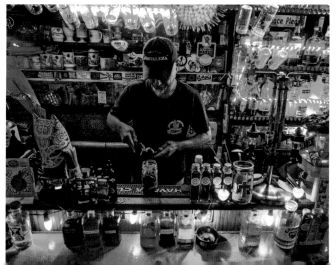

JINDAI BOTANICAL GARDEN

Location 5-31-10, Jindai Motomachi, Chofu 182-0017. **Access** Buses from Mitaka Station on the Tozai Line and Chofu Station on the Keio Line. **Hours** 9.30 a.m.–4.00 p.m., closed Monday. **Fee** ¥

Parts of Chofu still have a distinctly semi-rural character. At the Jindai Botanical Garden, you may be hardly aware that this is even a part of the city. An all-seasons garden, its botanical nature is reflected in a series of blossoming flowers, which include winter peonies, camellia, plum, clumps of spring cherry, azalea, wisteria, summer lotuses, and roses. Collectively, they represent an astonishing digest of cultivated nature, a flower calendar of the capital. A narrow back lane from the garden provides a reminder of the presence of water in Chofu. A number of water

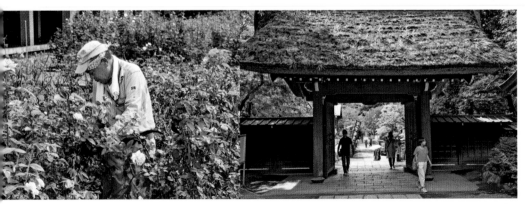

ABOVE A gardener tends to a large patch of fragrant roses.

ABOVE The thatched gate leading to Jindai-ji, a temple known to almost every Tokyoite.

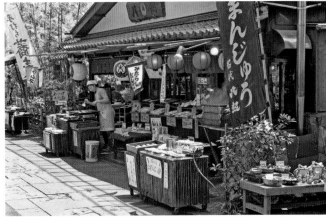

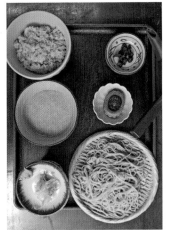

wheels, furred with moss, stand in purling brooks, running beside stone-flagged lanes, a reminder of the days when tea houses served homemade soba clustered around the streams, the locally grown buckwheat ground in mills powered by water. Hand-rolled and chopped soba noodles, known as *te-uchi*, are still the area's largest attraction. Soba is strongly associated with Jindai-ji, the area's foremost temple. Established in 733, it is one of the city's oldest religious establishments. A lively shopping lane leads to the thatched entrance gate to the serene grounds of this Tendai sect temple, its attractive watered grounds pressed against a wooded hillside.

ABOVE LEFT Good levels of rainfall and sunlight and a temperate climate make Tokyo an ideal location for horticulture.

ABOVE The lane leading to Jindai-ji has many interesting craft and souvenir shops.

LEFT Restaurants provide a simple but tasty meal of homemade soba dishes.

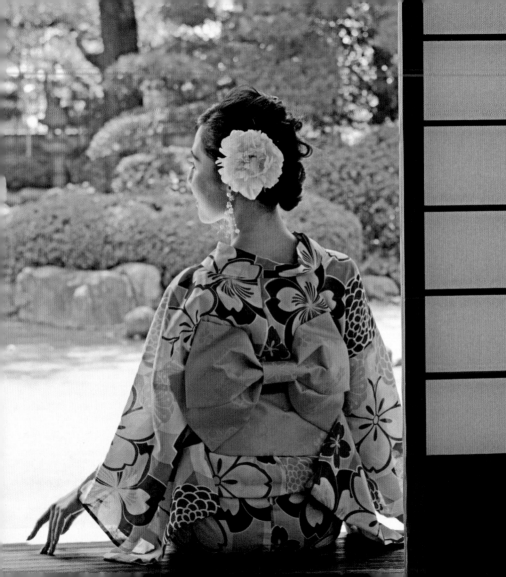

Excursions around Tokyo

Proximity to Tokyo has spurred the growth of many of the sites contained in this section of the book, but others have developed quite independently. Indeed, some of these locations, like the city of Kamakura, existed centuries before Tokyo was even dreamt of. There are countless surprises in store for visitors who venture outside of Tokyo. How many people know, for example, that Yokohama is Japan's second largest city, that Narita-san, a temple near the international airport of the same name, is one of the most visited religious sites in the country, that it is possible to white-water raft over the rapids of the Arakawa River in Nagatoro, that tours of the planet's largest flood water diversion site, a vast subterranean chamber, can be accessed in less than an hour from central Tokyo, that hot spring resorts are an easy train ride away from the capital, or that intriguing historical legacies exist in locations such as Kawagoe, Ashikaga, and Nokogiriyama, a mountain in Chiba Prefecture that is a storehouse for a wealth of Buddhist statuary? Forays into these peripheral sites are the first penetrations into the country itself, its astonishing cultural and historical diversity.

LEFT A young woman in *yukata*, a summer kimono, contemplates the garden of Kawagoe's Honmaru Goten, a historical structure.

RIGHT A painter in a pavilion of Narita Koen, a park-like garden.

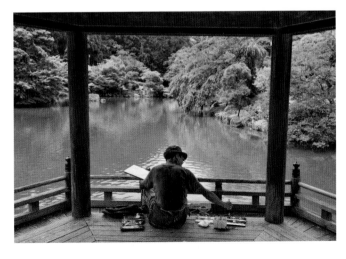

RIGHT Giant *Victoria amazonica* lily pads in one of Atagawa's botanical gardens.

LEFT A sweet potato vendor in Kashiya Yokocho, an old confectionery lane in Kawagoe.

TOP RIGHT The grounds of Washi-no-Sato, a paper making center.

ABOVE A kayaking group on the Arakawa River at Nagatoro.

LEFT A quarried slice of cliff at Nokogiriyama.

RIGHT Interestingly textured samples of *washi* paper in Ogawamachi.

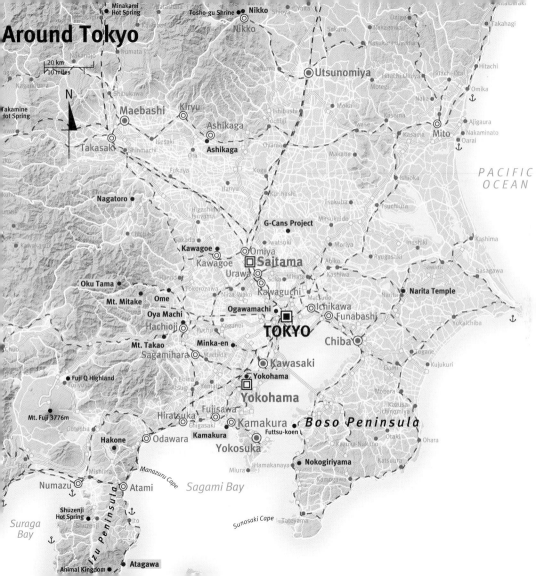

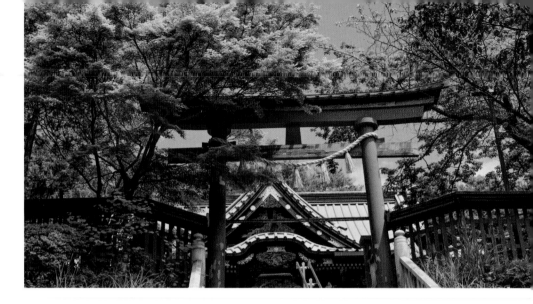

OUTING TO MOUNT TAKAO

Location Hachioji, Tokyo Prefecture. **Getting There** Keio Railways from Keio Shinjuku Station to Takaosanguchi Station or the JR Chuo Line from Shinjuku to Takao Station.

There is nothing perilous, or particularly daunting, about climbing Mount Takao, located on the outskirts of Tokyo. You won't find it included in Fukuda Kyuya's classic *One Hundred Mountains in Japan*, for example, a book in which the author defines peaks as forms with summits at a minimum of 1,500 m (4,900 ft). Mount Takao is a 599-m (1,965-ft) climb.

Using the popular Trail Number 1, it takes roughly 90 minutes to reach the summit. This can be reduced by using the cable car that goes halfway up the mountain. A center for mountain worship for over a millennia, statues of Shinto Buddhist deities pepper Takao-san. Yakuo-en is the mountain's premier temple. Associated with the Shingon Buddhist sect,

an impressive figure of Tengu stands in the grounds. A supernatural deity with a fierce, beaked mien, Tengu is believed to reside on the mountain. Takao-san is also associated with Shugendo, a form of mountain asceticism requiring extreme discipline. The peak is something of a nature reserve, with over 1,200 species of plants, flowers, and trees, and

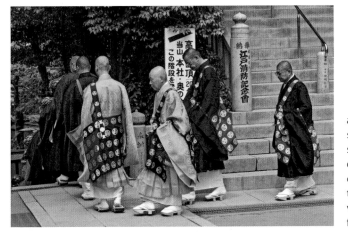

FAR LEFT A pilgrim with sedge hat and staff climbing one of the quieter routes.

LEFT Worshippers find countless sites for making offerings.

ABOVE A striking gold statue standing near the beginning of the trails.

LEFT The mountain hosts a lively and varied calendar of religious events, rituals, and ceremonies conducted by its priests and monks.

a healthy animal and insect eco-system that includes wild boar, snakes, and monkeys. On clear days, especially in autumn, when crowds descend onto its slopes to view the changing foliage, fine views of Mount Fuji are visible from the peak.

OME BILLBOARD STREET

Location Sumie-cho, Ome City, Tokyo. **Getting
There** On the JR Ome Line from Shinjuku Station.

In Ome, about a 90-minute train
ride from central Tokyo, the
names of screen idols from the
golden age of film in Japan are
hung on some one hundred
large-scale billboards (*kanban*)
covering walls and shop fronts
along Kyuome Kaido, the main
street. Many of the billboards
spring from the playful imagina-
tion of Bankan Kubo, a purist,

RIGHT A craft and
souvenir store
bedecked with retro
billboards.

CENTER RIGHT A
curious Miro-like
clock sculpture along
Kyuome Kaido.

LEFT A man decked out in retro
clothes poses before a poster in
the train station subway pass.

BELOW A poster evoking the
nostalgia of steam train travel
and strong family bonds.

BELOW Celebrated actor Okochi Denjiro in the role of Tange Sazen, a well-known historical figure.

BOTTOM A poster for a movie from the highly active Toei film company.

who insisted that traditional materials were superior to those used in today's mass-produced, computer-designed billboards. Research into the period can be conducted at the Showa retro Shohin Bijutsukan, a bijoux museum with small signboards set high up on the walls of the old building displaying an image of the actress Setsuko Hara. The Showa Gento-kan, doubling as a convenience store, is a museum of posters, postcards, and dimly lit dioramas of the old town. The signboards terminate in an eruption of color and drama above a corner noodle shop, where four of five paintings depict scenes from samurai action films (*chanbara*). Western movies of the time have not been neglected. The Japanese audience's unstinting loyalty to Audrey Hepburn is embodied in a board advertising *Roman Holiday*. Unlike some of the other signboards that have been allowed to weather and discolor, this one is as well maintained as a shrine.

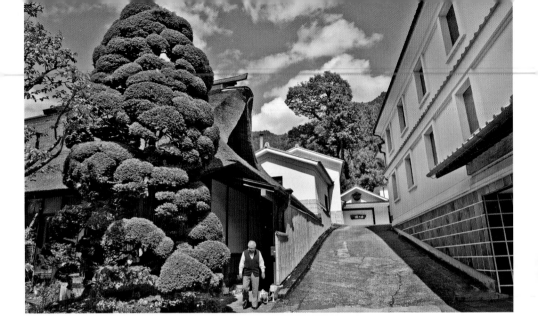

OKU-TAMA & MOUNT MITAKE

Location Oku-Tama-machi, Tokyo. **Getting There** Chuo Line trains from Shinjuku Station to Tachikawa, then transfer to the JR Oume Line for the one-hour ride to Sawai Station. Eight minutes by shuttle bus from the next stop, Mitake Station, to the cable car at Takimoto.

Nowhere better exemplifies the sensation of escaping from the megalopolis, but remaining officially part of it, than the Oku-Tama region of western Tokyo. Easily explored on foot, its many options include hiking, kayaking, rock climbing, and paddling in its gloriously clear emerald green pools. Located beside a graceful suspension bridge, the Gyokudo Museum exhibits the work of Gyokudo Kawai (1873–1957), a modern exponent of traditional Japanese painting. The museum's dry landscape garden, designed by Nakajima Ken, sits well in the surroundings, its bold stonework taken from the very river that flows beneath it. A little south of here a red *torii* gate announces a steep row of stone steps to Atago Shrine and its fine views of the valley. Several eateries with

good views huddle around the entrance to the river path. Mama-goto-ya, an elegant Kyoto-style establishment, specializes in tofu sets and exquisite river views. Twinkle, a more affordable option with tasty lunch sets, is canti-levered over the river. The Ozawa Saké Brewery has been operated by the same family for over 300 years. Tours of the building, its original roof rafters, plaster store rooms, and great stainless steel vats, conclude with the fun part: the saké tasting.

The adjoining region of Mitake is best known for the hiking trails and forest-smothered slopes of Mount Mitake. Most visitors opt to take the cable car from Taki-moto to Mitake Village, located at 831 m (2,700 ft), from where they

LEFT The river is perfect for practicing calm as well as white-water rafting.

OPPOSITE ABOVE The well-preserved complex of the Ozawa Saké Brewery is a must visit for saké fans.

ABOVE A hiker crosses one of the river's suspension bridges.

TOP The Mitake Tozan Railway is a cable car ascending to the mid-point of the mountain.

can follow a number of different tracks to Mitake-jinja, an ancient shrine sitting on the peak of the mountain. Follow trails from the shrine to the peak of Odake-san, a mountain sitting at 1,267 m (5,200 ft). On clear days, you should be able to glimpse Mount Fuji. It's a 90-minute hike, passing through the Rock Garden, a natural, borderless setting of moss-covered rocks, purling streams, and a great canopy of trees. It's an easy bus ride from the base of the mountain to Higashi-Nippara and the entrance of Nippara Cave, the largest in the Kanto region. A limestone grotto, where stalactites add dramatic contouring to the walls, its tunnels are not for claustrophobes. For an overnight stay along the river, there are a number of small affordable inns and guest houses. One of the finest was Kajika-en, which has now suspended business. Standing opposite the Gyokudo Museum, it is to be hoped that this magnificent wooden complex, with its superb views of the river, will reopen in the future in some capacity.

LEFT Kayakers in protective hard helmets battle a challenging white-water stretch of the river.

BELOW A stretch of the river with the Gyokudo Museum in the background.

FAR LEFT Walking these tranquil trails, you have to pinch yourself, recalling that this area is a part of Tokyo.

LEFT Twinkle, a modest restaurant serving sweetfish, has a superb river view.

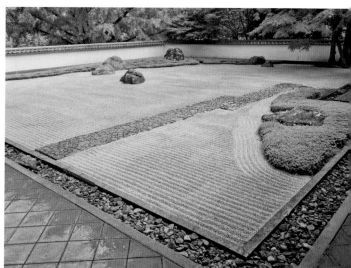

ABOVE A tofu set served at a modest eatery along the river.

RIGHT Moss grows well in the moist climate of the river valley in Nakajima Ken's dry landscape garden.

RAFTING THE ARAKAWA RIVER AT NAGATORO

Location Nagatoro, Nagatoro-machi, Chichibu-gun, Saitama-ken. Getting There JR Takasaki and Joetsu Shinkansen trains from Ueno and Tokyo Stations to Kumagaya. Change to the Chichibu Railway for the 50-minute ride to Nagatoro Station.

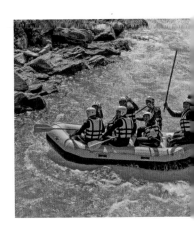

Nagatoro, a small country town in the Chichibu region of Saitama Prefecture, is known for its wealth of temples and shrines as well as its history of sericulture. Such sights, though, are a preamble to Nagatoro's main draw card, a natural formation shaping the upper ledges of a ravine bordering the Arakawa River. The flat rocks of the Iwadatami, as the name suggests, resemble the surfaces of geometrically laid out *tatami* reed mats. The cliffs, flat

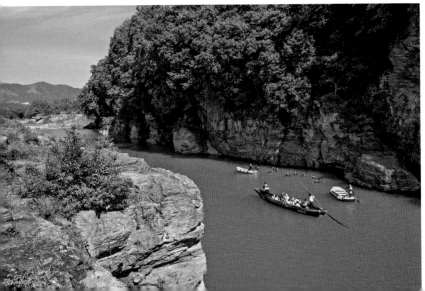

ABOVE Exhilarated, a group of kayakers rejoice at completing a white-water run.

LEFT Because of the twisting geology of the gorge, there are also tranquil stretches of the river.

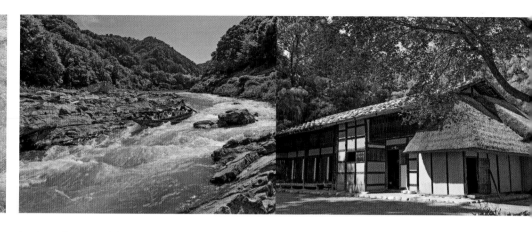

but irregular, extend for well over a kilometer above the river. Drawing its tones and coloration from the mineral content of the rocks, the fast river currents and swirling knots of water have turned parts of the river into a flailing blue dragon, its series of differing velocities modified by the serene, deep green of embankment pools. The name Nagatoro, in fact, means "long pool." A raised rock plate above a picturesque bend in the river, affording a broad view of wooded banks and the Chichibu Hills as backdrop, is a popular place to linger and

mingle. It is also a mooring spot for rental kayaks and the long-boats that take passengers along

the river and over its white-water rapids. Taking one of these craft is quite an adrenaline rush.

ABOVE LEFT A longboat thrills passengers as it tears between plates of rock.

ABOVE RIGHT A well-preserved thatched roof structure now serving as a silk museum.

RIGHT Two visitors attempt to lob stones onto the top beam of this *torii* gate. This confers good luck.

G-CANS FLOOD WATER PROJECT

Location 720 Kamikanasaki, Kasukabe City, Saitama 344-0111.
Getting There Minami-Sakurai Station on the Tobu Noda Line.
Haru bus from the South Exit. Alight at Ryukyukn stop. Tel:
048-746-0748. Reservations required. **Hours** 9.30 a.m.–4.00
p.m. Monday–Friday. **Fee** ¥¥

The G-Cans Project, also known
as the Metropolitan Area Outer
Underground Discharge Channel,
will be unlike anything you have
ever seen. Used for the under-
ground sewerage scenes in the
final installment of *The Hunger
Games: Mockingjay*, a dystopian
sci-fi movie, its cavernous main
vault is a vast subterranean
chamber reached by a series of
slippery staircases, taking you
into temperatures similar to a
wine cellar. The "Cathedral," as it
is nicknamed, consists of 59 sup-
port pillars soaring to a height of
25.4 m (83 ft) turning the storage
tank into a giant chamber, the
world's largest flood water diver-
sion project, designed to protect
the surrounding area and Tokyo
from the effects of excessive rain
and typhoons. Five silos, with
the help of massive turbines and

RIGHT A view down into
the heart of the complex,
a phenomenal feat of flood
prevention engineering.

BELOW Above ground, more
mysterious equipment and
installations appear.

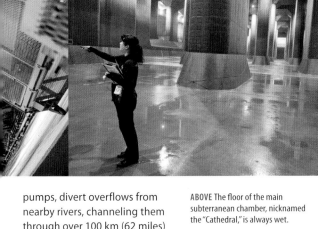

pumps, divert overflows from nearby rivers, channeling them through over 100 km (62 miles) of underground tunnels into the Edogawa River, which runs through the capital. The water is then disgorged into Tokyo Bay. The system can pump over 200 tons of water per second. Thirteen years in the making at a staggering cost of $2 billion, this extraordinary feat of engineering is located in Saitama Prefecture on the outskirts of Tokyo. Tours are conducted in Japanese, but the strong visual content, exhibits, videos, and the tour itself are largely self-explanatory.

ABOVE The floor of the main subterranean chamber, nicknamed the "Cathedral," is always wet.

ABOVE Pumps, dynamos, and hydraulic equipment are a common overground sight.

BELOW Visitors make their way back to their cars or the bus stop after the completion of their tour.

OGAWAMACHI PAPER MAKING TOWN

Location Ogawamachi, Saitama Prefecture. Getting There Tobu Tojo Line trains from
Tokyo's Ikebukuro Station to Ogawamachi Station. Workshop: oqawa-washi@mbn.nifty.com

The hills of Chichibu are well-known to hikers and pilgrims for trails that wind over verdant humps, descend into hushed gullies, and bifurcate into little-trodden byways. The lushness of these inner trails, the complexity of their threads, is mirrored in the deep, fibrous nature of the region's best-known local craft: hand-made *washi* paper. Paper making in Japan has a distinguished history. Records going back 1,300 years detail the production of traditional paper making in Oga-wamachi, originally as a material

BELOW LEFT An old thatched roof structure in the pleasantly laid out grounds of Washi-no-Sato.

BELOW Using a *suki-keta*, a braided bamboo frame, to evenly spread the mash of boiled mulberry bark.

RIGHT Held against the light, *washi* paper is pleasingly diaphanous.

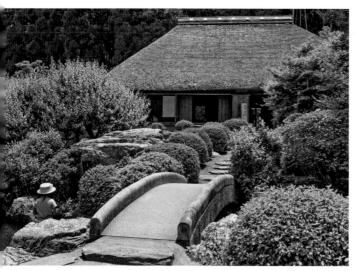

for the copying of Buddhist sutras and texts. Hand-made Japanese *washi* was designated a UNESCO Human Intangible Cultural Heritage in 2014. It's a flattering tribute to contemporary craftsmen, who, cognizant of global standards, take much-deserved pride in knowing that their best products rank as the finest hand-made paper in the world. The workshop and exhibition chambers at Washi-no-Sato, a 20-minute bus ride from Ogawamachi Station, provide a good introduction to the craft, but for a more authentic experience of paper making, the workshops of Kubo Takamasa are recommended for their insistently traditional methods. The rustic wooden workshops are located in a simple setting in the middle of a field. Kubo-san is happy to explain the paper making process to visitors, a method that transforms cellulose tree or plant fiber into a material that retains many of its original organic features and texture. Visitors can take part in workshops at the center, which includes a shop where paper souvenirs like purses, hats, paper screens, lanterns, fans and many other items can be bought. Quality, insect and tear-resistant *washi*, combining beauty and utility, will last for centuries.

ABOVE *Washi* paper can seem both traditional in appearance and very contemporary.

BELOW Stirring a boiled mash of mulberry bark and stems by hand is tough work.

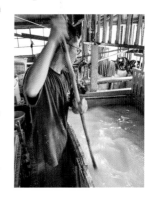

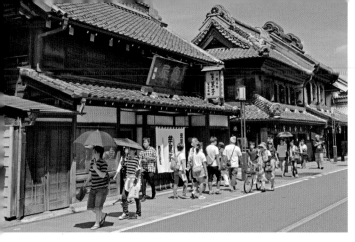
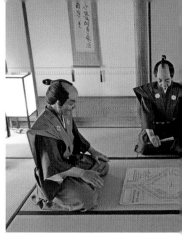

KAWAGOE "LITTLE EDO"

Location Kawagoe City, Saitama Prefecture. **Getting There** Hon-Kawagoe Station on the Seibu Shinjuku Line from Shinjuku Station or the Tobu Line train from Ikebukuro, terminating in Kawagoe Station.

BELOW RIGHT Custom has it that, if you count the number of statues equivalent to your age, you will arrive at the rakan that most resembles your own character.

Fondly known as "Little Edo," a reference to the old name of Tokyo, Kawagoe's primary attractions is Ichibangai, a main street known for its concentration of *kurazukuri*, old, fireproof storehouses. Once used to store goods like rice, saké, furniture, and clothing, they are made of clay and wood. The plaster of their outer walls was mixed with charcoal to create a black, buffed surface. Older women living in Kawagoe recall adjusting their hair and kimonos while gazing at the shiny, mirror-like surfaces. Both sides of the busy street are jammed with the storehouses, many serving as cafés, small museums, and souvenir shops. The symbol of Kawagoe, though, is a wooden bell tower called Toki-no-kane, which is rung three times a day. Sweet potatoes are big here. Old-style confectionery made from potatoes is sold along Kashiya Yokocho, or "Confectionery Street." Other sights of note are Kita-in Temple, which boasts a palace-style structure donated by the third shogun, Iemitsu, and the nearby Gohyaku-Rakan Statues, featuring enlightened disciples of the Buddha. The faces and poses of the figures, carved by priests, take in the entire human drama. One character looks decidedly drunk, another scratches his head, others meditate or sleep. One elderly sage is represented clasping a cup and teapot. Like humans, no two figures are quite alike.

FAR LEFT The old historical main street of Kawagoe, with its trademark black storehouses.

LEFT A display of Edo-era samurai administrators in the old palace buildings of Honmaru Goten.

RIGHT A young women in *yukata*, a light summer kimono, at the Honmaru Goten.

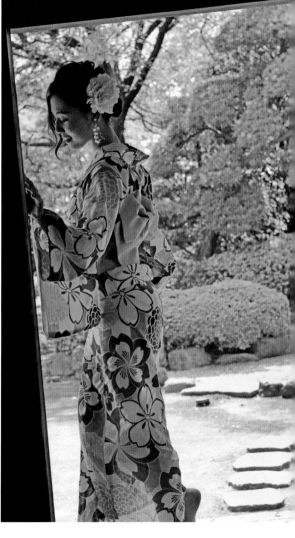

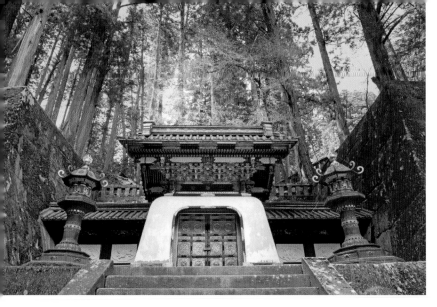

LEFT The forest at Nikko is full of shrines, tombs, and ornately decorated reliquaries.

ROYAL MAUSOLEUMS AT NIKKO

Location Nikko-shi, Tochigi Prefecture. **Getting There** Tobu-Niko Line train from Tobu-Asakusa. Shinkansen train from Tokyo and Ueno Stations.

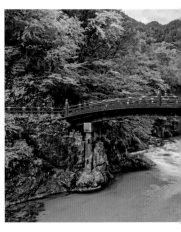

At Nikko, a Unesco World Heritage Site, we see that rarest of things in Japan: a tourist spot of international repute where development has been held at bay, the environment preserved as respectfully as the tombs that lay beneath the towering cryptomeria trees that stand sentinel over the grand approaches to the heritage structures here. Passing the red-lacquered Shin-kyo Bridge, a rising path introduces visitors to Nikko's world of moss. The Amida Buddha and thousand-handed Kannon statues inside the main hall of Rinno-ji, the first temple on the trail, hint at the divinity of the site, preparing visitors for the concentrated magnificence of the

Toshogu Shrine. Completed in 1636, the site is the resting place of the Shogun Tokugawa Ieyasu. There is a child-like pleasure in coming across the structure, like discovering treasure in a forest. This is partly attributable to the color scheme. The first sight in the complex is an impressive five-story pagoda, painted in striking greens and reds, a fitting introduction to the stunning Yomeimon, a gate encrusted with ornate designs, gilt finishings, and carvings of peonies, Chinese sages, dragons, peacocks, and

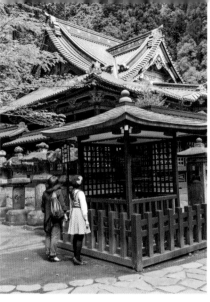

LEFT The brilliant red of the Shin-kyo Bridge is a hint at the exuberant colors met by visitors inside the woodland complex.

sculptures of Immortals springing from the bracketing. Nikko has its detractors, those who recoil at the hubris of the ornamentation. This makes the understated simplicity of Ieyasu's tomb, beneath a quiet glade of pines, a relief. It's a short walk west to the little-visited Nikko Tamozawa Imperial Villa, a tasteful residence surrounded by landscaped gardens, and, unlike the ostentatious brilliance of the shogun's shrine, an exercise in the very best of Japanese aesthetics.

ABOVE LEFT One of a row of Jizu statues, a deity tasked with protecting children and travelers.

ABOVE Visitors peer at a stone lantern in its own protective space.

BELOW Nikko's famous "see, speak, hear no evil" monkey relief.

OYA MACHI STONE VILLAGE

Location 909 Oya-machi, Utsunomiya City, Tochigi.
Getting There Trains from Tokyo's Ueno Station to
Utsunomiya. Buses to Oya-machi take 20 minutes.

LEFT The rock facing and
colonnaded windows of
this building create an
almost classic look.

Built on a plateau of *Oya-ishi*, or Oya stone, the area's porous cliffs and underground rocks were formed out of volcanic ash deposits created after a submarine volcano erupted some twenty million years ago. Deposits of sand, pebbles, and ash compacted into tuff, form the volcanic rock that is the leitmotif of Oya Machi. What is so startling about this Meiji-era village is that not only its commercial buildings, storehouses, and Buddhist statuary but its private residencies are made of stone, something more associated with the Mediterranean than Japan. The stone acquires a pleasing bluish, powdered green tea, even mustard hue with exposure to the elements. Zeolites within the stone, rust-colored minerals, leach out of the rock, leaving pock holes

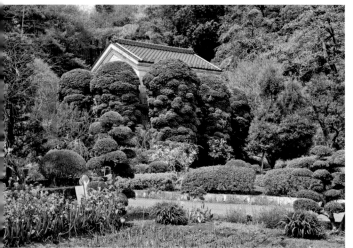

LEFT The rural setting of a
private home constructed of
Oya stone.

BELOW Souvenirs made from
Oya stone may be a little
heavy to take home.

and cavities of an interesting irregularity and graining. One of the most startling sights of Oya Machi is its 27-m (88-ft)-high Heiwa Kannon-zo (Kannon Peace Statue), a monumental figure cast in local stone. The ancient-looking statue was actually assembled in 1956. The Oya Shiryokan is a museum tracing the long history of the rock and how it was mined. Some 60 m (196 ft) below the museum, a subterranean cavern, quarried by hand from the rock, covers a mind-scrambling 20,000 sq m (21,520,000 sq ft), making it larger in volume than Tokyo Dome. About 1,500 years ago, the stone was used to line the walls of burial chambers. Today, with less demand as a building material, it is carved into ornamental garden frogs. Such are the imponderables of history.

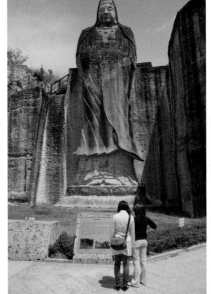

BELOW In this complex Buddhist carving, the stone has acquired an attractive bluish hue.

ABOVE RIGHT Two visitors give an idea of the scale of the Heiwa Kannon-zo statue.

RIGHT Raw *Oya-ishi* contrasts with the cut and buffed surfaces of a house made from the stone.

ASHIKAGA TRADITIONAL TOWN

Location Ashikaga-shi, Tochigi Prefecture. **Getting There** Limited Express (70 minutes) and semi-express trains from Tokyo's Asakusa Station to Ashikaga Station. The Ashikaga Flower Park is one stop on the Ryoma Line. **Hours** 9.00 a.m.–6.00 p.m.

The powerful Ashikaga shoguns lent their name to a town that is strongly associated with silk production and the study of Confucianism. Home to a school that is often called Japan's oldest university, a statue of Confucius, made in Shangdong Province in China, takes pride of place in the grounds. With the exception of the school's main gate, a narrow wooden structure dating from 1668, none of these structures are original, but major renewals in 1990 produced results remarkably faithful to the originals. The sites, including the Hojo, a large prayer room, library, living quarters, and sensitively laid out landscaped garden, convey the dignity and status of this former school of higher learning. Vestiges of authenticity are visible in tea houses, textile emporiums, and storehouses converted into souvenir shops. One stop from Ashikaga, Tomita is known in late

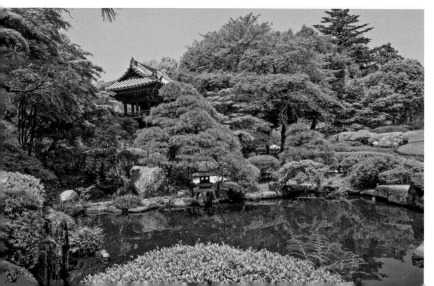

LEFT An old bell tower that is one of the few authentic structures in Ashikaga.

OPPOSITE ABOVE LEFT Sensitively reconstructed buildings seen from the surrounding moat.

April and early May for its huge wisteria park. The garden displays flowers in varying forms: some free-standing, others creeping along the tops of walls, gracing concrete tubs, and, at their most impressive, purple and white inflorescences hanging from large pergolas known in Japan as *fuji dana*. One of the most spectacular wisteria trellises is said to be over 150 years old. Entrance fees to the park are adjusted according to the degree of blossom; ergo, when in full bloom, ticket prices are at their steepest.

ABOVE A statue of Confucius. During the Edo era, the authorities used a form of neo-Confucianism to govern.

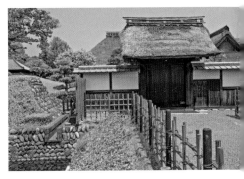

TOP Visitors posing for a photo in front of pendants of lavender-colored wisteria in full bloom.

ABOVE The buildings of the old school complex are accurately reconstructed and meticulously maintained.

MINKA-EN "FOLK HOUSES" PARK

Location 7-1-1 Masugata, Tama-ku, Kawasaki. **Getting There** Odakyu Line from Shinjuku to Mukogaoka-yuen Station. A well-signposted 13-minute walk from the station to the theme park. **Hours** 9.30 a.m.–5.00 p.m. (March–October), 9.30 a.m.–4.30 p.m. (November–February). **Fee** ¥

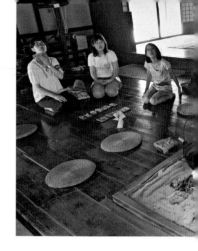

Dedicated to Japan's vernacular folk architecture, the *minka* of the theme park title refers to "folk houses," of which there are 25, relocated from all over Japan. Reflecting regional diversity, the museum grounds have architectural samples from prefectures as far apart as Yamagata, Kagoshima, Gifu, Kanagawa, and Toyama. The grounds contain a number of other structures of interest, including grain houses, a water mill, and firewood stores. Objects of everyday use, including agricultural tools and kitchen utensils, are displayed inside each house, alongside sculleries, sinks, and family altars. Special events include puppet shows, acts by traditional performing arts groups, workshops on making indigo towels, stone mill grinding, carpentry, house construc-

BELOW A fine example of the steep-roofed *gasho-zukuri* style of architecture.

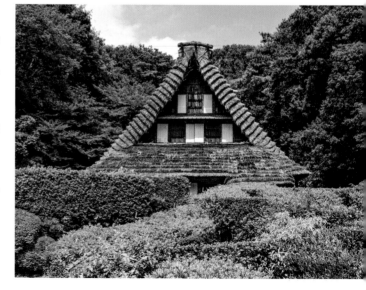

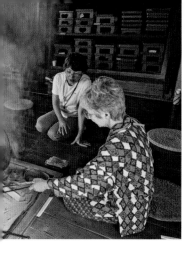

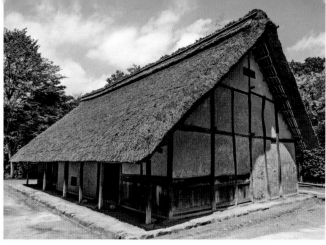

tion, and fire making, where volunteers bank hearth fires, adding coal and twigs, fanning the flames as the cinders ignite. The smoke from these rustic fireplaces lengthens the life of wooden beams and thatch, prevents damp and decay, and exterminates harmful insects. For a Japanese visitor, the mnemonic effect of smelling hearth smoke and scorched beams evokes a pre-industrial age of organic home materials. Foreign visitors can experience a similar nostalgia in the lingering aroma of wood fires, the polished glow of time-worn hardwood floors, and the luster of shadowy interiors.

ABOVE LEFT A volunteer demonstrates to a group of students how to light and maintain a traditional hearth fire.

BELOW An atmospheric Buddhist image of unknown provenance has been placed within the grounds of the park.

ABOVE Reinforced with wooden beams, this structure's walls are made from a mixture of mud and straw.

BELOW Getting ready to smooth out the ash before starting a fire.

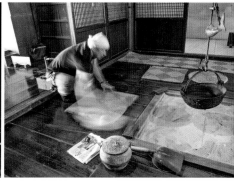

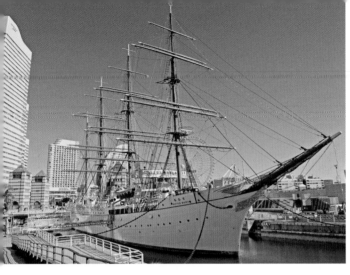

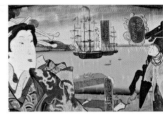

LEFT The *Nippon Maru*, a training vessel, dominates the dock in this part of Minato Mirai.

ABOVE A *ukiyo-e* style shop billboard represents Yokohama with Perry's "black ships" floating on the bay.

DAY TRIP TO YOKOHAMA

Location Yokohama-shi, Kanagawa Prefecture. **Getting There** Tokyu Toyoko Line from Shibuya Station. JR Tokaido, Keihin-Tohoku, and Yokosuka Line trains from Tokyo Station.

In print master Hiroshige's picture of Kanagawa Prefecture, we see two-story tea houses in what looks like a little-known fishing village located on mudflats. By 1859, a mere five years after Commodore Perry and his small fleet of "black ships" forced open the oyster of Japan for trade, the fishing settlement had become Yokohama, a town already showing signs of the great tiered port city and foreign settlement it would become. The Japanese of the day were drawn to the enclave for several reasons: its new architecture, which included Western-style homes and a large church on the Bluff, parks, gardens, meat-serving restaurants, coffee shops, and most curious of all, the foreigners themselves, women dressed in crinoline, men with luxuriant moustaches and gold watch chains. Yokohama retains its cosmopolitan character to this day. A good place to begin a waterfront exploration of the city is at Minato Mirai, a short walk from Sakuragicho Station. The futuristic zone is set aside for shopping, hotels, museums, and an amusement park with a large Ferris wheel. The graceful *Nippon Maru*, a training vessel built in 1930, is the first sight most visitors see. Two grand warehouses dating from the Meiji era, known as *akarenga*, have been converted into shopping, eating, and entertainment facilities. On the city's Bund, its original

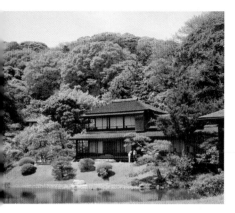

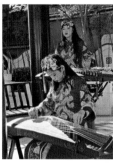

ABOVE A finely preserved clapboard structure in the old foreign residential district of Yamate.

TOP LEFT Located in a residential district, the Sankei-en garden is rarely crowded.

TOP CENTER A performance of classical Chinese music in the heart of Chinatown.

TOP RIGHT The fabulously decorated entrance gate to a Chinatown temple.

waterfront, the Silk Museum acknowledges a period when production was important to the nation's economy. The nearby district of Kannai has some stunning early buildings, including the Yokohama Archives of History, the Old Customs House, and the fine Port Opening Memorial Hall. One Meiji-era European observed of the Chinese in Yokohama, "If they were suddenly removed, business would come to an abrupt halt." That may no longer be true, but remains a sound observation when it comes to good food. Its Chinatown, one of the largest in the world, is a warren of lanes and passageways reeking of herbal medicines, spices, fried foodstuffs, and steaming cauldrons and pans of congee and dumplings. Chinese design influences are visible at Sankei-en, a spacious Japanese garden in the Honmoku district. European lifestyles reassert themselves in the graceful hilltop residential district of Yamate. The area boasts a number of airy wooden residences once owned by wealthy merchants or serving as temporary housing for diplomats. Christ Church, founded in 1862, with its Norman and Anglo-Saxon design elements and large belfry, seems to hail from a distant provenance. I half expected to see a game of cricket in progress, the surroundings not altogether unlike an English village green.

EXCURSION TO KAMAKURA

Location Kamakura shi, Kanagawa Prefecture. **Getting There** Kita Kamakura and Kamakura Stations on the JR Yokosuka Line from Tokyo Station. Enoshima is 25 minutes on the Enoden Line from Kamakura Station.

Less than an hour south of Tokyo, the ancient city of Kamakura has aged well. Along its northeastern borders, a rosary of temples and gardens, pressed up against cliffs and woods, are strung out along a rising terrain. Highlights would have to include Kita Kamakura's great Engaku-ji Temple, founded in 1282, the Rinzai sect temple of Kencho-ji, and the striking vermilion paintwork of Tsurugaoka Hachinman-gu, a major shrine with a forested backdrop. Eastern Kamakura is best known for Hokoku-ji, the "Bamboo Temple," where green tea is served, Sugimoto-dera, a thatched temple of great antiquity, and Zuisen-ji, a hillside temple with contrasting flower and austere dry landscape gardens. No trip to Kamakura is

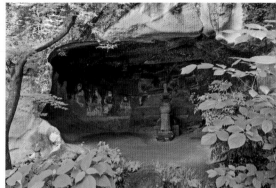

LEFT One of several sacred sites on an island that can seem almost like a religious theme park.

BELOW A cave recess in the grounds of Meigetsu-in, a temple and garden best known for its rainy season hydrangeas.

complete without paying homage to its Great Buddha. Constructed in bronze, the 11.3-m (37-ft) statue dates from 1252. A massive typhoon struck the area in 1335, leveling everything in the vicinity except the Buddha image, which stood firm in a flooded lake of sea water. A short stroll from here, past the temple of Hase-dera, leads to the Enoden tram line, which runs to the curious island of Enoshima. According to legend, the goddess Benten persuaded Enoshima's resident five-headed dragon king, the god Ryujin, to protect the island after it rose dramatically from the sea in something akin to a marine creation myth. The goddess, a patron of music and the arts, is much venerated on the island. There is even a Benten hall housing a statue of the deity, which owes its reputation less to craftsmanship than the fact that it is a nude study, a rarity anywhere for a religious icon.

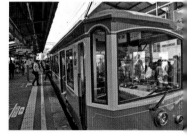

ABOVE The highly enjoyable Enoden train is also a tram.

OPPOSITE The Great Buddha, majestic, inviolable to storms and flooding.

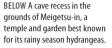

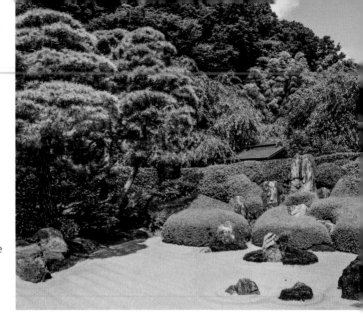

Modesty decrees that you can ogle but not photograph the image. At the top of the flight of stone steps, Enoshima Shrine, dedicated to the sea goddess Benten, is the first of the island's main religious sites. A steep rise and equally sharp descent takes you past the botanical grounds of the Samuel Cocking Park to the southwestern part of the island and a rocky shelf honeycombed with grottoes. Iwaya Cave has long been associated as the lair of the dragon king Ryujin. At the inner recess of the cave there is a rather lurid plastic model of the creature, its bulging eyes guaranteed to terrorize young children. The tunnels, replete with their icy blue lighting, dripping water, phosphorescent rocks, and ancient Buddhist statues, including depictions of cobras, are more of a psychedelic experience than a mystical one. Visitors seem to respond to the mood by becoming silent and pensively introspective.

ABOVE The dry landscape garden in the Rinzai sect temple of Meigetsu-in.

RIGHT The side streets close to Kamakura Station are popular with craft and souvenir shoppers.

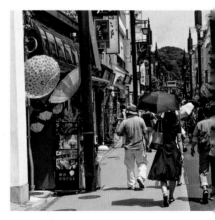

BELOW The eerily lit tunnels of Iwaya Cave lead to some interesting, even kitschy sights.

BELOW A blur of speed. *Yabusame*, or horseback archery, at Tsurugaoka Hachiman-gu's spring festival.

ABOVE This connecting bridge to Enoshima reduces its mystery but increases the convenience of access.

VOLCANIC HIGHLANDS AROUND HAKONE

ABOVE LEFT Volcanic rocks add authority to the Shinsen-kyo Japanese garden.

Location Hakone-machi, Kanagawa Prefecture. Getting There Odaykyu Line from Shinjuku to Hakone-Yumoto. Change for Hakone Tozan Railway.

Twenty minutes from Hakone-Yumoto, Miyanoshita is one of the oldest and most prosperous spa towns in the Hakone region. The Fujiya Hotel, opened in 1878, is among the most gracious places to stay. Two stops on, at Chokoku-no-Mori Station, the Hakone Open-Air Museum features modern sculptures artfully blended with landscaped gardens. Works by Calder, Brancusi, Rodin, Giacometti, Henry Moore, and other Western masters are displayed across sloping lawns alongside the works of Japanese artists like Hayashi Takeshi and Umehara Ryuzaburo. The line terminates at Gora, where some visitors can detour to the Pola Museum of Art, with its splendid collection of Western art. The funicular tram at Gora ends at Sounzan, but it is worth getting off at Koen-kami Station for the Hakone Museum of Art, with its ancient ceramic exhibits and a fine

ABOVE There is much visitor demand for the black eggs boiled in the hell pools of Owaku-dani.

ABOVE The rolling lawns and fine landscaping of the Hakone Open-Air Museum.

BELOW RIGHT Yellow streaks staining the sulphur pits of Owaku-dani.

ABOVE Visitors to the Hakone Open-Air Museum enjoying a free hot spring foot bath.

ABOVE This must be the perfect view for a golf range.

Japanese garden. From Sounzan, a cable car runs to Lake Ashino-ko, passing over dramatic sulphur pits. The first stop is Owaku-dani, the closest you can get to the valley's bubbling craters and lava formations. Eggs are boiled in the pools here and sold to visitors, the black-stained shells reeking of sulphur. The calm waters and pleasure boats of Lake Ashino-ko seem quite tame after the bellicose drama of Owaku-dani.

ATAGAWA HOT SPRING

Location Naramoto Higashiizu, 413-0302. **Getting There** JR Limited Express from Tokyo Station to Izu-Atagawa Station. **Fee** ¥¥ Alligator Park.

The Izu Peninsula is noted for the slightly higher temperatures it enjoys compared to the nearby capital. Atagawa Hot Spring thrives on subterranean minerals that have a visible effect on nature. Lush bamboo fronds and abnormally large clumps of fatsia grow in luxurious tumescence, their glossy leaves outlandishly healthy as if fed on super nutrients and fertilizers. The almost subtropical microclimate of the resort is mirrored in rows of phoenix palm, flowering bougainvillea, hibiscus, and cactus. Intensifying the heat are jets of steam spurting from vents punctured in the earth, the air rising through towers that look like small Texan oil derricks. At the Atagawa Tropical & Alligator Garden, the reptiles are raised in thermal waters fringed with plantings akin to jungle flora. Tickets for the alligator com-

ABOVE A subtropical succulent thrives in the outdoor grounds of the botanical garden.

RIGHT Wooden towers like this collect mineral deposits, which are packed and sold as bath powder.

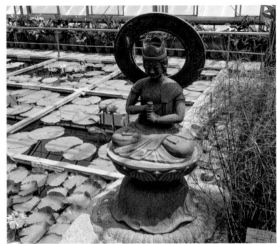

LEFT A seated Buddha presides over tanks of water lilies in the botanical greenhouses.

pound cover entrance to an excellent botanical garden just across the road. The thermal waters nourish great clumps of orchids, lotuses, tropical trees, fruit-bearing mango, starfruit, guava, and the faintly lemon-tasting Miracle Fruit. One greenhouse is dedicated to a single plant species, the gigantic lily known as *Victoria amazonica*. The town's heyday as a stylish resort has clearly passed, but there is a particular charm to this unfashionably quiet botanical spa that more crowded hot spring destinations have lost.

BELOW Bougainvillea in full bloom in the botanical garden.

ABOVE A visitor soaks in one of Atagawa's many indoor hot springs.

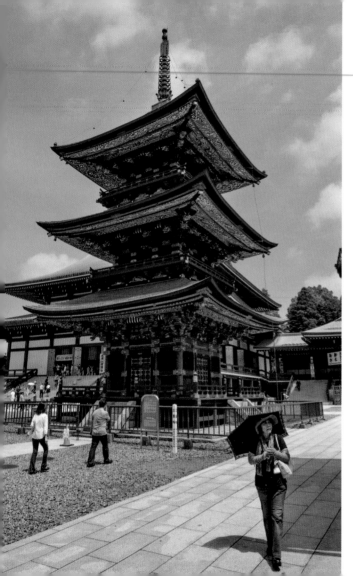

NARITA TEMPLE

Location 1 Narita, 286-0023. **Getting There** JR Narita or Keisei Narita Stations. **Hours** Open all hours.

Narita Temple, better known as Narita-san, is one of the most important religious sites in Japan, drawing an astonishing ten million visitors a year. Omotesando, a long, winding street leading to the site, lined with inns, souvenir shops, and stores specializing in religious trinkets, is a good place to sample the area's signature charcoal broiled eel. Visitors climb a row of steep stone steps and pass under a great gate to reach the main compound and an imposing three-story pagoda, dating from the 18th century. Key dates on the cultural calendar

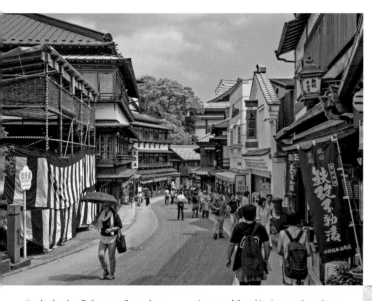

include the February Setsubun ritual, during which sumo wrestlers toss dried beans while imploring good luck for the coming year, and the July Gion Matsuri, a festival in which participants dressed in traditional clothing drag heavy, towering floats known as *dashi* down the slope of Omotesando. At the rear of the temple, there is no entrance fee to Narita Koen, a Japanese stroll garden surrounding a central pond. Its serenity represents a parallel but alternative world to Narita-san's animated main compound. The garden, replete with winding paths, stone lanterns, towering pine trees, and a floating pergola, offers a rare liberation of space.

ABOVE Visitors strolling along Omotesando, a commercial street leading to Narita-san.

OPPOSITE FAR LEFT Narita-san's magnificent three-story pagoda is visible for miles around.

OPPOSITE LEFT Daredevil participants standing above tall, wobbling floats.

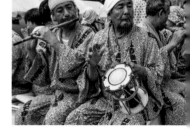

TOP A painter tries to capture the beauty of Narita Koen and its spacious pond.

ABOVE Ensembles of musicians add a steady sound track to the Gion Matsuri festival.

NOKOGIRIYAMA "SAWTOOTH MOUNTAIN"

Location Kyonan-machi, Awa-gun 299-2111, Boso Peninsula, Chiba Prefecture. **Getting There** Direct trains from Tokyo and Chiba Stations to Hamakanaya Station. Alternatively, a 40-minute ride on the JR Uchibo Line from Kisarazu.

LEFT A visitor on the woodland trail up the mountain inspecting a *chinowa*. Passing through the hoop is said to be an act of purification.

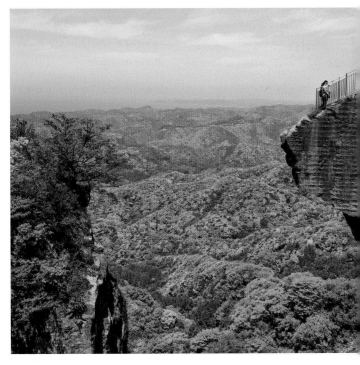

With deep cavities cut into the rock face of a mesa, first impressions of Nokogiriyama ("Sawtooth Mountain"), suggest a Mesopotamian ruin. At a mere 329 m (1,080 ft), its height is less monumental than its name suggests. Visitors can ascend by cable car or by a more interesting forest route following earthen trails and steep stone steps. Extensive quarrying took place here during the Edo period (1603–1868). Skillfully incised into a recess at the summit, the beautiful features of the Hyakushaku Kannon stand in perfect harmony with its rock gallery. The nearby Ruriko Observatory, a rock promontory, provides sweeping views across Tokyo Bay. Descending the other side of the mountain, one passes natural caves, cavities, and grottoes requisitioned as galleries for Buddha

235

ABOVE During the Edo era, rock was cut and then shipped across the bay to Edo, present-day Tokyo.

LEFT The sawtooth sides of the Ruriko Observatory indicate that it was partially quarried.

RIGHT The clear, rectilinear lines of quarried rock face look almost like designed structures.

FAR RIGHT Despite its aura of protective divinity, the Yakushi Nyorai underwent extensive restoration in 1966.

and bodhisattva statues, and the Tokai Arhats, models of disciples of the Buddha who have achieved spiritual enlightenment. Each face is different, from the craven to the beatific. Tradition holds that if you begin counting

your own age from any given figure you will arrive at the arhat that most resembles your inner self. Dominating the mountain is the Yakushi Nyorai, or Buddha of Healing. Completed in 1783, it is the largest sacred rock carving in Japan. From the base to the tip of the giant lotus bud that stands behind the statue's head like a stone antimacassar, it measures 31.05 m (100 ft). High on its windy plinth, the victim of sun and salt erosion, the Buddha is beginning to look its age.

Travel Tips

Best Time To Go

April and early May is the popular cherry blossom season. Autumn leaves are at their best in October and November. Summer is hot and steamy, winter cold, and the air very dry. Tokyo hosts a number of fantastic festivals, so check the city's cultural calendar.

Getting There

Tokyo International Airport in Chiba Prefecture is under an hour from central Tokyo. The bayside Haneda Airport, with more domestic than international flights, is within the city itself and is connected by a monorail. Trains, limousine buses, and taxis are available.

Tokyo Transport

Trains. The world's largest subway system is complex but visitor-friendly. Lines are color-coded, signage is in English and increasingly Chinese and Korean. Two companies operate the subway, the nine-line Tokyo Metro and four-line Toei. These lines share the same stations. Pre-paid PASMO and SUICA cards, usable on both systems, are easy to use. The JR Yamanote Line is an overground loop line that takes in many of the city's major hubs. Other lines, including the JR Sobu and Chuo Lines also operate.

Buses. These are an option but few overseas visitors use this more complex system.

Taxis. A good option for getting around. These charge a base rate currently of ¥730 for the first 2 km (1.2 miles). A red light means the cab is free, green indicates usage.

Bicycles. Bike rentals exist, but given that there are few bicycle lanes and roads can often be narrow, this might be a last option.

Tours

For a quick introduction to the city center, the Hato Bus (www.hatobus.com) is recommended. Japan Gray Line (www.jgl.co.jp/inbound) offers similar short and half-day itineraries. Several tour operators offer walking, cycling, and go-kart tours.

Media

NHK has two channels, including satellite channels and NHK World, an international channel. Bilingual sound tracks in English are available. Japan's foremost English language newspaper, with comprehensive news and events coverage, is *The Japan Times*. A free magazine, *Metropolis*, available at bookstores or online, is full of Tokyo-related news and recommendations.

Festivals & Events

There are festivals, known as *matsuri*, every month in Tokyo, so check online listings. These aren't designated national holidays. Notable events include January's *hatsu-mode*, first visit to shrines, the Hina Matsuri (Doll's Festival) in March, *hanami* cherry blossom viewing in late April, the large Kanda Matsuri in mid-May, Asakusa's massive three-day Sanja Matsuri in May, and the O-bon summer dances in August. Check for more contemporary events like Anime Japan, Art Fair Tokyo, Design Festa, and Tokyo Design Week.

Manners & Conduct

Liberal allowances are made for foreign visitors, but removing shoes in private houses, *minshuku* (guest houses), and some hotel rooms and restaurants is the norm. Blowing your nose in public is frowned upon. Punctuality is expected when meeting people. When bathing in public baths and hot springs, make sure to wash before entering the bath. The tub is for relaxation. Tattoos are an issue in Japan as the Japanese automatically associate them with members of criminal groups like the *yakuza*, this despite the fact that many young Japanese have tattoos. Many hot springs, public baths, and gyms continue to refuse admission to people who are inked, though this is gradually changing. When eating rice, it is polite to lift the bowl, then replace it. Refrain from leaving your chopsticks upright in the rice or passing food from one pair of chopsticks to another, both considered taboo. Sexual discrimination remains a major problem, Japan's world rankings miserably below those of developed nations. At its worse, it manifests itself in groping on subways, which have resorted to introducing women-only carriages for the morning rush hours. Foreign women visitors are rarely targeted.

Costs

Tokyo's reputation for being exorbitantly expensive dates from the bubble era when prices were inflated. Many international capitals have overtaken Tokyo in cost. It depends, of course, on where you come from, but good deals are to be had, particularly when it comes to lunch and dinner sets in local and chain eateries. Transportation costs are on par with many developed countries, but the system of charging per person for single-room occupancy means higher fees for couples and families. Consumption tax, imposed on most goods and services, is currently 10 percent.

Crime & Safety

Tokyo is one of the safest capitals in the world. Most Japanese follow the rules, resulting in low levels of theft and drug abuse. That said, it is always advisable to be careful with

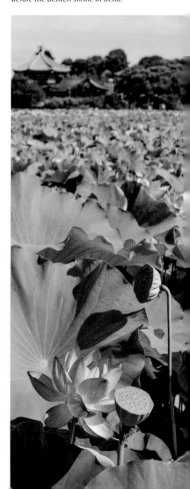

Sacred lotuses in morning bloom before the Benten Shrine in Ueno.

money, credit cards, passports, and documents when in crowded places. Police boxes called *koban* can be found in every neighborhood. If you do get stuck, contact Tokyo Metropolitan Police's English-language hotline (03-3501-0110). The Police telephone is 110.

Kids in Tokyo

Japanese people adore small children, in particular, and will go out of their way to show kindness. Tokyo is a remarkably safe city with an abundance of toy shops and computer games, anime, and manga stores. A love of the cute among many Japanese adults, particularly women, sets the scene for a kid-friendly city. It is common practice for families to share rooms in hotels, *ryokan* (inns), and *minshuku* (guest houses), arrangements that can suit visiting families very well. School-age kids are usually eligible for reduced rates at most attractions.

LGBT in Tokyo

Social resistance to LGBT is fading and such visitors will find little open hostility to their status.

Japan still has a long way to go in openly recognizing alternative relationships, with many Japanese choosing to live a double life. Public displays of affection are not common between people of any persuasion, so best avoided. There are numerous gay and lesbian venues in the city, most notably in the Shinjuku Nichome district.

Electricity & Internet

Tokyo runs on 100V, 50Hz AC electricity. Japanese plugs are two-pronged. This does not affect computers, cell phones, digital camera batteries, and other appliances. Adapters are easy to find in electronic stores. Japan lags behind when it comes to Internet access, but the scene is improving, with Wi-Fi becoming more common in convenience stores, trains, subways, and cafés, with broadband available in some hotels.

Mail

Japan's postal service is rapid and efficient. In the city center there are 24/7 services, notably at the Central Post Office on the west side of Tokyo Station.

Time & Opening hours

Japan has no daylight saving time. Tokyo is nine hours in front of Greenwich Mean Time, fourteen hours ahead of New York, two hours behind Sydney. Business hours run from Monday to Friday, 9 a.m.–5 p.m., though in reality workers are often grinding away until much later. Average shop hours are 10 a.m.–7 p.m., but there are lots of exceptions. Despite some recent cutbacks, convenience stores are open 24/7. Most museums and galleries close on Mondays and national holidays.

Disabled travelers

Disabled members of the family were routinely hidden from view in Japan, but that has changed dramatically in the last couple of decades, with the creation of more barrier-free facilities in hotels and assistance on trains and in subways. Tokyo, with its complex, multilevel stations and narrow sidewalks, can still be a challenging place to access and explore in a wheelchair. Trains have an area in at least one carriage designated for wheelchairs.

Smoking

Japan has been described as a smoker's paradise, but tobacco users are in decline. Compared to many developed nations like the US and Britain, though, smoking is commonplace in many restaurants and public spaces. Dedicated public zones have been set aside, and in one Tokyo ward, Chiyodu-ku, smoking is actually a finable offense.

Tourist Information

With the rapid influx of tourists to Japan in recent years, information services in various languages have multiplied. Prominent centers are:

Japan National Tourism Organization: jnto.go.jp. JNTO has several offices in Tokyo, its largest on the first floor of the Shin-Tokyo Building in Yurakucho.

Asakusa Culture and Sightseeing Center: 03 3842 5566. A multistory building opposite the Kaminarimon entrance gate to Senso-ji Temple.

Tokyo City: en.tokyocity-i.jp. In the basement of the Kitte Building in Marunouchi.

Money Issues

Yen note denominations are ¥1,000, ¥5,000, and ¥10,000. Coins have values of ¥1, ¥5, ¥10, ¥50, ¥100, and ¥500. Japan remains a cash society, but credit cards are gaining in use. Credit and debit cards can be used to withdraw cash from ATMs. Foreign credit cards are accepted by the post office, department stores, main stations, and convenience stores like 7-Eleven.

Phones

Pay phones can be found at stations and other public spots. These take ¥10 and ¥100 coins. The area code for Tokyo is 030. Almost everyone has a mobile phone. Most main brand cell phones work in Japan. Visitors should consult with their service provider before leaving home. Phones can be rented at international airports. Narita Airport has rental booths run by Softbank and DoCoMo.

Hospitals & Clinics

Health insurance is recommended before visiting. Hospitals and clinics are easily located in every district. Large hotels stock medicine, but for more detailed inquiries contact the Tokyo Medical Information Service (03 5285 8181/ www.himawari.metro.tokyo.jp) for assistance in English. English-speaking pharmacists can be found at several dispensaries, notably the American Pharmacy in Marunouchi (03 5220 7716), near Tokyo Station. For ambulances, call 119.

Earthquakes

Japan is one of the most seismically active regions of the world. There is at least one quake per day, though the majority are minor tremors. Quakes can trigger tsunamis, as happened in March 2011, but also landslides and fire. Tokyo has a good warning system and refined sensors, as well as many high-tech, supposedly earthquake-proof structures, but many buildings are substandard or built from impermanent materials like wood and mortar. In the event of a major earthquake, stay indoors and position yourself under a table or desk or near a door frame. Avoid glass windows. If outside, try to reach a local park. Embassies should be contacted as a last resort.

This book is dedicated to Kazuko, Yuki & Rupert

Published by Tuttle Publishing, an imprint of Periplus Editions (HK) Ltd

www.tuttlepublishing.com

Copyright © 2020 Stephen Mansfield
Stock photos copyright:
Front cover: Sean Pavone/
Dreamstime.com; spine: poludziber/
Shutterstock.com; back cover:
Bogdan Lazar/Dreamstime.com;
pages 72 top left: Sean Pavone/
Dreamstime.com; 72 top right: a_text
(4989 枚)/photolibrary.jp; 73 bottom:
TAGSTOCK1/istockphoto.com; 214
top: Dexgear/Dreamstime.com; 214/5
bottom middle: Taweep Tang/
Shutterstock.com

ISBN 978-4-8053-1508-8

22 21 20 10 9 8 7 6 5 4 3 2 1

Printed in Malaysia 2001VP

TUTTLE PUBLISHING® is a registered trademark of Tuttle Publishing, a division of Periplus Editions (HK) Ltd.

Distributed by

North America, Latin America & Europe

Tuttle Publishing
364 Innovation Drive
North Clarendon
VT 05759-9436 U.S.A.
Tel: 1 (802) 773-8930
Fax: 1 (802) 773-6993
info@tuttlepublishing.com
www.tuttlepublishing.com

Japan

Tuttle Publishing
Yaekari Building 3rd Floor
5-4-12 Osaki, Shinagawa-ku
Tokyo 141-0032
Tel: (81) 3 5437-0171
Fax: (81) 3 5437-0755
sales@tuttle.co.jp
www.tuttle.co.jp

Asia Pacific

Berkeley Books Pte. Ltd.
3 Kallang Sector #04-01
Singapore 349278
Tel: (65) 67412178
Fax: (65) 67412179
inquiries@periplus.com.sg
www.tuttlepublishing.com

THE TUTTLE STORY
"Books to Span the East and West"

Our core mission at Tuttle Publishing is to create books which bring people together one page at a time. Tuttle was founded in 1832 in the small New England town of Rutland, Vermont (USA). Our fundamental values remain as strong today as they were then—to publish best-in-class books informing the English-speaking world about the countries and peoples of Asia. The world has become a smaller place today and Asia's economic, cultural and political influence has expanded, yet the need for meaningful dialogue and information about this diverse region has never been greater. Since 1948, Tuttle has been a leader in publishing books on the cultures, arts, cuisines, languages and literatures of Asia. Our authors and photographers have won numerous awards and Tuttle has published thousands of books on subjects ranging from martial arts to paper crafts. We welcome you to explore the wealth of information available on Asia at **www.tuttlepublishing.com.**